MW00529153

After 1851

MANCHESTER
1824

Manchester University Press

After 1851

The material and visual cultures of the
Crystal Palace at Sydenham

Edited by Kate Nichols and
Sarah Victoria Turner

Manchester University Press

Copyright © Manchester University Press 2017

While copyright in the volume as a whole is vested in Manchester University Press, copyright in individual chapters belongs to their respective authors, and no chapter may be reproduced wholly or in part without the express permission in writing of both author and publisher.

Published by Manchester University Press
Altrincham Street, Manchester M1 7JA

www.manchesteruniversitypress.co.uk

British Library Cataloguing-in-Publication Data
A catalogue record for this book is available from the British Library

Library of Congress Cataloging-in-Publication Data applied for

ISBN 978 0719 09649 5 hardback

First published 2017

The publisher has no responsibility for the persistence or accuracy of URLs for any external or third-party internet websites referred to in this book, and does not guarantee that any content on such websites is, or will remain, accurate or appropriate.

Typeset in Monotype Baskerville by
Servis Filmsetting Ltd, Stockport, Cheshire
Printed in Great Britain by
TJ International Ltd, Padstow

Contents

Figures

Contributors

James Boaden is lecturer in modern and contemporary art history at the University of York. His work is focused on the intersection between experimental film and more traditional fine art practices in mid-twentieth-century North America. He has curated film screenings for Tate Modern and the British Film Institute, and has contributed to *Art History*, *Papers of Surrealism*, and *Burlington Magazine*.

Nic Earle is academic project manager at the University of Gloucestershire. His PhD was concerned with visual aspects of communication in online virtual worlds and he has published articles on this topic. His current work explores how technology combined with robot actors can make 3D historical visualisations engaging and useful to different user groups.

Jason Edwards is Professor of History of Art at the University of York and the author of *Alfred Gilbert's Aestheticism* (Routledge, 2006) and *Eve Kosofsky Sedgwick* (Routledge, 2009). He is also the co-editor (with Stephanie L. Taylor) of *Joseph Cornell: Opening the Box* (Verlag Peter Lang, 2007) and (with Imogen Hart) of *Rethinking the Interior: Aestheticism and Arts and Crafts, 1867–1896* (Routledge, 2009) as well as of two special issues of *Visual Culture in Britain*. His research focuses on queer and animal theory, and the global contexts of British Sculpture from c.1760–1940.

Shelley Hales is Senior Lecturer in Art and Visual Culture in the Department of Classics and Ancient History at the University of Bristol. She works primarily on Roman domestic art and architecture and the impact of Pompeii's domestic ruins on nineteenth-century audiences. She recently co-edited with Joanna Paul, *Pompeii in the Public Imagination from its Rediscovery to Today* (Oxford University Press, 2010).

Verity Hunt is a postdoctoral research fellow in English at the University of Southampton. She works on intersections between nineteenth-century literature, technology and visual culture. She has published on Victorian visual education and communication, optical toys and shows and the Great Exhibition. Her first book, *The Victorian eBook: Literature and Electrical Technologies of Representation, 1875–1910*, is forthcoming from Edinburgh University Press.

Melanie Keene is Graduate Tutor at Homerton College, Cambridge. She works on the history of science for children from the eighteenth to the twentieth centuries, and has published articles on familiar science, board games, construction kits, candles, pebbles and cups of tea. Her first book, *Science in Wonderland: The Scientific Fairy Tales of Victorian Britain* appeared with Oxford University Press in 2015.

Kate Nichols is Birmingham Fellow in British Art after 1800 at the University of Birmingham. Her first book, *Greece and Rome at the Crystal Palace. Classical Sculpture and Modern Britain, 1854–1936* was published by Oxford University Press in 2015. She is co-editor (with Rebecca Wade and Gabriel Williams) of *Art Versus Industry? New Perspectives on Visual and Industrial Cultures in Nineteenth-century Britain* (Manchester University Press, 2016).

Ann Roberts completed her PhD at Falmouth University in 2012. Her thesis, entitled 'Painting by Mouth: Art, Modernity and Disability', was a culturally located study of the disabled artist, Bartram Hiles, who forms the principle subject of her contribution to this book. She is currently an independent scholar and researcher with a primary interest in late nineteenth and early twentieth-century cultural and art histories. She also works and researches in the field of creative making for health and well-being and has contributed to AHRC-funded projects led by Falmouth University and Arts for Health Cornwall.

Sarah Victoria Turner is Deputy Director for Research at the Paul Mellon Centre for Studies in British Art and was previously a lecturer in the History of Art Department at the University of York. She is working on a book on the India Society and encounters with South Asia in British art at the beginning of the twentieth century. She has published widely on sculpture and the relationship between art and the British Empire *c.*1850–1950.

Foreword
After 1851: the material and visual cultures of the Crystal Palace at Sydenham

Isobel Armstrong

This group of essays challenges the striking lack of attention that the Crystal Palace at Sydenham, opened in 1854, has received in comparison with the Crystal Palace of 1851. The shift in the nomenclature of the building's alternative titles is indicative – the 'Great Exhibition', the 'Palace of the People'. A hyperbolic space devoted to grand display hints at the cultural authority of the museum in addition to the works of industry: a populist playground in which 'Nothing was too large or too silly … to astonish and amuse the masses.' The editors quote Christopher Hobhouse's assessment of Sydenham to indicate the cultural status of the second Crystal Palace. But Victorian intellectuals also took pleasure in lampooning Sydenham, even though the work of intellectuals and scholars went into it – for instance, that of Owen Jones and Digby Wyatt. The Assyrian Court owed its imagery to the excavations of Layard.

The subtext is the high seriousness of the Kensington museum site and the low comedy of Sydenham – history repeating itself as farce in the second Crystal Palace. Ruskin, despite reluctant cooption into writing for the Palace, despised the 'cucumber frame' and shuddered at the appearance of a gigantic clown who repeated inane phrases. George Eliot in *Daniel Deronda* implies the vulgarity of the Syrian Court through Hans Meyrick's gross anti-Semitism – Mirah's brother, he speculates, might be 'a fellow all smiles and jewellery – a Crystal Palace Assyrian'. Gissing disgustedly portrayed the Palace as the degenerate site of working-class consumption in *The Nether World* (1889), as people swill and fight. John Davidson's poem, 'The Crystal Palace', in *Fleet Street and Other Poems* (1909), characterised it as a 'shed,/Intended for a palace'.

Refreshingly, the chapters here refuse this denigration, past and

present, of popular culture and the Victorian urge to education through recreation. The editors, Kate Nichols and Sarah Victoria Turner, argue for the seriousness of Sydenham's cross-class project, its eclectic activities and its simultaneous celebration of a fairyland environment, global commodity and the technologies of empire, the railway and the telegraph. High art and commodity, imperial message and demotic participation – these are the contradictions of Sydenham but also its strength as a cultural experiment. The contributors break down any monolithic reading of the second Crystal Palace. Verity Hunt writes of the miniature souvenirs that make use of microphotography, a peep egg and a needle case, to forge narratives of the Palace through the senses. Jason Edwards explores the middle-class cosmopolitanism of the Sydenham portraits as mapped by Phillips's *Guide*, both liberal and Eurocentric, progressive and racist. Ann Roberts charts the combination of painting and entertainment, freak show and art show, in the entrepreneurial opportunism of the disabled painter by mouth, Bartrum Hiles, and the showmanship of the classically trained lightning cartoonist, Herbert Beecroft.

The unprecedented presence of the naked body in copies of classical sculpture and as living ethnographic spectacle, the cultivation of physique through commercial and official sports, is the theme of Kate Nichol's chapter, while the grotesque bodies of the notorious dinosaurs and their role in the imaginative life of children's stories in Melanie Keene's chapter demonstrate how the human and ecological body was alike the source of ideological fictions. The strange occlusion of India as colonial space, and yet its presence in the circuits of empire through copy and photograph, a kind of return of the repressed, in Sarah Victoria Turner's discussion, contrasts with James Boaden's account of the spaces of the afterlife of the Palace, another heterotopia, where mourning and melancholy cohabits with the sexual pleasures of the park. Shelley Hales and Nic Earle conclude this collection with a bravura trip into the virtual space of Matthew Digby Wyatt's Pompeian House, another exercise in thinking through alternative spaces.

How we think about copies, on which the displays of Sydenham depended, how we theorise the imagined and actual spaces of Sydenham, are topoi that arise from this collection. But I think that these are subsumed in a larger issue that all the contributors address directly or indirectly. This is the move from the deprecating terminology of 'mass culture' to a more open language of 'popular culture'. Walter Benjamin, the cultural thinker who is a point of reference in this volume, is on the cusp of this change, critiquing cultural consumerism on the one hand and celebrating the radical potential of the dream world of popular media on the other.

The two terms, mass culture and popular culture, have always been in tension, sometimes used as synonyms of one another, sometimes set in opposition. But from the days of the Frankfurt School to Stuart Hall in the 1960s, both mass culture and popular culture have been associated with an attempt to define the effects and common characteristics of a homogenous body of mediated culture on an audience largely seen as passive and at worst 'reified'. 'We wish to know', wrote Leo Lowenthal, 'whether the consumption of popular culture really presupposes a human being with preadult traits ... half mutilated child and half standardized adult'.[1] Stuart Hall and Paddy Whannel in their pioneering book of 1964, *The Popular Arts*, drove a wedge between creative popular arts and 'mass media': 'A very sharp distinction has to be drawn between popular art and the "art" of the mass media.' But though they granted a genuine aesthetic to popular art, they still provided a totalising account of it – popular art 'is essentially a conventional art which restates, in an intense form, values and attitudes already known'.[2]

The writers in this collection are distinguished by their respect for popular culture and its consumers. This respect arises because the authors understand the cultures of Sydenham as readable in many ways and attribute agency to the mixed audience who responded to them. The chapter that ends the collection, Hales's and Earle's ludic entry into virtual Sydenham, stands as a methodological concluding statement for this volume, demonstrating as it does that there were 'many possible paths' through the spaces of the second Crystal Palace, so that it could never be legible in a single way. Verity Hunt sees the miniatures that harboured the Stanhope glass as 'cognitive tools' that enabled the viewer to make imaginative sense of her world, not vehicles of estrangement. Jason Edwards writes of the 'complex cultures' disclosed in Phillips's *Guide* to portraiture and its origins. Ann Roberts describes how her classically trained painters transgressed the boundaries of spectacle and fine art, which in many ways itself precipitated the crossing from high culture to spectacle and made the high/low distinction problematic. The trained physique of the male body, Kate Nichols writes, was valorised through the naked images of ancient classical sculpture, and given ideological justification for the expansion of empire by a white elite. But she shows that nationalistic sporting displays were poorly attended. She argues that it would be 'reductive' to assume that bodies used as spectacle lacked agency over their representation, refusing containment as objectified figures. The cultural trophies of India, Sarah Victoria Turner shows, were open to multiple readings, and 'different messages about Britain's relationship with the colonies could be articulated alongside, or in competition, with one another'. Melanie

Keene writes of the 'shifting uses of the Crystal Palace monsters'. James Boaden considers the subversiveness of the Crystal Palace park – 'a kind of vast lovers lane'.

This collection is one of a number of studies pointing the way to a more subtle and open reading of the extraordinary achievements of Sydenham.[3] It confirms that the two Crystal Palaces are inexhaustible as sites of popular cultures and points the way to further work and further debate – in particular on the status of the archive, and on the conceptualisation of popular culture. It opens the way to a history at once more generous and more detailed, and above all, exciting.

Notes

1 Leo Lowenthal, 'Historical Perspective on Mass Culture', in Stephen Eric Bronner and Douglas MacKay Kellner (eds), *Critical Theory and Society. A Reader* (New York and London: Routledge, 1989), p. 197.
2 Stuart Hall and Paddy Whannel, *The Popular Arts* (London: Hutchinson, 1964), p. 66.
3 See the editors' endnote 3, 'Introduction', p. 20.

Acknowledgements

This collection of essays developed from a one-day conference held at the University of York in 2011, where we were both employed at the time in the Department of History of Art. We would like to thank the Department of History of Art, the British Art Research School and the Centre for Modern Studies at York for supporting the event from which this book originated. The event was also generously funded by an Education Grant from the Paul Mellon Centre for Studies in British Art. Sarah would like to thank the continued support of the Paul Mellon Centre, where she now works, and especially her colleagues Mark Hallett, Mary Peskett Smith, Maisoon Rehani and the Collections staff for their research assistance. The York event encouraged a lot of lively discussion and we would like to thank all the speakers and contributors including those who participated in the event, in particular Jasmine Allen, Isobel Armstrong, Whitney Davis, Gowan Dawson, Sadiah Qureshi, Deborah Sugg-Ryan and Gabriel Williams. We have made extensive use of a number of local studies libraries and archives and would like to thank the staff at Bromley Libraries, the National Art Library, the Guildhall Library and the archives of the Imperial War Museum. For helping in sourcing images and creating an indispensible virtual Crystal Palace on the Sydenham Town Forum we would like to thank 'Tulse Hill Terry' for his encyclopaedic knowledge and generosity. We would also like to thank staff at Manchester University Press for all their help throughout process of preparing the manuscript, and also to the anonymous readers.

This has been a true collaboration. We sat down and wrote the introduction together, sharing the intellectual and the physical labour of committing words onto the computer screen. We would also like to thank

our authors who have also been wonderful collaborators in the long, but enjoyable, process of publishing this volume.

Sarah Victoria Turner and
Kate Nichols

I

'What is to become of the Crystal Palace?' The Crystal Palace after 1851

Kate Nichols and Sarah Victoria Turner

'The 10th of June, 1854, promises to be a day scarcely less memorable in the social history of the present age than was the 1st of May, 1851', boasted the *Chronicle*, comparing the opening of the Crystal Palace, newly installed on the crown of Sydenham Hill in South London, to that of the Great Exhibition (figure 1.1).[1] Many contemporary commentators deemed the Sydenham Palace's contents superior, the building more spectacular and its educative potential much greater than its predecessor.[2] Yet their predictions proved to be a little wide of the mark, and for a long time, studies of the six-month long Great Exhibition of 1851 have marginalised the eighty-two-year presence of the Sydenham Palace.[3] This volume looks beyond the chronological confines of 1851 to address the significance of the Sydenham Crystal Palace as a cultural site, image and structure well into the twentieth century, even after it was destroyed by fire in 1936.

The Crystal Palace at Sydenham, both as complete structure (1854–1936) and as ruin, does not belong exclusively to any one period. It was an icon of mid-Victorian Britain, but at the same time embodied from its inception architectural innovation and modernity – what Henry James described in 1893 as its 'hard modern twinkle'.[4] The chapters in this book provide close case studies of the courts, building, gardens, visitors and workers at the Sydenham site, spanning 1851 to the early twenty-first century. Examining a wealth of largely unpublished primary material, this collection brings together research on objects, materials and subjects as diverse as those represented under the glass roof of the Sydenham Palace itself; from the *Venus de Milo* to souvenir 'peep eggs', war memorials to children's story books, portrait busts to imperial pageants, tropical plants to cartoons made by artists on the spot, copies of paintings from

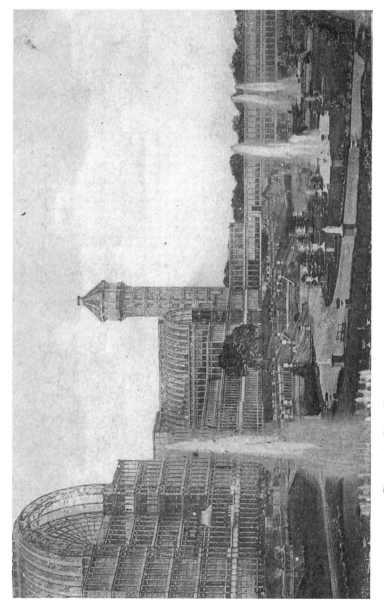

1.1 Postcard of the Crystal Palace, early twentieth century. Author's collection.

ancient caves in India to 1950s film. The chapters do not simply catalogue and collect this eclectic congregation, but provide new ways for assessing the significance of the Crystal Palace at Sydenham for both nineteenth- and twentieth-century studies, questioning the caricature of a twentieth-century cultural revolt against the 'Victorian'.

The Sydenham site offers cultural and social historians a vast and largely unexplored archive showing the intersections of leisure, pleasure and education, articulated through the dazzling display of imperial, industrial and artistic material culture. The visitors were as diverse as the exhibits.[5] Part of the Palace's allure, especially for middle-class commentators, was the frisson of this social mix, which encompassed the British working, middle and upper classes, international tourists and diplomats, exhibited peoples from across the Empire, through to members of the Royal Family who were regular and avid attendees (figure 1.2). Chapters in this volume

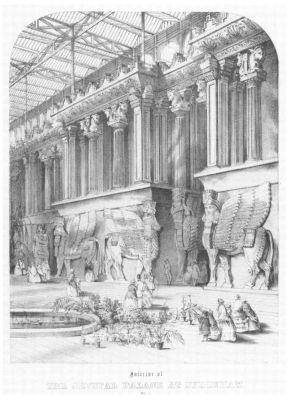

1.2 A mixed group of women, men and children in front of the Nineveh Court at Sydenham. Anonymous, 'Interior of the Crystal Palace at Sydenham, number 8', lithograph, 1854. © Victoria and Albert Museum, London.

argue for the importance of the Palace in understanding early formations
of mass culture in Britain. Echoing the question posed by Joseph Paxton,
architect of the 1851 structure, at the close of the Great Exhibition, 'What
is to become of the Crystal Palace?' this book argues that there is consid-
erable potential in studying this unique architectural and art-historical
document after 1851.[6]

Through a series of display rooms, clearly delineated on the ground
plan, and described in the guidebook and much subsequent literature
as 'courts', the directors of the Palace sought to present an 'illustrated
encyclopaedia of this great and varied universe' (figure 1.3).[7] In his widely
reported opening speech, Palace company director Samuel Laing set out
the mission of visual instruction combining what he claimed was 'every
art and every science'.[8] The organisers hoped that visitors would not
simply wander aimlessly (although many presumably did), but would
participate and learn through a systematic encounter with a carefully
selected display of objects in a curated and highly managed environment
– what Jason Edwards describes in his chapter as 'an eclectic, cosmopoli-
tan world system'. This combination of a serious educative purpose with
mass entertainment, designed with pleasure and crowd pleasing in mind,
was something of a hallmark of the Sydenham Palace. As Matthew Digby
Wyatt, one of the architects of the Fine Arts Courts, put it, the displays at
Sydenham were designed to educate 'by eye', as well as to be a source of
'stimulating *pleasure*'.[9]

The Crystal Palaces

The memory of what art historian Lady Elizabeth Eastlake described as
that 'old friend' the Great Exhibition lived on in visitors' recollections,
contributing towards the horizon of expectations that many brought to a
visit to Sydenham.[10] The Palace of 1854 certainly had an umbilical con-
nection to 1851. The design-reforming zeal of the Great Exhibition con-
tinued at Sydenham with a crossover of personnel. Matthew Digby Wyatt
and his fellow Fine Arts Court architect Owen Jones, had also decorated
the interior of the 1851 building, and theorised the connections between
objects of art and industry that both palaces contained.[11] Scholarship has
frequently conflated (and sometimes mistaken) the Sydenham Palace with
the Great Exhibition, despite the fact that the Sydenham Palace displayed
entirely different material on different organising principles, was larger,
and had additional architectural features such as the highly visible water
towers. The chapters in this collection attest that the Crystal Palace post-
1854 needs to be understood as an enterprise quite distinct, with very

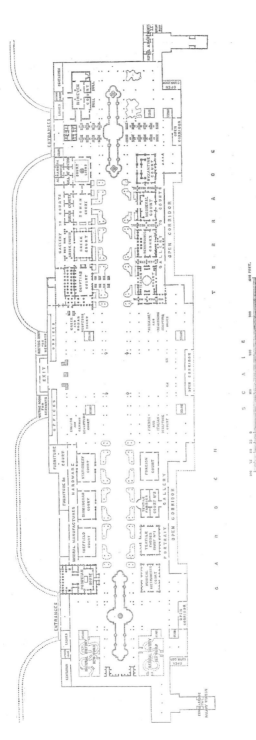

1·3 Ground plan of the Crystal Palace at Sydenham in 1854, *Illustrated London News* (17 June 1854). p. 581. Author's collection.

different aims, and different adaptations during its long lifespan across the nineteenth and twentieth centuries. The Sydenham Palace was built in an 1850s design-reforming moment, but it formed as much a part of the later Victorian and Edwardian cultures of museum visiting, archaeological reconstruction, sports participation and spectatorship, amusement parks, shopping centres and pet shows.

The ever-developing and extensive nature of the Sydenham Palace poses problems of how to study, describe and assess the contents within the interior courts, as well its vast grounds. As Verity Hunt explores in Chapter 2 of this book, since its inception in the nineteenth century, authors have frequently commented on the challenges of describing the Palace, due to a combination of its physical size, its architectural novelty and the diversity of its displays and exhibits. The record and recollections of the Palace's high turnover of participants, viewers and performers is now scattered across collections of ephemera, in personal archives, published letters and diaries, in the local history libraries of South London and in a handful of official documents in the London Metropolitan Archives and at the Guildhall.[12] Even its very building fabric, glass, as Isobel Armstrong has explored, is contradictory and many-faceted, claiming transparency and industrial modernity, but riddled with the 'scratches, fingerprints … impurities and bubbles of air' that testify to its production by human breath.[13] Jan Piggott's *The Crystal Palace at Sydenham 1854–1936* (2004) was the first publication to offer a comprehensive history of the multifaceted life of the Palace, inside and out, to accompany an exhibition at the Dulwich Picture Gallery, and is an essential point of departure for all chapters here. This collection aims to evoke the eclecticism of the Palace on Sydenham Hill in bringing together the research of scholars from the disciplines of art history, English literature, classics, digital humanities, film studies and the history of science.[14] The chapters in this volume consider parts of the Palace less well explored; not just specific courts but the relationships among permanent Fine Arts Courts and shifting displays, representations and responses to the Palace, both inside and outside.

Visiting fairyland

'What it will be when the sound of the workman's hammer has ceased, and the decorative artist has put his last touches to its ornaments, and it is filled with "gems rich and rare" from the four quarters of the world, one can only imagine: we must wait to see', wrote a commentator in the *Art Journal*.[15] Anticipation ran high in the lead-up to the Palace's opening,

and the press presented it as a site worthy of pilgrimage. Alighting at the newly completed Low Level railway station, the Crystal Palace experience began before entering the building. Eager visitors peering through the train windows for a glimpse of the Palace might have caught sight of one of the 'monsters' that formed part of the display of geology on the lower lake even before the train pulled into the station. Railway enthusiast and imperial electrical engineer, Alfred Rosling Bennett, recounting in 1924 his first visit to the Palace at the age of eight, noted the mounting excitement he felt on disembarking the train in 1858:

> The platforms were at a considerable distance from the Palace proper, but, being joined to it by long glass corridors embellished with flowers and climbing plants and affording views of the beautiful grounds, the hiatus was not much felt; indeed, it served to heighten expectation by avoiding a too rapid transition between the prosaic puffer and fairyland.[16]

Bennett suggests that the glass corridor linking the station and the Palace prepared the visitor for the otherworldly environment of the Sydenham site. Climbing the 700 stairs of the corridor, visitors would pop up, no doubt short of breath, into the Natural History Department in the south nave, with its tableaux of brightly painted plaster casts of non-European peoples. These had been arranged by Vice-President of the Ethnological Society, Robert Gordon Latham and were displayed alongside stuffed exotic animals and specimens of botany. Curated by naturalist Edward Forbes, the tableaux were arranged geographically to show that 'Animals and plants are not scattered indifferently over the earth's surface'.[17] The Natural History Department was, somewhat incongruously, interrupted by a screen designed by Matthew Digby Wyatt containing plaster models for statues of the Kings and Queens of England made by John Thomas in the 1840s for the new Houses of Parliament.[18] Taxonomic groupings were not limited to the Natural History Department. The Fine Arts Courts in the north nave – described as Egyptian, Greek, Roman, Alhambra, Nineveh, Byzantine, Medieval, Renaissance and Italian – also used a similar system of organisation for arranging plaster casts of architectural features and sculpture by culture, chronology and geographical region. Where to go next was open to myriad possibilities; within easy striking distance in the south nave were the reconstructed Pompeian House or the Sheffield Court next to it, the Musical Instruments Court or the Stationery Court. Guidebooks and plans, both official and unofficial, offered a range of potential routes around the courts and the grounds. Samuel Phillips's officially sanctioned guide led the visitor through the courts in chronological sequence, but maintained that 'as a reference

to the plans will show, there are many other roads open, which may be explored in future visits'.[19]

The Palace was celebrated as a destination for all seasons. Even on rainy bank holidays, it could comfortably house a large number of people who sought shelter in the almost tropical climate under its glass roof and walls. Lush foliage, fountains and the squawking parrots which populated the Tropical Department, sadly destroyed by the fire of 1866, created a hothouse environment for botanical instruction and enjoyment which shared many similarities with the 'Winter Gardens' opened across London at Kew Gardens in 1863 (figure 1.4). In clement weather, visitors promenaded along the terraces and gardens landscaped by Joseph Paxton. These contained impressive water features, planted beds showing the history of gardening, sporting facilities and an extensive programme of sculpture, some specially commissioned and others copies of Egyptian, Greek,

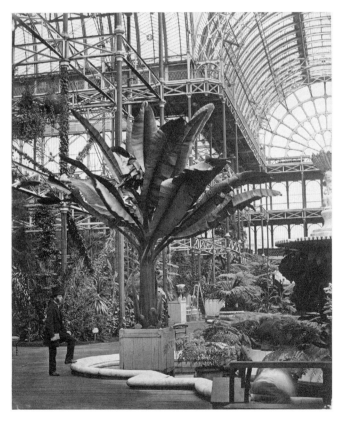

1.4 Photograph of tropical plants in the south nave of the Palace. Philip Henry Delamotte, albumen print c.1852–60. © Victoria and Albert Museum, London.

Roman and more modern reputed works. The 'antediluvian monsters', concrete and brick visualisations of what would now be called dinosaurs, populated the geological islands in the furthest corner of the Palace park, as discussed in detail by Melanie Keene (see figure 8.1). By the end of a day out at Sydenham, a visitor who took in all the sights must have left exhausted.

Leisure and learning

Entertainment and education were combined from the inception of the Palace; nevertheless a tension between it as *both* a place of leisure and learning runs throughout its history. Detractors tirelessly lamented the loss of its lofty educative mission and descent into the pursuit of crass popularism, while supporters into the twentieth century praised its dual ambition to continue to combine education and entertainment. Christopher Hobhouse's assessment of the Sydenham site, written shortly after the Palace's demise, has too often been taken at face value: 'Nothing was too large or too silly for the [Sydenham] Crystal Palace; everything was swept together in hotchpotch to astonish and amuse the masses.'[20] The carefully planned exhibits were anything but random, and Hobhouse's assessment arguably has more to do with prevailing attitudes towards the Victorians in the 1930s, and snobbery towards mass entertainment, than with the social significance that mid-Victorians attributed to leisure as rational recreation.

Cultural historians are increasingly interested in the fairground and sporting entertainments, which formed part of emergent cultures of mass entertainment and consumption in the late-nineteenth/ early-twentieth century.[21] This volume aims to situate the Palace as a significant location for such cross-class leisure activities. Kate Nichols's chapter examines the role of Sydenham in shaping Victorian and Edwardian body cultures. Ann Roberts examines how the Palace Company's management employed leisure as a strategy to bolster their flagging fortunes in the last quarter of the nineteenth century, recreating the Palace as a fashionable destination for the middle-class consumer. As her case studies demonstrate, watching art being produced on the spot was part of this new commercialised cultural milieu at the Palace. Verity Hunt's chapter brings together the themes of leisure and pleasure through her discussion of small souvenirs of the Palace, the peep egg and the Stanhope viewer. Made for the domestic and often female market, these handheld objects distilled the overwhelming scale of the Crystal Palace edifice through a lens, and into something compact, manageable and most importantly, portable.

Empire in suburbia

Situated on the interstices between the suburban spread of the ever-grow-
ing capital city and the rolling, fertile countryside of the county of Kent,
the Palace at Sydenham was envisioned as a key site in the symbolic
geography of imperial London right from its inauguration, where it was
described as a 'fitting ornament to the greatest metropolis of the civilised
world; an unrivalled school of art and instrument of education and a
monument worthy of the British empire'.[22] This status was conferred
on it not only because of its contents and the kinds of exhibitions and
displays organised there, but also by the fact of its location. Perched atop
Sydenham Hill, the Palace offered a physical vantage point from which
to survey and take in a panoramic sweep of London – and the quintes-
sentially 'English' countryside. Guidebook author Samuel Phillips directed
people, after taking in the Indian Court, to ascend two flights of stairs to
reach a gallery 108 feet above the ground. There the visitor was instructed
to take in the vertiginous bird's-eye view down into the nave. Then, peep-
ing between the louvre boards at the north-west corner of the Great
Transept, the presumably breathless and slightly dizzy spectator could,
Phillips observed:

> behold from the commanding height, London spread out before him like
> a map, the towers of Westminster Abbey marking the west end, and the
> dome of St. Paul's, half shrouded in smoke, indicating the heart of the
> city, whilst the hazy veil, extending far beyond either extremity, serves to
> measure the vast area of this 'Province covered with houses'.[23]

Phillips's guide took considerable satisfaction in the elevated position
of the Palace on the hill from which the city centre could be viewed and
surveyed. Suburban sites (and sights) were certainly not marginal to the
centres of financial, political and religious power in the city, as geographer
David Gilbert has persuasively argued in his work on suburban modernity
and the imperial geographies of Edwardian London. He identifies the
creation of an 'Edwardian edge city' which hosted major exhibitions such
as the Franco-British Exhibition at the White City in Shepherd's Bush
(1908), and the Festival of Empire at the Crystal Palace in 1911, an event
discussed in further detail in Sarah Turner's chapter.[24]

The map included in the 1858 revised edition of the *Official Guide* to
the Palace used bodily allusion to suggest the connectivity of the Crystal
Palace in its new location (figure 1.5). It represents the Palace as the
'heart' of the imperial metropolis, linked by thick arterial routes to central
London, delineated in red. Road and railway lines, both existing and in

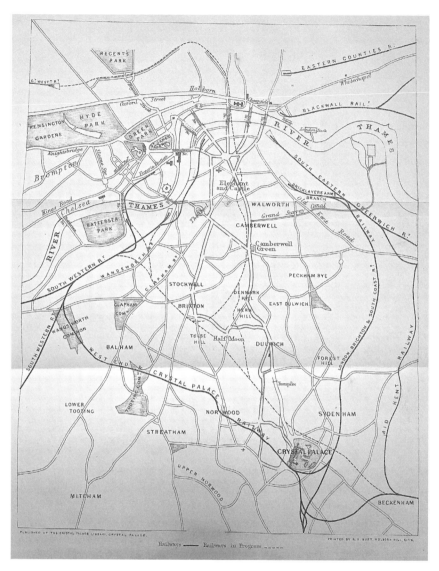

1.5 Plan of the Crystal Palace and railway connections, from S. Philips, *Guide to the Crystal Palace and its Parks and Gardens* (London: Crystal Palace Company, rev. edn, 1858). Author's collection.

progress, are represented on the map as a complex network of veins and capillaries flowing in and out of the Palace. The fact that the owners of the Crystal Palace Company were a syndicate made up of a number of railway owners and bosses under the chairmanship of Samuel Laing of the Brighton and South Coast Railway explains this 'networked' approach,

and the integral role played by transport and travel in the conception and management of the Palace from the inception of the plan to move it from Hyde Park to Sydenham.[25]

The Stationery Court inside the Palace also highlighted such links, advertising itself as 'being in Telegraphic communication and Railway connection with all parts of the United Kingdom' where goods could be 'packed and forwarded to any part of the world'.[26] Connected not just to London and the provinces, but to the world – this was the message that the directors wanted to convey through their 'monument to empire' atop Sydenham Hill. For the 1911 Festival of Empire, a mile-and-a-half journey by the 'All Red Route' electric railway (a reference to the areas of the British Empire coloured red on maps) was constructed in the Palace park at the cost of £40,000 (figure 1.6). On the journey the train passed three-quarter replicas of parliament buildings in the colonies and dominions, tableaux of colonial life populated by 'natives' and live animals, and scenes of imperial landscapes and industries, such as an Indian tea plantation. In November 1910, the *Illustrated London News* had featured an article on the construction of what it described as 'A "World" in a Suburb: The All-Red Empire in Miniature'.[27] To create a 'world in a suburb' had arguably been the aim of the Palace since it had opened its doors.

Networked into this sophisticated grid of international communication and transport, the Sydenham site played host to a number of other events designed to promote and celebrate the British Empire, including the African Exhibition of 1895, the Victoria Cross Gallery which opened in the same year, the Naval and Military Exhibition of 1901 and the Colonial Exhibition of 1905. These were not just static displays, but were often accompanied by pageants, musical performances, lectures, talks and practical demonstrations.[28] As Jan Piggott has noted, every part of the Palace was used for such events – even its lofty aerial spaces were put to use, perhaps most famously by the acrobat and trapeze artist, Blondin, who had notoriously crossed Niagara Falls via a tightrope.[29] Dressed in a costume with beadwork made by indigenous tribes from the Niagara area, and with ostrich feathers in his cap, Blondin made his first appearance at Sydenham on 1 June 1861 before a large audience which included the art critic John Ruskin, as eager as anyone else to see the 'Hero of Niagara' make the crossing of 320 feet across the Central Transept. The 'Mohawk Minstrels' accompanied his other performances, and Blondin was eager to play on these colonial ties to add to the spectacular nature of his performance. Spectators and performers – like Blondin and the minstrels – came from far and wide to participate in Sydenham's imperial spectacles.

Sydenham's role as an imperial space in which the nation's history

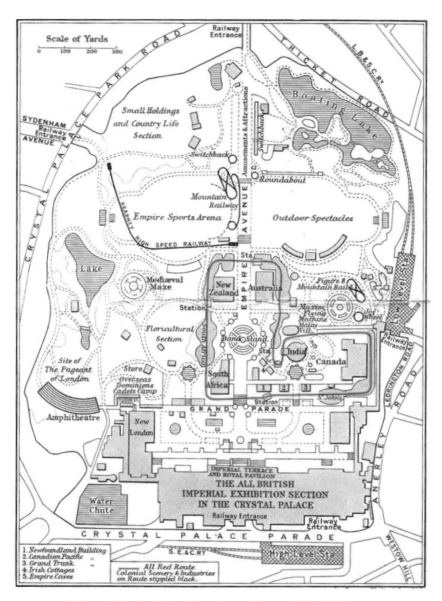

1.6 Plan of the Festival of Empire and Imperial Exhibition, 1911.
Author's collection.

could be curated was made particularly apparent at certain moments of political wrangling and international calamity. The Crimean War formed a tumultuous backdrop to the planning and opening celebrations at Sydenham. On 21 June 1854, eleven days after the Palace opened its

doors, an Anglo-French taskforce fought Russian forces at the Battle of
Bomarsund. In December 1854 a gun and mortar from Bomarsund were
put on display at Sydenham, bringing the Crimea right into the Palace.
Joseph Paxton, a Liberal Member of Parliament from 1855, mustered the
Army Work Corps, known informally as the 'Crystal Palace navvies', and
1000 workmen left construction work at the Palace to support the British
Army in August 1855.

By September 1855, the Stationery Court had become the Crimean
Court. One visitor, Emily Hall of West Wickham, described in her diary
visiting the 'Crimean relics' gathered together, which depicted 'the very
height and depth of all the miseries of that terrible campaign'.[30] This
reminds us that the exhibition halls of the Palace were not only a place in
which to feature and narrativise national history, but also to memorialise,
and even question or criticise it as well. A replica in imitation granite
of Baron Marochetti's Scutari Monument (the original was outside the
Scutari Hospital in Constantinople), and a 'Peace Trophy to the Crimea'
by G. Stacy, were unveiled in front of the Queen and Prince Albert in
1856 (figure 1.7). Marochetti's sculpture met with much public derision
and grumbling in the press who were unhappy that a British sculptor had
not been chosen over the Italian Marochetti, a favourite of Prince Albert.

The Palace's spaces were frequently militarised, but this operated

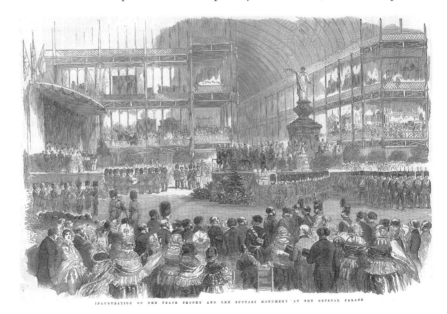

INAUGURATION OF THE PEACE TROPHY AND THE SCUTARI MONUMENT AT THE CRYSTAL PALACE

1.7 'Inauguration of the Peace Trophy and the Scutari Monument at the
Crystal Palace', *Illustrated London News* (17 May 1856), p. 524. Author's collection.

alongside the image of the building as a symbol of peace, an idea that had originated at the 1851 Great Exhibition. Lord Roberts saw no contradiction in opening the Naval and Military exhibition in 1901 by declaring that

> the directors of the Crystal Palace Company could not have chosen a more proper way of celebrating the jubilee of the 1851 Exhibition than by organizing that magnificent collection of exhibits and the imposing naval and military displays which corresponded so well with the sentiment of the people of this Empire at the present moment.[31]

As well as replica models of all the ships in the British navy, the north reservoir was used for a reconstruction of the Battle of Trafalgar. As Kate Nichols discusses in her chapter, these pacific ideals were tested even further in the twentieth century when the Palace was requisitioned by the Royal Naval division and closed to the public during the First World War. Artist John Lavery's official wartime oil paintings of the Palace, now used for drilling naval recruits, show the terraces transformed into 'quarter decks', the dark grey Palace looming like a battleship (figure 1.8). After the Armistice, the Palace housed the first incarnation of the Imperial War Museum from 1920 to 1924.

Well into the 1930s, the Sydenham Palace was envisioned as a 'monument to empire'. In 1935 William A. Bayst produced a twopenny pamphlet, *Empire Bridge and World Approach in lieu of War* proposing that the Sydenham site become a permanent shrine to the British Empire.[32] Bayst suggested that an arterial road should run from what he called the 'Empire Bridge' across the Thames, forging a direct imperial processional thoroughfare from The Strand to Sydenham. This proposal by Bayst, known only as a 'resident of South Woodford', gained little traction and his notion of the 'crystal domes' of Sydenham acting as a 'lighthouse', of imperial ideas was shattered when the Palace burnt down on the night of 30 November 1936. However, the vision – or ghost – of Sydenham as a monument or 'shrine' to empire was one that lingered on well into mid-century.[33] The organisers of the Festival of Britain on London's bomb-damaged South Bank were keenly aware of the relationship between nation and empire evoked by the Palace building and its grounds, as James Boaden discusses in his chapter.

The Crystal Palace and the Artistic Imagination

Camille Pissarro's *Crystal Palace* (1871) is perhaps the definitive image of the Palace as 'modern', in both form and subject matter (figure 1.9). Its impressionist depiction of the goings-on of modern life outside the Palace building have arguably perpetuated the idea of the Crystal Palace as a

1.8 John Lavery, 'RNVR Crystal Palace, 1917', 1917, oil on canvas, 76.2 × 63.5 cm. Published under Imperial War Museum's non-commercial licence © IWM (Art.IWM ART 1275) www.iwm.org.uk/collections/item/object/16255.

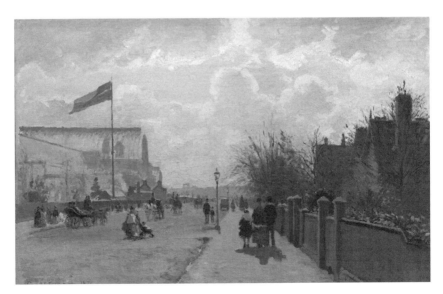

1.9 Camille Pisarro, 'The Crystal Palace, 1871', 1871, oil on canvas, 47.2 × 73.5 cm, Art Institute of Chicago © The Art Institute of Chicago. www.artic.edu/aic.

symbol of modernity. It is, however, the least characteristic nineteenth-century image of the Palace, its formal qualities distinguishing it from the precise, hard-edged Palace and individuated audiences that populate engravings and sketches in the nineteenth-century illustrated press (see figures 1.2, 1.7 and 5.2).

The Palace interior – especially the architectural reconstructions and unprecedented collection of plaster casts in its Fine Arts Courts – appears, often unacknowledged, in a far wider range of nineteenth-century canvases. William Holman Hunt's *The Finding of the Saviour in the Temple* (1854–60), for example, presents itself as an orientalist, anthropological and religious image, with claims to scriptural and geographical specificity grounded in biblical antiquity. Yet the setting for this supposedly painted-on-location in Jerusalem image, was in fact the Alhambra Court at Sydenham.[34] The fascination with archaeological exactitude in later nineteenth-century painting made the Fine Arts Courts – especially those of Egypt and Pompeii – essential reference points for painters such as Edward Poynter and Lawrence Alma-Tadema.

It was not just Royal Academicians that made use of the Palace, however. It became an important training and exhibitionary space for a selection of artists who were, in nineteenth-century terms, much less conventional. The Crystal Palace School of Literature, Science and Art opened in 1860, and invited female as well as male pupils, and by the 1890s had an intake of 500 young women per year. Commentators attributed the success of the schools to the use of the Palace's collections for teaching.[35] Local artists including Henrietta Rae studied and sketched the cast collections. Women were often excluded from the academic life class, so the Palace played an important role in providing female art students with access to the unclothed (albeit lifeless) form. The Palace also became a site for the live production and performance of contemporary art. Here, Ann Roberts's chapter explores the Palace as a space of commercial art entertainment through case studies of disabled artist Bartram Hiles, and 'lightning cartoonist' Herbert Beecroft.

The Palace's role in the visual imagination did not suddenly stop when it burnt to the ground, as chapters by Melanie Keene, James Boaden, and Shelley Hales and Nic Earle examine here in their discussions, dealing with the various afterlives of the Palace in children's literature, film and digital reconstructions respectively. Dramatic photographs and films of the Palace in the process of burning, and its smoking embers, had a large circulation and are still widely available as part of the Crystal Palace's extensive visual archive (figure 1.10).[36]

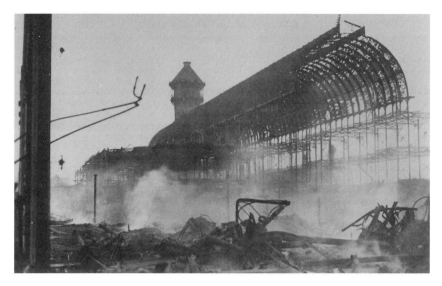

1.10 Commemorative postcard depicting the still-smouldering Crystal Palace, 1936. Author's collection.

The Crystal Palace and exhibitionary culture

The Crystal Palace's 1851 incarnation occupies a special position within the history and theory of museums.[37] The 1851 Palace's viewing balconies were the origin point of Tony Bennett's enormously influential (if now often contested) conceptualisation of the 'exhibitionary complex': 'a set of cultural technologies concerned to organise a voluntarily self-regulating citizenry'.[38] How might a focus on the Palace's new life at Sydenham provide alternative perspectives on the formation of modern exhibitionary culture? The interdisciplinary scope of this volume, and several chapters' engagements with visitor responses to the exhibits offer some suggestions. Jason Edwards's chapter critically examines how 1850s guidebooks created an ideal public engaged with high culture to survey its idealistic exhibits, while Ann Roberts's discussion of 1890s Palace ephemera uncovers a less scholarly visitor-consumer at the turn of the century.

In 1855, Lady Elizabeth Eastlake's account of her first visit suggests that its wonders would only be comprehended over time, on reflection, after a visit, and through the anticipation of subsequent visits: 'Hour after hour finds us in wandering mazes lost – the sport of impressions gone as soon as formed, all rapid, vivid, but fleeting – glancing at what we are to see, tasting what we are to feed upon – all hope fixed upon some future which is to sort the present tangle of the brain.'[39] Here Shelley Hales and Nic Earle

experiment with digital humanities to attempt to fathom the Palace across time, but as they acknowledge, their attempts to reconstruct the Pompeian House suggest anew the difficulties in untangling the sights and sounds at Sydenham. Spanning and combining both the twenty-first-century virtual reality environment of Second Life, and the textual responses of Victorian Palace-goers, the diverse visitor responses foregrounded by Hales and Earle challenge any monolithic notion that people behave in ways prescribed by museum or exhibition organisers. The Sydenham Palace is crucial to understanding the complex development of exhibitionary cultures across the nineteenth and twentieth centuries.

Conclusion

There is further work to be done in situating the Sydenham Palace among its nineteenth- and twentieth-century relatives, beyond its parent building from 1851. These might include Kew Gardens, the also highly flammable Alexandra Palace (opened in 1873), the South Kensington Museum (now the Victoria and Albert Museum) and Imperial Institute, the People's Palace in Glasgow, as well as prefabricated and portable exhibition and display architecture which appeared across the world creating a global genealogy of glass and iron, as, for example, the glass house of Lal Bagh in Bangalore. Its legacy can also be detected in contemporary 'edu-tainment' structures, such as Millennium Dome, and the 'Olympicopolis' currently under construction in Queen Elizabeth Olympic Park, East London, which is slated to house a design school, a centre for culture and heritage, science, technology and business 'hubs', as well as an outpost of the V&A.[40] Combining commerce and culture, entertainment and education, social and moral messages, these new plans reincarnate many aspects of the founding principles of the Sydenham Palace, suggesting that it is not so much of a Victorian white elephant as it might initially appear.

Despite its chequered fortunes, even the built environment of the Palace has not entirely vanished. Its footprint is stamped on the terraces of the popular public park in the borough of Bromley, where it is still possible to trace the outline of the Palace's structure, and various parts of its walls, steps, fountains, arcades and other landscaping are incorporated into the current site. Sporting facilities in its park continue its athletic legacy, as Kate Nichols discusses in Chapter 5. The long extinct 'antediluvian monsters' on the geological islands of the Palace lake are today the sole surviving exhibit; they were listed as Grade I monuments in 2007, deemed to be 'of exceptional historical interest in a national and probably international context'.[41] Paxton's question 'What is to become of the Crystal Palace?'

continues to occupy the local community, as well as politicians, planners and, most recently, property developers. The latest plans to rebuild the Palace, which hit the headlines in July 2013, are indicative of the long-standing pull of the site for commercial and cultural activities, although as of February 2015 these latest plans have been quashed.[42] Newspaper articles discussing this potential re-re-built Palace were dominated by the Great Exhibition of 1851, tending to ignore the much longer history of its life at Sydenham.[43] This volume makes the case for a more serious consideration of the Palace on Sydenham Hill, drawing on the important archive and research collected together by local historians, the Palace museum and local studies libraries.[44] We hope it will be a launchpad for future research into the material and visual cultures of the Crystal Palace after 1851. To give the final word to Samuel Phillips's 1854 guidebook 'there are many other roads open, which may be explored in future visits'.[45]

Notes

1 'The Opening of the Crystal Palace, Sydenham', *Chronicle* (10 June 1854), p. 109.

2 See, for example, C. E. Smith (ed.), *Journals and Correspondence of Lady Eastlake. Vol. 1* (London: John Murray, 1895), p. 325; C. Knight, *Knight's The Pictorial Gallery of Arts, comprising nearly four thousand illustrations on wood, and a series of beautiful steel engravings. Vol.1: Useful arts* (London and New York: The London Printing & Publishing Company, 1858–60), p. xv; A. C. Wigan, *The Great Wonders of the World. From the Pyramids to the Crystal Palace* (London, 1856), p. 135; 'Opening of the Crystal Palace, June 19th, 1854', *Musical Times and Singing Class Circular*, 6:126 (1854), 99.

3 Historians did not seriously start to re-evaluate the reputation and historiography of the Great Exhibition until the 1990s. These, and more recent studies, emphasise the plurality of meanings which the Exhibition offered to its visitors. They focus on the controversy that the preparations generated, rather than solely the glorifying reports of its organisers. Although these accounts emphasise that the Great Exhibition no longer has a definitive meaning, they tend to view the Sydenham Palace as a unified whole – with the exceptions of articles by Peter Gurney in L. Purbrick (ed.), *The Great Exhibition of 1851: New Interdisciplinary Essays* (Manchester: Manchester University Press, 2001) and J. Buzard, J. W. Childers and E. Gillooly (eds), *Victorian Prism. Refractions of the Crystal Palace* (Charlottesville and London: University of Virginia Press, 2007). If discussed at all, the Sydenham Palace appears as a debased version of 1851. Ironically, many of the concerns identified in these new studies – including the role of working-class visitors, commodity fetishism or the display of Empire – were far more prominent at Sydenham than they had

been at the Great Exhibition. See J. Auerbach, *The Great Exhibition of 1851. A Nation on Display* (New Haven, CT and London: Yale University Press, 1999); M. Billinge, 'Trading History, Reclaiming the Past: The Crystal Palace as Icon', in G. Kearns and C. Philo (eds), *Selling Places. The City as Cultural Capital, Past and Present* (Oxford: Pergamon, 1993), pp. 103–31; Buzard, Childers and Gillooly (eds) *Victorian Prism*; J. R. Davis, *The Great Exhibition* (Stroud: Sutton, 1999); S. Johansen, 'The Great Exhibition of 1851: A Precipice in Time?', *Victorian Review*, 22:1 (1996), 59–64; Purbrick (ed.), *The Great Exhibition of 1851*.

4 H. James, *Essays in London* (New York: Harper & Brothers, 1893), p. 20.

5 When the Palace opened, entry was 1s from Monday to Thursday, 2s 6d. on Fridays, while Saturday entry was 5s. By December 1857, admission on any day cost 1s. See 'The Crystal Palace – the Shilling Days', *Observer* (6 September 1857), p. 5.

6 J. Paxton, *What is to Become of the Crystal Palace?* (London: Bradbury & Evans, 1851).

7 S. Laing, quoted in 'Crystal Palace', *The Times* (12 June 1854), p. 9.

8 *Ibid.*

9 M. D. Wyatt, *Views of the Crystal Palace and Park, Sydenham* (London: Day & Son, 1854), p. 7.

10 E. Eastlake, 'The Crystal Palace', *Quarterly Review*, 96:92 (1855), 304.

11 S. Moser, *Designing Antiquity: Owen Jones, Ancient Egypt and the Crystal Palace* (New Haven, CT and London: Yale University Press, 2012).

12 For the most extensive list of archives with relevant Crystal Palace material, see J. R. Piggott, *Palace of the People. The Crystal Palace at Sydenham 1854–1936* (London: Hurst & Co., 2004), p. 223.

13 I. Armstrong, *Victorian Glassworlds: Glass Culture and the Imagination 1830–1880* (Oxford: Oxford University Press, 2008), p. 14.

14 *The Crystal Palace Sydenham: The Home of Science, Art, Literature and Music and the Scene of the Festival of Empire. To be sold by auction on Tuesday 28th day of November, 1911 at the Estate Room, 20, Hanover Square, London, W. at two o'clock precisely by Howard Frank* (London: Hudson & Kearns, 1911), p. 7.

15 'The Crystal Palace', *Art Journal*, 6:64 (April 1854), 117.

16 A. R. Bennett, *London and Londoners in the Eighteen-Fifties and Sixties* (London: T. Fisher Unwin, 1924), p. 183.

17 R. G. Latham and E. Forbes, *Handbook to the Courts of Natural History* (London: Bradbury & Evans, 1854), p. 80.

18 B. Read, *Victorian Sculpture* (New Haven, CT and London: Yale University Press), pp. 37–9.

19 S. Phillips, *Guide to the Crystal Palace and Park* (London: Bradbury & Evans, 1854), p. 163.

20 C. Hobhouse, *1851 and the Crystal Palace* (London, 1937), pp. 159–60. P. Beaver, *The Crystal Palace 1851–1936. A Portrait of Victorian Enterprise* (London, 1970) also portrays the Sydenham Palace as an amusing Victorian curiosity.

21 Sport is explored in further detail in Chapter 5. On amusement parks see

J. Kane, *The Architecture of Pleasure: British Amusement Parks 1900–1939* (Farnham: Ashgate, 2013).

22 S. Laing, quoted in 'Crystal Palace', *The Times* (12 June 1854), p. 9.

23 Phillips, *Guide to the Crystal Palace and Park*, pp. 167–8.

24 D. Gilbert, 'The Edwardian Olympics: Suburban Modernity and the White City Games', in M. O'Neill and M. Hatt (eds), *The Edwardian Sense: Art, Design, and Performance in Britain, 1901–1910* (New Haven, CT and London: Yale University Press, 2010), p. 73.

25 The role played by railway owners is highlighted by Anne Helmreich in her excellent essay on the opening of the Crystal Palace at Sydenham. See A. Helmreich, 'On the Opening of the Crystal Palace at Sydenham, 1854', *BRANCH: Britain, Representation and Nineteenth-Century History*, www.branchcollective.org/?ps_articles=anne-helmreich-on-the-opening-of-the-crystal-palace-at-sydenham-1854 (accessed 20 August 2014).

26 Advertisement for the 'Stationery Court', in S. Phillips, *Official General Guide to the Crystal Palace and Park*, rev. edn, F. K. J. Shenton (London: Crystal Palace Library, 1860).

27 'A "World" in a Suburb: The All-Red Empire in Miniature', *Illustrated London News* (12 November 1910), p. 744.

28 The musical life and culture of performance and sound at Sydenham, although a topic not covered extensively by any of the essays in this collection, is certainly ripe for further attention. The one major study covering music and the Crystal Palace is M. Musgrave's *The Musical Life of the Crystal Palace* (Cambridge: Cambridge University Press, 2005). Deborah Sugg Ryan's pathbreaking work on pageants, performance and empire has been important for our discussion and approach. See D. S. Ryan, 'Staging the Imperial City: the Pageant of London, 1911', in F. Driver and D. Gilbert (eds), *Imperial Cities. Landscape, Display and Identity* (Manchester: Manchester University Press, 1999), pp. 117–35.

29 Piggott, *Palace of the People*, p. 188.

30 Emily Hall, 'Crystal Palace – The First Five Years' (1854–59), Bromley Public Libraries, 855/U923.

31 Lord Roberts, quoted in *The Times* (24 May 1901), p. 5.

32 W. Bayst, *Empire Bridge and World Approach: in Lieu of War* (London: Forsaith, 1935).

33 *Ibid.*, pp. 2–12.

34 See J. Bronkhurst, *William Holman Hunt. A Catalogue Raisonné*, I (New Haven, CT and London: Yale University Press, 2006), pp. 173–7.

35 A. Montefiore, 'The Educational Institutions of the Crystal Palace', *Educational Review*, 1:3 (1892), 151–61.

36 A short Pathé film of the Crystal Palace fire of 1936 is available at www.britishpathe.com/video/crystal-palace-fire (accessed 18 March 2015).

37 See e.g. D. Preziosi, *Brain of the Earth's Body: Art, Museums, and the Phantasms of Modernity* (Minneapolis: University of Minnesota Press, 2003), pp. 92–114.

38 T. Bennett, *Birth of the Museum: History, Theory, Politics* (London: Routledge, 1995), p. 62.

39 Eastlake, 'Crystal Palace', 306.

40 www.london.gov.uk/media/mayor-press-releases/2014/07/mayor-announ ces-major-new-plans-for-queen-elizabeth-olympic-park (accessed 18 March 2015).

41 'Dinosaurs Given Protected Status', *BBC News* (7 August 2007), http://news. bbc.co.uk/1/hi/england/london/6934908.stm (accessed 18 March 2015).

42 Tim Donovan, 'Bromley Council pulls out of Crystal Palace rebuild talks', *BBC News* (26 February 2015), www.bbc.co.uk/news/uk-england-london-31639207 (accessed 18 March 2015).

43 For example, O. Hatherley, 'Plans to Recreate the Crystal Palace are as Jingoistic as a Gove History Lesson', *Guardian* (29 July 2013), www.theguard ian.com/commentisfree/2013/jul/29/crystal-palace-replica-jingoistic-gove-london (accessed 19 March 2015); 'Plans for Crystal Palace Replica', *BBC News* (27 July 2013), www.bbc.co.uk/news/uk-england-london-23475994 (accessed 19 March 2015).

44 See in particular the excellent and community-run Sydenham Town Forum: https://sydenham.org.uk/forum/viewtopic.php?f=10&t=1500 (accessed 18 March 2015).

45 Phillips, *Guide* (1854), p. 163.

2

'A present from the Crystal Palace': Souvenirs of Sydenham, miniature views and material memory

Verity Hunt

> The palace being no longer merely a court of honour for the trial of nation against nation, but a court of profit, there will be temptations, we fear, to exhibit, on the whole, a lower class of goods ... the purchases will, we should think, tend to take the form of souvenirs of the palace of an inexpensive kind ... a pen-wiper for 'our Mary Ann' at home; a workbox, ticketed 10s 6d., for 'Sister Mary'; or 'something in the handkerchief way for Tom', will be incessantly called for.[1]

Writing in the pages of *Fraser's Magazine* in the year preceding the Crystal Palace's grand reopening on Sydenham Hill, in this passage the physician and author Andrew Wynter (1819–76) looks back to the first Crystal Palace of 1851 to laud it as 'a court of honour', unsullied by commercialism. Yet other Victorian commentators and contemporary critics alike have read the Hyde Park Palace as a 'temple of consumerism'.[2] Many have noted that in architectural terms, the first Palace stands as a significant antecedent of the shopping mall, an inspiration for the famous department stores of the later nineteenth century.[3] Scholars have associated it with the birth of advertising and global commodity culture.[4] However, while the 1851 Palace may have offered visitors an alternately fascinating, and bewildering, 'window shopping' experience, importantly, goods were not priced or actually bought and sold there. In contrast, the Sydenham Palace offered a dedicated shopping area selling everything from furniture and large household goods through to the kind of 'inexpensive' souvenirs described above. It is the ramifications of this new 'court of profit' for the Palace's broader cultural status and meaning that Wynter contemplates here.

As the author anticipates, for many visitors, shopping and purchasing a souvenir, whether for personal consumption, or as a gift for family

and friends at home, was a major component of the Sydenham Palace experience.[5] Souvenirs of Sydenham bearing a picture of the Palace were diverse in shape, quality and price and included a wide range of everyday objects such as plates and other ceramics (often mass produced in Austria, Germany and Czechoslovakia before the First World War), fans, scarves, handkerchiefs, tiles, writing accessories (such as inkwells and pen-wipers) and sewing-kit essentials (such as tape measures and needle cases).[6] Wynter draws our attention to a new conflict of scale introduced into the dominant Palace narrative by this trade: the public, monumental, global scale of a suggestive 'trial of nation against nation' (embodied by 1851's official, catalogued international exhibits) is newly set against the domestic scale and private concerns of family and home (characterised by the alternative, commercial displays of souvenirs). Indeed, souvenirs of Sydenham stood as a kind of symbolic bridge between the spaces of the Palace and home; they served as a material carrier for the personal memory of a visit for their purchaser; or if received as a gift, they functioned as a homely visual introduction to the site.

Wynter betrays anxieties about standards of taste at the Palace, which will allegedly be newly challenged by the presence of an 'active mart' there.[7] How will the alternative 'trivial' commercial displays of the kinds of everyday objects desired by the likes of 'our Mary Ann' and 'Sister Mary' fit alongside the educational and/or beautiful official exhibits at the Palace, such as the Pompeian house, the antediluvian monsters and the cast collections? Wynter reassures his (largely well-educated middle- to upper-class) readers that the Palace directors will 'ensure the best class of goods only' are put on sale, to 'prevent the degeneracy' of aesthetic standards he fears.[8]

His implicit snobbery about the Palace's working and middle-class visitors' shopping preferences is perhaps not surprising considering that the history of taste (as expressed through the collecting and display of objects) had, until fairly recently, been predominantly associated with the souvenir habits of upper-class young men of means on the Grand Tour.[9] By the 1850s, the formation of major national public museum collections stood as new models of tasteful collecting for the masses.[10] The Crystal Palace's official exhibits fit into this broader context of contemporaneous canonical displays intended to offer public lessons in aesthetic virtue. Yet if we look to the Palace's commercial galleries and consider the objects purchased there by visitors for their own personal collections of mementos of holidays and travel, they bear testimony to their own standards and rules of collecting, which demand critical attention in their own right.[11]

As this chapter shows, the inexpensive objects bought for casual pleasure

by the middle and lower classes at the Crystal Palace bear testimony to the ways in which their purchasers conceived of both the Palace and their own lives and identities.[12] Through a close reading of two spyglass souvenirs of Sydenham, a peep egg (after 1851) (figures 2.1a and 2.1b) and Stanhope viewer needle case (*c*.1860–68) (figure 2.3), this chapter investigates how relatively low-tech, low-end miniature view mementos emerged to function as both an important visual record of the Sydenham Crystal Palace, and as an emblem of popular visual memories of the site. It considers how such keepsakes stand testimony to a prevalent affection or fondness for the Palace in the second half of the nineteenth century, or at the very least, its currency in popular culture and the growing leisure industry.

The Palace has, until very recently, been characterised as falling dramatically out of fashion in the later nineteenth century, and declining into a mere vulgar, frivolous playground for the working classes.[13] It is perhaps most famously painted thus in George Gissing's novel *The Nether World* (1889), which features a hedonistic working-class wedding celebration at Sydenham that descends into drunkenness and violence. The affectionate sentiment attached to the optical keepsakes discussed in this chapter complicates this kind of cynical, rather condescending picture of 'the people' at the Crystal Palace; the souvenirs contribute to the collection of alternative, positive narratives of consumption and spectatorship at the Palace recently recovered by Peter Gurney in *Victorian Prism* (2007).[14] I show how the telescoped Crystal Palace (glass-under-glass) is compressed into the viewer's private experience of time and space under the miniature lens of the spyglass souvenir; she or he is offered a private, domesticated view of the grand public landmark. Peep eggs and Stanhope viewers have thus far only been written about from the point of view of niche critical frameworks: collectors' journals and the history of photography respectively. The analysis put forward here brings these miniature views to the forefront of discussions about vision and memory at the Sydenham Crystal Palace for the first time.[15] It contributes to existing debates about the nature of vision and representation at the Hyde Park Crystal Palace, and begins to carve out a distinct visual schema for the Sydenham Palace.

Coup d'oeil

Reflecting on her first visit to the Crystal Palace at Sydenham, the art historian Lady Elizabeth Eastlake (1809–93) wrote: 'The first visit is made up of *the past as well as the present and the future*; for, pleasure at recovering the old friend from whom we parted on that 14th day of October, 1851, never, as we thought, to meet again, forms great part of our enjoyment.'[16] The

Hyde Park Palace had purported to show the whole world, altogether and all at once at the Great Exhibition.[17] The scientist and polymath, William Whewell, famously described the 1851 Palace as a kind of time machine, suggesting that by displaying examples of art and industry from all over the globe within one 'vast crystal frame', it made the 'scientific dream' of time travel a 'visible reality'.[18]

Eastlake's comment that a first visit to the newly enlarged Sydenham Palace is 'made up of the past as well as the present and the future' suggests that the building's well-established associations with ideas of spatiotemporal transcendence followed it to southeast London. Like the Hyde Park Palace, the Sydenham Palace similarly telescoped time by displaying international artefacts and specimens together under one vast glass roof. But haunted by individual trippers' memories of the Hyde Park Palace (Eastlake's 'old friend'), and coupled with the Crystal Palace Company's ambitions that it would provide a cross-class educational legacy for the arts and science as a permanent exhibition space, the Sydenham Palace's slippery spatiotemporal dimensions signify rather differently. In its second incarnation, the building stands for its past at Hyde Park, its present on Sydenham Hill and the intention that in the future it will be used by 'mankind long after its original founders […] have passed away'.[19] So that at the Sydenham site, importantly, it is the spectral glass edifice of the Crystal Palace itself (more than the contents displayed within its 'crystal frame') that evokes an uncanny sense of timelessness, or rather, all time.

If, as the emblem of a one-off 'trial of nation against nation', the Hyde Park Palace was predominantly designed to appeal to a sense of collective public memory, the multifunctional Sydenham Palace, with its far greater lifespan, appealed to a sense of individual, personal memory in a quite different way. Like the Hyde Park Palace, one of the Sydenham Palace's many functions was to host numerous international exhibitions and festivals, each designed to construct and memorialise a particular notion of national and imperial identity.[20] However, as many visitors returned to the Palace for multiple holiday trips across many years, each visit offering a quite different experience (from a turn in the Italian gardens and evening firework display, through to a music concert or cat show), individual personal memories of the site, embodied by the souvenirs people bought to encapsulate them, play an especially significant part in understanding the multi-stranded Sydenham story. My point here is not that the first palace tells just one story, rather that because of its longevity and multifunctionality, personal memory plays a significantly different role in understanding the second Palace.[21]

This new focus on the individual and personal in the Palace's story

is reflected by a parallel development in the primary visual models used
to represent the building's unique spatiotemporal dynamics. Despite the
claims to visual totality made by the first Crystal Palace and its 'Show
both for and of the World', just three years later, the significantly enlarged
buildings and 'superior' contents of the second Palace promised to out-
shine the spectacle of the Hyde Park exhibition.[22] It is important to con-
sider how the kinds of language used to describe the Sydenham Palace
highlight the fact that, like its predecessor, it was conceived of as a par-
ticularly visual project. There was continuation of the dominant strand of
rhetoric of 1851 that had likened the Crystal Palace to fairyland or a palace
out of *The Arabian Nights*.[23] For instance, in the pages of Dickens' *Household
Words*, the Sydenham site appears as 'a fairy palace with fairy terraces,
and fairy gardens, and fairy fountains' and its architect Joseph Paxton is
likened to a 'burly Djin in a white hat and a frock coat with a huge lily in
the button hole'.[24] There was also an extension of the important notion of
the Palace offering a visual education, which had been at the conceptual
heart of the Great Exhibition: it was intended as a place where spectacle
and education would combine. James A. Secord explains that the visual
scheme at the Sydenham Palace 'was grounded in the theories of the Swiss
educational theorist Johann Heinrich Pestalozzi, with the aim of convey-
ing knowledge directly through the senses'.[25]

Like the Palace guidebooks of 1851, guides to the new Palace suggested
that visitors' vision would be particularly tested and trained there as the
primary sensory mode of experience. For instance, the introduction to
Samuel Phillips's *Guide to the Crystal Palace and its Park and Gardens* (1854)
gives the potential Sydenham tripper a taste of 'the wonders that are to
meet his eye'[26] and highlights the fact that the objective of a visit will be
'to educate them by the eye'.[27] The *Penny Guide to the Crystal Palace* (1862)
describes the Sydenham Palace as a 'giant teacher whose ministry is con-
veyed through the medium of the eyes'.[28] Finally, and most importantly
for this chapter, the panorama and panoramic view, which had emerged
as the best analogical fit for reading and representing the first Crystal
Palace, transferred to narratives of the second Palace. Famed for its all-
embracing visual scope (which could condense a city or even the whole
globe into one punchy visual hit or *coup d'oeil*), and associated with virtual
travel and imperial ambition, the panorama seemed to provide the ideal
model for describing the Crystal Palace's global ambitions, and particular
spatiotemporal dynamic.[29]

I have previously explored the panorama's conceptual and material
influence on the shape of Great Exhibition print supplements and souve-
nirs.[30] The ever bigger, more spectacular new visual experiences offered

in the significantly enlarged Palace grounds at Sydenham can be read as a kind of attempt to actualise this panoramic rhetoric. For instance, the Italian garden's spectacular fountains (the largest ever built), were described as creating 'flashing waves of rolling light' and '*a coup d'oeil* of an unique and fascinating character'.[31] The Palace's 'Archery Ground became famous from 1859 for Balloon ascents offering panoramic views of the site, which are well recorded in engravings and photographs'.[32] And finally, in 1881, an actual panorama rotunda was built in the Palace grounds showing patriotic and historical scenes.[33] *The Times* suggested it was 'scarcely possible … to speak too highly of its [the panorama's] popularity as one of the Crystal Palace's attractions'.[34]

However, as in 1851, there was a danger that the hyper-visual nature of the Palace might overwhelm visitors' powers of perception.[35] Lady Eastlake explains that on a first visit:

> the mind does not recover from its pleasant tumult, *nor fasten upon any one individual thing* … Hour after hour finds us in wandering mazes lost – the sport of *impressions gone as soon as formed*, all rapid, vivid, but fleeting – glancing at what we are to see, tasting what we are to feed upon – all hope fixed upon *some future which is to sort the present tangle of the brain*.[36]

The implication is that return visits in the future will lead to a fuller, more complete reading of the 'tumultuous' scene that confronts, and bewilders, the Palace visitor. Initially, at first sight, only partial comprehension is possible, so that a cumulative process of reflection, a layering of memories, is necessary for the 'reward' of understanding. In other words, remembrance, recollection and reminiscence were key to visitors' interpretations of Sydenham. Therefore, a general impression of the Palace *mise-en-scène* took precedence in the experiences of one-time or first-time visitors: *Black's 1861 Guide to the Crystal Palace* (1861) notes that for the 'general tourist … the great beauty of the palace is in its ensemble, rather than its detail'.[37] The suggestion is that specialists or scholars will seek out and explore specific courts and exhibits for educative purposes, whereas 'the general tourist' looks to consume a more general leisure 'experience'.[38]

One response to the challenge to understanding posed by Sydenham's 'pleasant tumult' was to draw on the latest photographic technologies and techniques to create a visual record that would memorialise and narrativise the Palace. Popular visual mementos and supplements for the Hyde Park Palace had used relatively simple paper engineering technologies in the form of toy panoramas, peepshows and telescopic folding views to capture its grand scale and impression as *un coup d'oeil*. In contrast, aerial bird's-eye-view shots, photographic panoramas and stereoscopic images

promised to represent the scale and depth of the Sydenham site with espe-
cially lifelike results. These technologies had been in their infancy at the
time of the first Palace. Stereographs, for instance, first captured the pub-
lic's attention in 1851 when they were displayed at the Great Exhibition
and praised by Queen Victoria. Through the 1850s, businesses such as
the London Stereoscopic Company quickly developed technologies for
mass-producing stereograph scenes of the tourist destinations of the day.
The optical instrument manufacturers Negretti and Zambra produced
stereograph images of every part of the Sydenham Palace, and these were
for sale at their stall on the site as early as July 1856.[39] Indeed, photography
became the Crystal Palace's official mode of visual documentation. Philip
Henry Delamotte was the building's original official photographer; a
deliberate record was taken weekly of the 'Works in Progress' and a series
of 'above 120 photographs' titled 'The Progress of the Crystal Palace' was
put on sale.[40]

But in terms of a *personal* visual memento of a visit to the Sydenham
Palace such official records seemed wanting. It was a comparatively low-
tech, low-end material manifestation of the *coup d'oeil* view, the spyglass
miniature, that emerged as particularly suited to the task of figuring the
site for the 'general tourist'. Keepsakes featuring a miniature view of the
exterior of the Palace building could help answer the conceptual needs
highlighted by both Lady Eastlake and *Black's Guide*. They would operate
as crucial repositories for memories and tools for reminiscence; they would
compact and negate the building's potentially visually disruptive 'detail'
and allow viewers to focus on its 'ensemble' at a glance; and (despite being
practically the converse of the panorama) they would evoke a sense of
timelessness particularly suited to the space–time of the Sydenham site
and symbolically conquer its grand scale via a compression of large to
small.

Peep egg

Named 'peep eggs' in the 1950s by collectors, miniature peepshow sou-
venirs like the one shown in figure 2.1a and 2.1b were originally known
simply as 'views'. They belong to a group of souvenirs known as spar
ornaments made out of alabaster (a kind of gypsum). They were manu-
factured by a cottage industry, which made objects including candlesticks,
inkstands, tobacco jars and eggcups. At 3*s* 6*d*. (today's 17.5p), the same
price as an inkstand, peep eggs were at the pricey end of the spar orna-
ments market; in contrast, egg cups were only 6*d*. (today's 2.5p).[41] The
number and range of different tourist destinations figured inside surviving

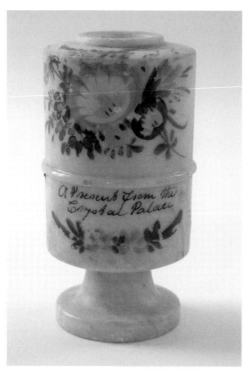

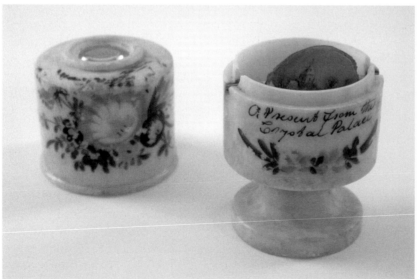

2.1a and 2.1b Two views of a Crystal Palace peep egg inscribed with 'A Present from the Crystal Palace'. Courtesy of Bill Douglas Cinema Museum, University of Exeter.

peep eggs stands testimony to its popularity as a Victorian souvenir, from seaside resorts around the British Isles through to the Thames Tunnel and Sydenham Crystal Palace.

The peep egg is a relatively early nineteenth-century optical toy (dating from the 1830s/40s) in the peep-show tradition, which remained popular until the end of the century. The top part of the alabaster egg is turned thin to allow light in, and a lens mounted on top allows the viewer to see inside. Typically, a shaft passing through the middle of the egg displays two or three images of a landmark or tourist destination. These are copperplate illustrations that were often coloured with watercolour paints. The shaft can be rotated by turning the knobs on the sides of the egg, thus revealing the different images. Most eggs also include a 'grotto' (see figure 2.2), a collection of pieces of shell, crystal, sand and dried flowers or seaweed, sometimes arranged around a mirror to look like a rock pool. The outside is varnished and usually painted with a floral design and the name of the tourist attraction with which the egg is associated. From an aesthetic point of view, the effect of the peep-egg 'grotto' is reminiscent of the

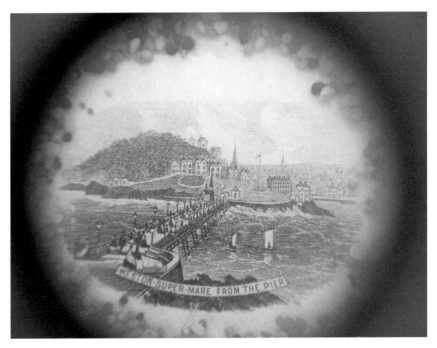

2.2 Interior of a peep egg showing a 'grotto' surrounding an image of Weston-Super-Mare from the pier. Courtesy of Bill Douglas Cinema Museum, University of Exeter.

kaleidoscope – another popular early nineteenth-century optical toy. But it also evokes the semantics of the microscope, that essential optical instrument used by nineteenth-century scientists and hobbyists alike to examine the secret life of the natural world and marvel at the spectacle of the miniscule. The tiny natural fragments presented in the grotto emphasise the fact that symbolically, the lens seals in and protects an entire miniature world inside the egg – a concept that resonates powerfully with the imperial and universalising ambitions associated with the Palace.

As a microcosm and tiny 'memory theatre', the peep egg shares some conceptual common ground with the *Wunderkabinette* or cabinet of curiosities which, from the sixteenth century, presented collections of natural specimens as objects of study and wonder and stood as symbolic 'theatres of the universe'.[42] And, of course, the egg stands as a traditional symbol of regeneration and immortality; it is a self-contained, complete environment.

The edges of the scene within the peep egg's viewfinder and the restricted visual field delimited by the action of peeping through the souvenir's lens enclose the Crystal Palace spatially, completely filling out the viewer's visual field. The peep egg thus cuts the Palace down to a 'manageable' size, organising it and bringing it under sensorial control. It physically layers a compressed, focused and magnified view of the building over the 'messiness' of the Palace's empirical reality. The souvenir performs a reduction of the monumental, the three-dimensional, into an object that can be enveloped into the body and held in the palm of your hand, educating the viewer in how to make sense of the 'tumultuous' Palace environment. In this sense the peep egg fits into the wider context of the alleged contemporary shifts in mid-to late nineteenth-century spectacular culture famously identified by Jonathan Crary (2001).

According to Crary, the advance of physiological optics in the early nineteenth century gave rise to a subjective conception of vision: vision was newly conceived as produced by the viewer and subject to the physical imperfections and limitations of the eye.[43] Attention became understood as the means by which the observer could transcend those subjective limitations, but attention was also a means by which the observer could become open to control by external agencies.[44] The peep egg helps recover a fraying consciousness of the Palace, in danger of unravelling before the tumultuous Sydenham scene, but also reveals how self-coherence emerges in the activation of the miniature view frame.[45] By producing an internal, enclosed mode of looking, the peep egg invests the viewer's act of contemplation with a crucial temporal dimension: it 'moves history into private time.'[46] As Susan Stewart explains, the private, individualised view offered

by the miniature is 'a world clearly limited in space but frozen and thereby both particularized and generalized in time – particularized in that the miniature concentrates upon the single instance and not the abstract rule, but generalized in that that instance comes to transcend, to stand for, a spectrum of other instances'.[47] The temporal dynamic of the world inside the miniature figures a neat and especially fit parallel to the 'all-at-onceness' or rolling together of past, present and future associated with the Crystal Palace. The tiny image of the Palace inside the peep egg comes to stand for the 'single instance' of one particular view of the building, and the 'spectrum of other instances' associated with the viewers' sense of self, which extends not only into their present material environment, but forward and backward in time via memories and aspirations.[48] In other words, as the viewer looks through the peep-egg lens, 'a dynamic process of interpretation and reinterpretation begins, which extends far beyond the mere perception of what the object is'.[49]

By definition, no past experience can ever be recouped. Although produced on a large commercial scale and generalised, souvenirs such as optical keepsakes respond to individual nostalgia for a past day out or holiday by resonating with the distant experience. But they also heighten the sense of longing as they can only ever offer a partial recuperation of the trip. Stewart suggests that 'we need and desire souvenirs of events that are reportable, events whose materiality has escaped us, events that thereby exist only through the invention of narrative'.[50] In the case of a holiday destination like the Crystal Palace, generally understood to be especially difficult (if not impossible) to conceive and describe in the first instance, the desire to memorialise and narrativise it via souvenirs takes on even greater significance.

Peep eggs can be fitted into the group of optical toys featuring perspective views that Barbara Maria Stafford terms 'serious playthings'; this oxymoronic label perfectly encapsulates the reflective element of these apparently frivolous devices as perceptual and cognitive focusing tools.[51] Like Wynter, writing in the *Westminster Review* Harriet Martineau (1802–76) anticipates that the 'buying and selling' of such objects in the Palace's shopping galleries can only shorten its lifespan and legacy, fearing that '[a]s a bazaar, it [the Palace] would probably be ephemeral'.[52] In fact, the souvenirs sold in the commercial areas of the Palace were of prime importance to its legacy on an individual level, and its symbolic place in personal relationships. Describing the Sydenham shopping galleries, Lady Eastlake notes that 'as a tribute to the happy influences which thrive under this roof, it may be added that the stalls of toys in the Galleries have answered the best of all'.[53]

John Birch Thomas, who as a teenager in the 1870s worked at a toy stall in the Palace, similarly notes the brisk business in toys and gifts at Sydenham: 'Our stall was on the ground floor … there was a constant stream of visitors passing to and fro … We were not very busy in the morning, but later when people came flocking in from the gardens we sold lots of toys and things for presents.'[54] Thomas writes warmly of his days spent working at the Palace, emphasising how the stalls added to the holiday atmosphere. Remembering a particular day when he sold a big batch of false whiskers, which many lads bought and wore while chasing girls about the Palace, he writes, 'our stall certainly helped to make things jolly that day'.[55]

Interestingly, Eastlake and Thomas's connection between the happy atmosphere at the Palace and the popularity of toys and gifts exactly corresponds to more recent tourism theory, which suggests that a trip or holiday out of the responsibilities or mundaneness of 'ordinary' everyday time inspires tourists to pick humorous, childish or even corny souvenirs.[56] Souvenirs bought at the Crystal Palace functioned as key material prompts to memories of the site. The physical presence of a toy keepsake featuring a miniature view of the Palace could help 'locate, define, and freeze in time' something of the fun and pleasure of a transitory 'extraordinary' Sydenham visit and transfer it into the familiar space of home and ordinary, everyday routines.[57] Indeed, the inscription on the peep egg, 'a Present from the Crystal Palace', reflects the fact that souvenirs and holiday mementos 'not only allow us to confirm the [extraordinary] experience to ourselves, but they may allow us the conversational cue for telling others about it'.[58] Given as a gift, the miniature view could perform a visual introduction to the Palace for someone who had not yet visited, and act as a conduit for a vicarious Sydenham experience.

The floral decoration on the outside of the peep egg is indicative of the fact that it is partly a display object, which would likely have sat on a mantelpiece, side table or cabinet. Optical toys were relatively common among the deluge of objects on show in the Victorian drawing room. The peep egg thus fulfilled two purposes, as ornament and viewer. Design writers of the period encouraged the collection and display of souvenirs of travel in the home, but the quirky and exotic were favoured.[59] Mrs Orrinsmith, in her *The Drawing Room, Its Decoration and Furniture* (1877), rejects 'coal-scuttles ornamented with highly-coloured views of, say, Warwick Castle […] [or] screens graced by a representation of "Melrose Abbey by Moonlight," with a mother-o'-pearl moon' as too commonplace and/or home grown; she suggests that the home-decorator should be on the lookout for something a little more exotic or unusual: 'A Persian tile, an Algerian flower-pot, an

old Flemish cup, a piece of Nankin blue, an Icelandic spoon.'[60] This trend
goes some way to further account for Wynter's snobbery about working-
and middle-class shoppers' desire for souvenirs of Sydenham – it seems
for some the Palace was perhaps simply too close to home to warrant a
memento. Yet Robert MacDonald highlights the fact that it is not certain
whether peep eggs were sold only in the location shown on them.[61] Spar
ornament sellers at the Palace probably sold a whole range of different
popular views – not just scenes of Sydenham. It also seems very likely
that peep egg views of the Crystal Palace were available at other tourist
destinations.

When two or more different destinations or attractions are figured
inside the egg, this brings into question which image takes primary/
secondary position; in other words, which (if indeed either) depicts the
place of purchase. The Crystal Palace peep egg featured here also con-
tains a picture of an unidentified church in snow (presumably the sec-
ondary image), and another egg in the Bill Douglas Collection depicts
Rhyl, North Wales and the Crystal Palace.[62] In the Rhyl/Crystal Palace
example, it seems most likely that the souvenir was bought at Rhyl (the
more obscure leisure destination) and the Crystal Palace was added as a
secondary 'filler' picture. This raises further questions about the currency
of the Crystal Palace image: it highlights the point that even the purchaser
may not necessarily have visited the Palace, and points towards the fact
that the image of the Palace also carried appeal and currency in a more
general way, as a national landmark and icon of London.

Sewing kit essential

The fancy floral decoration on the exterior of the peep egg suggests the
souvenir is gendered 'feminine'.[63] Combined with the fact that the draw-
ing room where it was likely displayed was conceived of as 'the room from
where the woman governed her domain' in the period, the object points
towards a female intended viewer.[64] This fits the fact that women – 'Sister
Mary' and 'Our Mary Ann' – are the primary target of Wynter's snob-
bery about the tastes of the shoppers for, and recipients of, inexpensive
Sydenham souvenirs. At both the Hyde Park and Sydenham palaces,
women are figured as particularly easily distracted from the building's
more cerebral exhibits and drawn towards the more 'superficial' attrac-
tions of displays of fancy goods. However, as Beth Fowkes Tobin points out,
although women are particularly associated with shopping in this period,
'it does not necessarily follow that the act of consuming mass-produced
commodities partakes of alienation' or indeed inanity; consumption may

be understood 'as a form of expression or a means of agency for the con-sumer'.[65] The peep egg offers its owner a sense of agency by performing a symbolic ordering of the 'tumultuous' Sydenham scene *and* standing as an expression of taste in ornament and interior decoration (albeit a taste that may not be judged *à la mode* by the likes of Mrs Orrinsmith).

The Stanhope viewer needle case featuring a tiny photograph of the Sydenham Palace (figure 2.3) goes one step further in investing its implied female purchaser/recipient with agency: it reflects the important fact that women not only consumed material culture, they also produced material objects and manipulated the material world around them. Made from carved bone, the case is in the shape of a folded umbrella, a fairly common type.[66] The handle unscrews and there is a storage compartment bored down the centre of the umbrella for keeping needles. Roughly the size of

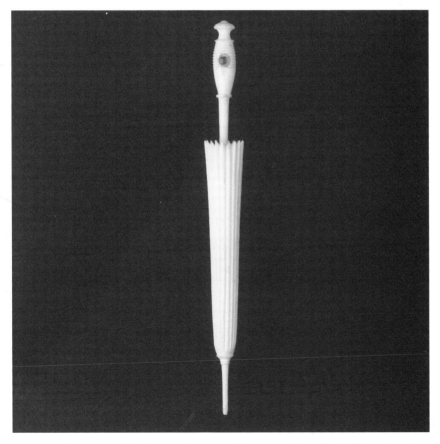

2.3 A Sydenham Stanhope viewer needle case, *c.*1860–68. © Victoria and Albert Museum, London.

a pinhead, the Stanhoped image of the Crystal Palace, positioned in the centre of the umbrella handle, measures approximately 1.95 mm in diameter and is seen through a tiny magnifying lens, approximately 6.35 mm long and 2.54 mm in diameter.[67]

Needlework and femininity were inextricably linked in nineteenth-century culture. Needlework, knotting and tatting required skill and provided women with scope for the exercise of good taste and ingenuity. They were also considered an appropriate means of inculcating feminine virtues such as modesty and obedience.[68] Critics including Fowkes Tobin and Maureen Daly Goggin have recently shown that traditionally feminine handicrafts and art forms were also 'central to constructing social meanings that operate in the world beyond the traditionally prescribed (and circumscribed) boundaries occupied by women'.[69] Objects from scrapbooks and shell work, through to handkerchiefs and undergarments, materialise important narratives about the lives and identities of the women who made them. While the ornamental peep egg appeals primarily to the eye, the Stanhoped needle case, as a functional needlework tool that would have been integrated into everyday sewing routines, appeals to the eye and the domain of the hand and touch, an oft overlooked sensory way of knowing space and place.[70] It seems inevitable that the owner of this Sydenham needle case would have occasionally reminisced about her day at the Crystal Palace while sewing, and thus symbolically 'stitched' a trace of Sydenham into whatever she was making.

The ranges of needlework souvenir wares available in this period reflect the growing number of fashionable holiday destinations and the concurrent boom in the souvenir trade.[71] In addition to needle cases, needlework tools bearing Stanhope viewers and magnified photographs of popular resorts dating from the 1860s onwards include tape-measure cases, scissors and thimbles. The development of microphotography and Stanhope viewer souvenirs and mementos is associated with two particular names: the Englishman, John Benjamin Dancer (1812–87) and Frenchman, Prudent René-Patrice Dagron (1819–1900). It is claimed that as early as 1839, Dancer, a scientific instrument maker, used an achromatic lens combination to produce a minute image on a daguerreotype plate, arguably the world's first microphotograph and the precursor of modern microfilm. The technique was perfected in 1851, and Dancer went on to market a long series of microphotographs that proved extremely popular with both the public and contemporary photographers.[72]

Dancer's microphotographs prompted Dagron to begin his work in the same field. Dagron was the owner of a Paris shop selling stationery and office equipment in 1860, when he first put together his plan

for making microscopic photographs mounted in jewellery. These tiny photographs were viewed by means of a tiny magnifying lens popularly known as a 'Stanhope' after its supposed inventor, the English Lord Charles Stanhope. In 1862, Dagron displayed Stanhope viewers at the International Exhibition in South Kensington, London, where he got an 'Honourable Mention', and presented them to Queen Victoria. In 1864 Dagron became a celebrity of his day when he recorded 450 portraits on a single photograph roughly the size of a pinhead.[73]

The great demand for Stanhoped jewellery and souvenirs showing amazingly detailed photographs of popular resorts and travel destinations in North America and Europe soon allowed Dagron to build a factory for their manufacture. The Frenchman established a highly successful mail order system to export cheap novelties featuring his 'cylindres photomicro-scopiques' around the world; Dagron's flair for publicity ensured the sales of his Stanhope viewers outstripped all other competitors.[74] Stanhoped souvenirs cover a wide range of personal effects including jewellery and accessories, writing equipment, sewing tools, smokers' requisites and reli-gious artefacts. They continued to be manufactured into the early twen-tieth century. If, in a small way, the nature of the spar ornaments trade potentially helped spread the image of the Crystal Palace around the UK, boosting its currency as a popular London landmark, the international nature of the Stanhope viewer trade meant that the image of the Palace was possibly regularly seen on keepsakes as far afield as Dagron's factory in Gex, on the border of Switzerland. In this context, new narratives about the Crystal Palace would have circulated around the tiny photographs and through the lives of people who had perhaps never been to the UK, let alone Sydenham.

The model of viewing demanded by the needle case's microphotograph bears many similarities to the spatiotemporal dynamic inside the micro-cosm of the peep egg. The act of peeping into the Stanhope magnifier also encloses the Crystal Palace spatially, completely filling out the viewer's point of view. However, the comparatively more sophisticated, newer visual technologies utilised by the Stanhope viewer highlight slightly differ-ent contextual changes in viewing in the period. The practice of copying objects on an exceedingly small scale and producing a tiny photograph intended to be viewed through a magnifier or microscope, practically and conceptually goes hand in hand with the practice of photographing and fixing a magnified view seen through a microscope. Martin Willis has highlighted how the microscope engendered a significant change in models of vision of the period: its power 'to reveal new and ever smaller worlds provoked observers to marvel at the spectacle of the miniscule'.[75]

Microphotography represents the practical antithesis of the majestic, monumental scale of the Crystal Palace. Yet the world of the tiny could inspire even more wonder than the huge. In his *The Microscope and its Revelations* (1856) William Carpenter suggests that 'all size is but relative, and ... mass has nothing to do with real grandeur. There is something in the extreme of minuteness, which is no less wonderful, – might it not almost be said, no less majestic? – than the extremes of vastness.'[76]

If analogy between the visual schemas of the sweeping panorama canvas and Palace had become rather tired or emptied of meaning, often lapsing into panoramic satire, then the majesty of the minute could (perhaps counterintuitively) capture something of the grandeur of the Palace via a visual model that neatly paralleled the shift in scale from large to small associated with the Palace souvenir trade.[77] In contrast to the famously immersive 360 degrees viewing experience figured by the panorama, the Stanhoped needle case viewer is positioned on the outside looking in; once herself an object on display in the Palace scene along with the other exhibits and visitors, she is invited to scrutinise the building with the microscopist's critical eye, and to reminisce with the tripper's emotive gaze.

Mid-century Victorian photographers noted the affinity between microphotography and the process of fixing a view seen through a microscope, but initially dismissed tiny, large-to-small photographs as mere novelties. *A Dictionary of Photography* (1858) lauds the potential to fix the views revealed by the microscope as 'a branch of photography of the highest interest and importance', but dismisses the photographic shrinking of large-to-microscopic as 'a process which must strike any reasonable person as somewhat trifling and childish'.[78] The microscopic view of the Crystal Palace featured on this needle case souvenir would likely have been regarded by its purchaser primarily as a photographic novelty or toy. But it might also have resonated with something of the rational wonder of its 'more scientific' photographic counterpart.

Conclusion

Souvenirs have barely featured in extant critical discussions of the Sydenham Crystal Palace. Yet they play an important part in the story of its place in nineteenth-century popular culture and the burgeoning tourist industry. The emergence of mid-century keepsakes featuring miniature views of the building is symptomatic of Sydenham visitors' need to make the hyper-visual attraction readable and coherent in personal, small-scale terms. Unlike stereograph card souvenir views of the interior of the Palace and official photograph collections that document its wider grounds and

individual exhibits, both the low-end peep view souvenirs discussed here present an image of the exterior of the Crystal Palace building that stands in for the experience of visiting its spectacular displays. Discussing the popularity of postcards showing exterior views of the British Museum's façade with twentieth-century British Museum visitors, Mary Beard suggests that for the visitors who purchase them, the 'imposing façade on these cards is more than a picture of "somewhere we have visited"; it *is* the museum visit; it *is* history'. In other words, the image of the British Museum building is the 'treasure chest' that promises to reveal the totality of history.[79]

Tiny peep views of the exterior of the Crystal Palace similarly stand as neat emblems for the official pedagogical and imperial ambitions connected to the Sydenham site – the pretension that the Palace and park would somehow figure the totality of the whole globe and all history all at once. However, more than that, the sense of the building's familiarity as an 'old friend' based on its association with the Palace of 1851 (shared by Eastlake and many others visitors) made an exterior view of the Palace an especially identifiable, sympathetic visual supplement for the overwhelming spectacle of the jumble of objects within. A miniature view purchased in the dedicated shopping area in the Palace could provide an especially evocative repository for fond memories of a day out there, and operate as a symbolic bridge between the Palace and home. Displayed on a sideboard or mantelpiece, or integrated into a daily activity, like sewing, writing a letter or smoking, spyglass keepsakes ensured the Palace held currency in Victorians' domestic daily lives. More than that, as I have shown, they could offer a visual introduction to the iconic London landmark to those yet to visit.

I began this discussion by considering the particular spatiotemporal dynamics of the Sydenham Palace – its associations with timelessness, or rather 'all time'. The Sydenham peep egg and Stanhoped needle case examined here similarly present tiny time machines of a sort. They represent multiple moments in time, suspended altogether and all at once in a dynamic relationship: the specific instance of the view of the Palace presented in the image, the memory of a particular Sydenham tripper's visit and the occasion of purchasing the souvenir, and the extended timescale of every viewer to look through the lens since, from the Victorians through to us. It is too easy to dismiss relatively low-tech and/or low-end nineteenth-century mementos such as these as sentimental ephemera, and to assume that they are straightforwardly superseded by technologically superior visual records.

However, the enduring popularity of low-tech miniature view tourist

souvenirs like snow globes today (despite popular twenty-first-century digitisation of our holiday and travel experiences) stands testimony to their unique material and conceptual qualities. The miniature peep view souvenirs discussed here perfectly encapsulate the conflict of scale wrought by the Crystal Palace's removal to, and reinvention on, Sydenham Hill: they present *un coup d'oeil* befitting the sense of totality associated with the site's aspirations as a national exhibition and landmark, but deliver it on the individual, personal terms that I have shown were central to the story of the shape-shifting second Palace.

Notes

1 A. Wynter, 'The New Crystal Palace at Sydenham', *Fraser's Magazine*, 48:288 (1853), 617.

2 T. May, *Great Exhibitions: From the Crystal Palace to the Dome* (Oxford: Shire Publications, 2010), p. 59.

3 *Ibid.*

4 See T. Richards, *The Commodity Culture of Victorian England: Advertising and Spectacle, 1851–1914* (Stanford: Stanford University Press, 1990), and P. Young, *Globalization and the Great Exhibition: The Victorian New World Order* (London: Palgrave Macmillan, 2009).

5 For more on the importance of souvenirs to tourist experiences, see, J. Goss, 'The Souvenir: Conceptualizing the Object(s) of Tourist Consumption', in A. A. Lew and C. M. Hall (eds), *A Companion to Tourism* (Oxford: Blackwell Publishing, 2004), pp. 327–36.

6 A good range of Crystal Palace souvenirs can be viewed on the Crystal Palace Foundation website: www.crystalpalacefoundation.org.uk/collections/ (accessed 2 August 2012); and on the website of the Crystal Palace Museum: www.crystalpalacemuseum.org.uk/artefact.html (accessed 2 August 2012).

7 Wynter, 'New Crystal Palace', 615.

8 *Ibid.*, 617.

9 See J. Elsner and R. Cardinal, 'Introduction', in J. Elsner and R. Cardinal (eds), *The Cultures of Collecting* (London: Reaktion Books, 1994), p. 4.

10 On the formation of the major national public museum collections in the nineteenth century, see, for example, T. Bennett, *The Birth of the Museum* (London: Routledge, 1995); K. Hill, *Culture and Class in English Public Museums, 1850–1914* (Aldershot: Ashgate, 2005); A. MacGregor, *Curiosity and Enlightenment: Collectors and Collections from the Sixteenth to the Nineteenth Century* (London: Yale University Press, 2007).

11 Elsner and Cardinal, 'Introduction', p. 5. See also M. Beard, 'Souvenirs of Culture: Deciphering (in) the Museum', *Art History*, 15:4 (December 1992), 505–32.

12 On the ways in which we use everyday domestic objects as a vehicle for

introspection and self-reflexivity, see A. Appadurai (ed.), *The Social Life of Things: Commodities in Cultural Perspective* (Cambridge: Cambridge University Press, 1986); J. Hoskins, *Biographical Objects: How Things Tell the Stories of Peoples' Lives* (London: Routledge, 1998); D. Miller, *The Comfort of Things* (Cambridge: Polity Press, 2008).

13 J. R. Piggott, *Palace of the People: the Crystal Palace at Sydenham 1854–1936* (London: Hurst & Co., 2004), p. 166.

14 P. Gurney, '"A Palace for the People"? The Crystal Palace and Consumer Culture in Victorian England', in J. Buzard, J. W. Childers and E. Gillooly (eds), *Victorian Prism: Refractions of the Crystal Palace* (Charlottesville: University of Virginia Press, 2007), pp. 138–50.

15 Amy F. Ogata makes a strong case for the role peepshow souvenirs played in materialising the burgeoning 'phantasmagoria' of nineteenth-century consumer culture. However, the Sydenham Palace is not included in her study. See A. F. Ogata, 'Viewing Souvenirs: Peepshows and the International Expositions', *Journal of Design History*, 15:2 (2002), 69–82.

16 E. Eastlake, 'The Crystal Palace', *Quarterly Review*, 96:92 (1855), 304 (emphasis mine).

17 On the particular scheme of space–time associated with the Hyde Park Crystal Palace see I. Armstrong, *Victorian Glassworlds: Glass Culture and the Imagination 1830–1880* (Oxford: Oxford University Press, 2008).

18 W. Whewell, 'General Bearing of the Great Exhibition on the Progress of Art and Science', in W. Whewell, *Lectures on the Results of the Great Exhibition of 1851, Delivered before the Society of Arts, Manufactures, and Commerce* (London: Bogue, 1851), pp. 12–15. See also S. Edwards, 'The Accumulation of Knowledge or, William Whewell's Eye', in L. Purbrick (ed.), *The Great Exhibition of 1851: New Interdisciplinary Essays* (Manchester: Manchester University Press, 2001), pp. 26–52.

19 S. Phillips, *Guide to the Crystal Palace and its Park and Gardens* (London: Robert K. Burt, 1862), p. 10.

20 See further Piggott, *Palace of the People*, pp. 166–203.

21 Critics have recently brought to light important 'unofficial' Great Exhibition narratives that have similarly nuanced understanding of the Hyde Park Palace. See Buzard, Childers and Gillooly (eds), *Victorian Prism*.

22 In 'majesty and grace' the new Palace was 'more vast, more beautiful, more permanent, and devoted to more comprehensive purposes'. *Chambers's Edinburgh Journal*, 20:516 (19 November 1853), 321.

23 See Armstrong, *Victorian Glassworlds*, p. 142.

24 G. A. Sala and H. W. Wills, 'Fairyland in 'Fifty-four', *Household Words*, 8:193 (3 December 1853), 313.

25 J. A. Secord, 'Monsters at the Crystal Palace', in S. de Chadarevian and N. Hopwood (eds), *Models: the Third Dimension of Science* (Stanford, CA: Stanford University Press, 2004), pp. 140–1.

26 Phillips, *Guide to the Crystal Palace*, p. 1.

27 *Ibid.*, p. 3.

28 *Penny Guide to the Crystal Palace* (London: Grant & Co., 1862), p. 1.

29 See R. Bellon, 'Science at the Crystal Focus of the World', in A. Fyfe and B. Lightman (eds), *Science in the Marketplace* (Chicago: University of Chicago Press, 2007), pp. 301–35.

30 V. Hunt, 'Narrativizing "The World's Show": The Great Exhibition, Panoramic Views and Print Supplements', in J. Kember, J. Plunkett and J. A. Sullivan (eds), *Popular Exhibitions, Science and Showmanship, 1840–1910* (London: Pickering & Chatto, 2012), pp. 115–32.

31 Phillips, *Guide to the Crystal Palace*, p. 2. Other spectacular entertainments staged at Sydenham included demonstrations of the first moving picture shows towards the end of the century and the famous firework extravaganzas.

32 Piggott, *Palace of the People*, p. 186.

33 L. Garrison, S. Erle, V. Hunt *et al.* (eds), *Panoramas 1787–1900: Texts and Contexts*, 3 (London: Pickering & Chatto, 2012), pp. 251–76.

34 *The Times* (2 August 1887), p. 9.

35 On visual perception at the Great Exhibition, see I. Armstrong, 'Languages of Glass: The Dreaming Collection', in Buzard, Childers and Gillooly (eds), *Victorian Prism*, pp. 55–83.

36 Eastlake, 'Crystal Palace', 306 (emphasis mine).

37 *Black's 1861 Guide to the Crystal Palace* (Edinburgh: Adam & Charles Black, 1861), p. 1.

38 On key types of museum visitors, and for a predictive model of visitor experience, see J. F. Falk, *Identity and the Museum Visitor Experience* (Walnut Creek, CA: Left Coast Press, 2009).

39 They also sold optical equipment of all kinds, took portraits and sold those of celebrities. Piggott, *Palace of the People*, p. 136.

40 The Palace directors received two large folios of mounted photographs from the series. Piggott, *Palace of the People*, p. 134.

41 R. MacDonald, 'Spar Ornaments: The History of the Peep Egg', *Magic Lantern Society Newsletter*, 10:5 (Autumn 2009), 79–81; W. Barnes, 'The Peep Egg', *Magic Lantern Society Newsletter* 88 (June 2007).

42 F. Terpak, 'Wunderkammern and Wunderkabinette', in B. M. Stafford and F. Terpak (eds), *Devices of Wonder: From the World in a Box to Images on a Screen* (Los Angeles: Getty Publications, 2001), pp. 148–57.

43 The eminent German physicist and physician Hermann von Helmholtz (1821–94) famously demonstrated the imperfection of the human eye in his much-quoted lecture of 1868 – part of a course of lectures delivered in Frankfurt & Heidelberg, and republished in the *Preussische Jahrbücher* (1868). Available in English as H. von Helmholtz, *Popular Lectures on Scientific Subjects*, trans. E. Atkinson (London: Longman, Green & Co., 1895), pp. 175–276.

44 J. Crary, *Suspensions of Perception: Attention, Spectacle, and Modern Culture* (London: The MIT Press, 2001), p. 2.

45 B. M. Stafford, 'Revealing Technologies/ Magical Domains', in Stafford and Terpak (eds), *Devices of Wonder*, p. 108.

46 S. Stewart, *On Longing: Narratives of the Miniature, the Gigantic, the Souvenir, the Collection* (London: Duke University Press, 1993), p. 138.

47 *Ibid.*, p. 48.

48 On the relationship between objects and the 'extended sense of self', see C. Belk and Y. Marshall, 'The Cultural Biography of Objects', *World Archaeology*, 31:2 (1999), 169–78; I. Kopytoff, 'The Cultural Biography Of Things: Commoditization as Process', in Appadurai (ed.), *The Social Life of Things*, pp. 64–94.

49 S. M. Pearce, 'Objects as Meaning; or Narrating the Past', in S. M. Pearce (ed.), *Interpreting Objects and Collections* (London: Routledge, 1994), p. 26.

50 Stewart, *On Longing*, p. 135.

51 Stafford, 'Revealing Technologies', p. 108.

52 H. Martineau, 'The Crystal Palace', *Westminster Review*, 62:122 (1854), 548.

53 Eastlake, 'Crystal Palace', 343.

54 J. B. Thomas, *Shop Boy* (London: Century Publishing, 1983). p. 126. On Thomas and representations of the Sydenham Palace in working-class autobiographies, see K. Nichols, *Greece and Rome at the Crystal Palace: Classical Sculpture and Modern Britain, 1854–1936* (Oxford: Oxford University Press, 2015), pp. 46–9.

55 Thomas, *Shop Boy*, p. 128.

56 B. Gordon, 'The Souvenir: Messenger of the Extraordinary', *Journal of Popular Culture*, 20:3 (1986), 138.

57 *Ibid.*, 135.

58 R. W. Belk, 'The Role of Possessions in Constructing and Maintaining A Sense of Past', in M. Goldberg, G. Gorn and R. Pollary (eds), *Advances in Consumer Research*, 17 (Provo, UT: Association for Consumer Research, 1990), p. 670.

59 J. Flanders, *The Victorian House* (London: Harper Perennial, 2004), pp. 145–6.

60 L. Orrinsmith, *The Drawing-Room, Its Decoration and Furniture* (London: Macmillan & Co., 1877), pp. 5, 132–3.

61 MacDonald, 'Spar Ornaments', p. 81.

62 See the Bill Douglas Centre catalogue, www.bdcmuseum.org.uk/explore/item/69073/ (accessed 6 February 2015).

63 On the effects that particular notions of femininity and masculinity have on the conception, design, advertising, purchasing and giving and using of objects, see P. Kirkham and J. Attfield, *The Gendered Object* (Manchester: Manchester University Press, 1996).

64 Flanders, *Victorian House*, p. 131.

65 B. F. Tobin, 'Introduction: Consumption as a Gendered Social Practice', in M. D. Goggin and B. F. Tobin (eds), *Material Women 1750–1950, Consuming Desires and Collecting Practices* (Farnham: Ashgate, 2009), p. 3.

66 E. Johnson, *Needlework Tools: A guide to Collecting* (Oxford: Shire Publications Ltd, 1978), pp. 13–14.

67 See, 'V&A, Search the Collections': http://collections.vam.ac.uk/item/
 O78797/needle-case-unknown (accessed 6 August 2012).

68 V. Richmond, 'Stitching the Self: Eliza Kenniff's Drawers and the
 Materialization of Identity in Late-Nineteenth-Century London', in M. D.
 Goggin and B. F. Tobin (eds), *Women and Things 1750–1950, Gendered Material
 Strategies* (Farnham: Ashgate, 2009), pp. 43–54.

69 M. D. Goggin and B. F. Tobin, 'Introduction: Materializing Women', in
 Goggin and Tobin (eds), *Women and Things 1750–1950*, p. 2.

70 Constance Classen explains that touch has been marginalised in historical
 accounts since the nineteenth century when it became 'typed by the scholars
 of the day as a crude and uncivilised mode of perception'. She highlights the
 longstanding historical association between women and touch that lay behind
 the cultural designation of handicrafts, particularly needlework, as appropri-
 ate female work of the hand or 'ladies work'. C. Classen, *The Deepest Sense: A
 Cultural History of Touch* (Urbana: University of Illinois Press, 2012), pp. xii and
 133–6.

71 Johnson, *Needlework Tools*, p. 4. The needlework tools featured in Johnson's
 book include a novelty tape measure case bearing a colour print of the Crystal
 Palace under glass on p. 21.

72 'John Benjamin Dancer', in L. Day and I. McNeil (eds), *Biographical Dictionary
 of the History of Technology* (London: Routledge, 1998), pp. 191–2.

73 'Prudent René-Patrice Dagron', in Day and McNeil (eds), *Biographical Dictionary
 of the History of Technology*, p. 187.

74 See 'Stanhopes', www.stanhopes.info/who_made_stanhopes.html (accessed 7
 August 2012).

75 M. Willis, *Vision, Science and Literature, 1870–1920: Ocular Horizons* (London:
 Pickering & Chatto, 2011), p. 12.

76 W. Carpenter, *The Microscope and its Revelations* (London: John Churchill, 1856),
 p. 37.

77 For more on the Palace and panoramic satire see Hunt, 'Narrativizing "The
 World's Show"'.

78 T. Sutton, J. Worden and F. Peabody, *A Dictionary of Photography* (London:
 S. Low, Son & Co., 1858), p. 295.

79 Beard, 'Souvenirs of Culture', 513.

3

The cosmopolitan world of Victorian portraiture: the Crystal Palace portrait gallery, *c.*1854

Jason Edwards

This chapter returns to centre stage the 500 plaster cast portraits, ranging from Homer to Queen Victoria, comprising the Crystal Palace portrait gallery, that ran alongside the better-known, more widely discussed Fine Arts Courts. It considers the portraits as a microcosm of the Palace project, and develops 'close' and 'distant' readings of Samuel Phillips's official 1854 guide.[1] Countering myopic, insular interpretations of Sydenham as a provincial, proletarian, carnivalesque pleasure park, the chapter explores the complex, cosmopolitan ambitions and experiences of a specific subset of visitors: the ideal audience addressed by the official guides. This chapter argues that the idea of bourgeois visitors armed with guides, such as Phillips's, powerfully challenges the classist caricatures of unreflective, undiscriminating mid-Victorian consumerism and jingoism that circulated around Sydenham in the period and that have continued to dominate recent scholarship.[2]

The chapter thus contests the paradigmatic status of the violent, anarchic, drunken wedding party in the oft-cited twelfth chapter of George Gissing's *The Nether World* (1889), and of Susan Flood, the aptly-named, equally fictional, provincial iconoclastic schoolgirl described in chapter 11 of Edmund Gosse's *Father and Son* (1907), whose sense of decency is so affronted that she begins to attack the plaster casts with her parasol. Replacing such caricatures, the chapter argues that more culturally ambitious visitors engaged sympathetically, patiently and in detail with the Sydenham directors' desire to create, within the Palace complex, an eclectic, cosmopolitan world system, both cultural historical and ecological.[3]

Recognising its wide-ranging and still-challenging juxtaposition of natural and cultural artefacts as one of the Palace's defining characteristics,

the chapter attempts to articulate, and to understand anew, the precise character and contours of the mid-Victorian world as Sydenham's directors imagined and represented it in 1854, and the complex palimpsest of systems of imagining that world that the portrait sequence offers. The chapter explores Sydenham's mid-Victorian world system by bringing into focus three attempts to systematise the globe. The first is the apparently discrete, systematic sequence of historical cultures, each with their own defining characteristics, on offer at the macro level of Phillips's portrait guide, with its separate sections on ancient Greece and Rome, and modern Italy, France, Germany and England, where 'modern' refers to a broad post late-antiquity.[4]

The second, less systematic attempt to encompass the world that I consider in more detail is the micro-textual level of the myriad individual journeys undertaken by individuals between specified villages, towns and cities, as articulated in the 497 biographies included in Phillips's guide, that repeatedly traverse the supposedly more stable, and geographically discrete, macro sequence of Greece, Rome, Italy, France, Germany and England. In order to give a concrete sense of this various, specified world, the article is accompanied by a table listing each of the approximately 1500 places Phillips mentions, accompanied by a number signalling how many references to it Phillips makes in the guide (see table 3.1).

Moving from the kind of distant, statistical reading of Phillips's guide represented by the table, to a close reading of some of his sentences, the chapter then considers Phillips's attitudes to a range of cultural contexts, such as Ireland, the United States and France, to give a further sense of the character and contours of his cosmopolitanism.[5] The chapter concludes by considering the significant fact that the portrait sequence was juxtaposed with various ethnographic and natural historical specimens and that all three categories of exhibit were contained within the larger ecosystem of the Palace. By adding an ecological dimension to the cultural-historical perspectives that dominate accounts of Sydenham, as well as the majority of contemporary theories of cosmopolitanism,[6] the chapter makes the polemical point that any analysis of the complex cultures in which mid-Victorian and contemporary human beings find themselves are damaged to the degree that they do not include our companion species. In so doing, the chapter seeks to demonstrate that, rather than representing an embarrassing, tacky, pop-cultural liability, Sydenham's diverse, difficult-to-systematise ecology may be its strongest historiographical asset within a still anthropocentric humanities at a moment of world history in which species are disappearing at an unprecedented rate.

Of culture and anarchy: Harriet Martineau's Crystal Palace

The portrait gallery represents one of the least illustrated and discussed components of the Crystal Palace, and, at first glance, its collection of plaster busts, full-sized figures, equestrian groups, effigies, medallions, statuettes and masks might not seem the most likely source for considering the precise character of mid-Victorian cosmopolitanism. After all, even if spectators might have identified the individuals depicted with certain regions, portrait statues do not generally make direct visual reference to geographical locations. And yet, if a macrocosmic understanding of the cosmopolitanism on offer at Sydenham must ultimately include an account of the Fine Arts Courts, with those courts being understood alongside Sydenham's zoological, botanical, ethnological and geological specimens, the portrait gallery perhaps offers the best single (and most manageable), microcosm for thinking about cosmopolitanism in Britain *c*.1854, the year in which the official guides to Sydenham were first published.

In beginning to think about the various, potentially cosmopolitan experiences that mid-Victorian viewers might have had as they engaged with the Sydenham portrait gallery, scholars have, however, been hampered by treating as pieces of objective sociology, rather than as self-serving, misleading pieces of rhetoric, accounts of the Palace by period commentators such as Gissing, Gosse and Harriet Martineau. In particular, they have been misled by Gosse and Martineau's encouraging their readers to imagine that their contemporaries experienced Sydenham's 500 plaster cast portraits as a single, sublime spectacle or as so many interchangeable, undifferentiated *things* that they barely noticed on their way to the supposedly more compelling ethnographic and natural history, industrial, and food courts.

For example, writing in the 1854 *Westminster Review*, Martineau was scathing about the cultural capacities of the vast majority of visitors to Sydenham, making considerable capital out of the 'often painful' and 'sometimes astonishing and mortifying' remarks she supposedly heard visitors making in the courts laid out below her. She suggested that the largest crowds of 'school-children', 'artisans' and 'trades-people' were found staring at the 'savages' and taxidermy specimens in the natural history and geological courts, 'evidently wondering whether all those brown fellows and yellow termagants were really men and women'.[7] Scholars have taken remarkably seriously Martineau's caricature of the Sydenham audience, perhaps because of the way in which she seeks to establish her proto-sociological, qualitative and quantitative credentials.[8] For instance, Martineau asserts that she attended the Palace 'more than most people',

spending 'whole days' sitting, incognito, in the upper gallery, so as to establish, like a good statistical utilitarian, what was the 'most attractive spectacle to the greatest number'.[9]

But should scholars treat the nearly deaf Martineau as a reliable witness, especially regarding her supposedly first-hand *aural* testimony? And isn't the precariously middle-class Martineau protesting her bourgeois cultural credentials a little too hard? After all, even she had to admit that some of the ethnographic displays were truly 'thrilling' to visitors, perhaps including herself, who had 'read voyages and travels all their lives'.[10] Martineau was also forced to acknowledge that Sydenham's polar and tropical worlds could not have been witnessed, at first hand, by 'one visitor in a million', however cosmopolitan they imagined themselves to be.[11] In addition, while she might have publicly condemned the conspicuous 'buying and selling' and 'eating and drinking' that occurred at Sydenham, could she have spent entire days there without consuming anything herself?[12]

In addition to her classism, Martineau's racism and Islamophobia should also make scholars question her credentials as a supposedly reliable and cultured, cosmopolitan witness. After all, Martineau compared a cast of John Bell's bronze *Eagleslayer* to a 'negro' because of its 'dark' patination; while her use of the term 'termagant' refers to a disparaging name given by Europeans to a god they erroneously believed Muslims worshipped.[13] If Martineau is, then, anything but a 'scientific' witness, in the remainder of this chapter I consider how our understanding of Sydenham might change if we put aside her snobbish 'sociology' and examine instead the ideal, middle-class audience addressed by Phillips's guidebook to the portrait sequence.

>6 but <1500:
A 'distant reading' of Phillips's cosmopolitanism

Born in London on 28 December 1814, Phillips was the third son of Jewish parents. Studying first at the universities of London, Göttingen and Cambridge, Phillips subsequently turned to journalism, writing for the *Morning Herald*, *Literary Gazette* and *The Times*, where he was a literary reviewer. With the aid of Alderman David Salomons – the first Jewish man to be elected an MP in Britain – Phillips purchased the *John Bull*, although financial misfortune meant that he ceased to be editor and proprietor within a year. When the Sydenham Palace was established, Phillips was appointed its literary director and company treasurer, going on to write the guide to the portrait gallery and the general guide. In these, his

journalistic eye for detail served him well. After all, rather than riding roughshod over the five hundred or so plaster casts that made up the portrait sequence, Phillips encouraged culturally ambitious, middle-class, mid-Victorian viewers – and encourages more recent commentators – to engage in a patient, detailed, comparative-anatomical, as well as art-historical and cultural-historical way with each sitter's life and work, body and soul. He achieves this by offering a short biography of each sitter, framed by the dates and places of their birth and death, alongside a close reading of their physiognomy and costume, a formal assessment of the achievements and shortcomings of the sculptor's stylistic strategies, and anecdotes about the materials, making, reception history, and casting and transport of each object.

In addition, Phillips's guide encouraged its readers to undertake comparisons of the objects in front of them with related examples, immediately adjacent to them in the case of multiple busts of the same sitter; at other historical moments and geographical locations in the portrait sequence; and in any number of private and public collections.[14] This process ensured that the stable geographical parameters and temporal progress of a portrait collection divided into ancient and modern, and into Greek, Roman, Italian, French, German and English sitters, was repeatedly undermined.

For example, Phillips suggested that the physiognomic details of Machiavelli's bust might 'furnish materials for the study' of the 'curious question' of whether *The Prince* (1532) was to be regarded as a satire or doctrine.[15] Phillips encouraged his readers to look, in Galileo's face, for the signs of his 'robust and intrepid intellect';[16] to consider the unskilful restoration of the nose of Claude Fabri de Peiresc;[17] to note how Chantrey indicated the deafness of John Raphael Smith through his facial expression;[18] and to compare the 'two types' of Shakespeare portrait, 'the 'round-faced' and the 'oval-faced'.[19] In addition, having told his readers that Chaucer was often described as having 'something elvish' in his countenance, Phillips asks us directly: 'Does he?'[20]

Phillips's guide also has clear ethical and political intentions, such that, in engaging with the various sitters' portraits and biographies, viewers and readers are encouraged to consider the virtues and vices not only of different individuals, as part of an interpersonal encounter, but, in a more international frame, the characters and 'destinies' of the 'great nations'.[21] For example, while the Athenians, and presumably the mid-Victorians, could become 'more virtuous' from the contemplation of the 'bright examples' of the best Greek citizens, the busts of Roman emperors and their consorts were, evidently, cautionary tales.[22] Phillips's British imperial readers were

meant to admire Alexander the Great, whose 'conquests rendered eastern Asia accessible to European enterprise',[23] but to despise the 'bloated and debased' Vitellius whose life was 'devoted to eating, drinking, and acts of cruelty'.[24] It would also have been 'difficult to find in history a woman more blackened' by crime, lust, avarice, and ambition than Valeria Messalina, Phillips suggested.[25]

Phillips's comparison of Greece and Rome, a mid-Victorian staple, was echoed by his similarly generalising remarks on Italy, France, Germany and England.[26] But before we consider the specific idioms Phillips employed to discuss those later examples, it is worth pausing to reflect on the alphabetised list of the nearly 1500 separate locations in table 3.1 that Phillips references, noting first the sheer number of locations and then their relative incidence. For example, while the table's alphabetical ordering does not give an impression of the precise sequence of places Phillips mentions as the guide unfolds, it offers a flavour of the strange, and constantly disorienting imaginative itineraries that Phillips's readers traverse as they journey from Homer's Greece to Victoria's empire, and a taste of what Phillips calls the geographical 'web' or 'labyrinth' of 'adventures' that occur in any individual's life or any nation or region's history.[27]

Indeed, Phillips's prose constantly encouraged his readers to imagine being in, or adjacent to, literally thousands of institutions, places, and geographical features, at various scales, some of them familiar, some of them unknown, including galleries, museums, schools, palaces, universities, convents, churches and villas; rivers, lakes, ports, coasts, bays, islands, seas, capes and oceans; woods, forests, and mountain ranges; lanes, streets, and roads; villages, towns, cities, capitals, and counties; states, countries, provinces, principalities, kingdoms, colonies, and empires; as well as entire continents and hemispheres. As readers will quickly realise, the table emphasises the complicated way in which Phillips's at-first-glance stable, six-nations cosmopolitan structure – echoed in the bird's-eye, tessellating, jigsaw-like macrocosmic organisation of the Palace, seen on a plan or by a visitor from the upper galleries – is everywhere complicated, patterned, textured, criss-crossed and undermined by a more densely cosmopolitan range of 1500 locales, with individual biographical journeys often originating in, or outside of, the nations in which the subjects nominally find themselves classified.

To give another sense of Phillips's cosmopolitan contours and hotspots, the way in which his references cluster around certain geographical locales, it may be helpful to imagine a map depicting every place he mentions in the guide.[28] But the most cursory glance at the table or at such an imaginary map would suggest how predictable this would be. When it comes

3.1 Table of 1500 places mentioned in Samuel Phillips' *Guide to the Crystal Palace and its Parks and Gardens*.

Abbeville, in South Caroline (213),
Abbotsford (184),
Abergen in Germany (153),
Abricium, in Thrace (42), near Abricium (38),
Adrumetum, in Africa (50),
Aegean (202),
Africa (vii, 33, 47),
Agen in France (106),
Agram (161),
Aigueperse in France (109),
Aix, in Provence (100),
Aix-la-Chapelle (114),
Ajaccio in Corsica (132),
Albi in France (104),
Aldgate (216),
Aleppo (115),
Alexandria (viii, 24, 31),
Algiers (111),
All parts of the world (200),
Alloway, in Ayrshire (182),
Alsace (116),
Altinum, in the country of the Veneti (35),
Amboise, in France (59),
America (116, 133),
America (198, 201, 203),
American Colonies (206),
Americas, the two Americas (173),
Andelys (93), in France (83),
Andes, near Mantua, in Cisalpine Gaul (52),
Angers in France (209),
Angoulememe (125),
Anjou (125), Charles of (69),
Annoux in Burgundy (120),
Anspach-Bayreuth (160),
Antinoea (42),
Antioch (viii, 38, 45; in Syria 50),
Antium in Latium (30, 32),
Antwerp in Flanders (136),
Apameaia, in Syria (29),
Appenine province (71),
Aprinium (51),
Apulia (47),
Aquileia (39) and before Aquileia (37),
Arabia (39, 106),
Arce, in Phoenicia (38),
Archelas, in Cappadocia (36),
Arctic (218),
Arcueil in France (105), Italy (105),
Argua, near Padua (70),
Aroldsen (148),

Arret in France (91),
Asia (33, 44, 45, 48, 107),
Assaye (209),
Asti, in Piedmont (73),
Athens x 12 (15, 16, 17, 18, 19, 20, 21, 22, 23, 25, 26, 27, 144),
Attica (17, 25),
Auerstadt (120, 166),
aurora borealis (191),
Aussig in Bohemia (137),
Austerlitz (119, 120),
Austria (72, 73, 77, 78, 79, 107, 180, 116, 125, 127, 129, 130, 131, 137, 164, 167, 168, 223),
Aversa, near Naples (67),
Avignon in France (87),
Babylon (24),
Baden (112, 140),
Balkans (167),
Bamborough, Northumberland (177),
Bastille (113),
Bath (173),
Bautzen (120),
Bavaria (115, 134, 136, 137, 142, 144, 145, 149, 155, 156, 165, 176),
Beaugensier in France (111),
Beaumont in France (106),
Beaunée in France (105),
Belgium (166),
Belgrade (77, 114),
Bengal (205),
Bergamo, in Italy (76),
Berlin (68, 97, 104, 136, 139, 141, 142, 142, 149, 153, 154, 155, 157, 158, 160, 163, 164, 165, 166, 167. 168),
Besancon, in France (108),
Biorgo-Forte, in Italy (77),
Birkenhead (200),
Black Forest (149),
Blois in France (125),
Bohemia (161),
Bologna (64, 65, 66), in Italy (64, 73) and the "Bolognese school" (65), in Italy (73),
Bonn, in Rhenish Prussia (140),
Bordeaux (98),
Boston [USA] (191, 210),
Botany Bay (104),
Boulogne (185), Boulogne-sur-Mer (96, 117, 127),
Bourges in France (125),
Brandenburg (163),
Brecknock (174),

to countries, Phillips predominantly references England, France, Spain, Italy, Germany, Austria and Greece, with infrequent detours to Russia, Japan, China and India, the Capes, the Arctic, North America, and a thin slither of North Africa. And when it comes to density of individual references, we might be surprised that Rome and Paris trump London, but perhaps less that there are no non-European countries in the top ten; that Phillips references Windsor as often as Africa; Jena as frequently as the East, America and Asia; Bologna as often as India; and Europe as often as Prussia, Florence, or Vienna. England, in second place, trumps Britain, in seventeenth, and the UK, in nineteenth place.

If Phillips's hotspots are predictable, a distant reading of his guide focused on precise locations suggests an exciting conceptual middle ground between humanities methodologies that consider single countries or two country polarities, such as the cross-channel or Anglo-Indian, and a fashionable commitment to the global, as if there was not a complex constellation of cosmopolitan possibilities in between. Indeed, to draw on the work of Eve Kosofsky Sedgwick and Adam Frank, the very 'many-valuedness' of such a table, which refers to '*more than two*' but '*finitely many*' dimensions, may be the Crystal Palace and cosmopolitanism's strongest asset, in a current intellectual climate in which the 'conceptual space between two and infinity' remains difficult to inhabit. [29]

To open up this theoretical and conceptual impasse, between two and infinity, Sedgwick and Frank turn to the work of affect theorist, Silvan Tomkins, and make the strategically risky move of accepting his biologically determinist assumption that there are a number of specific affects hardwired into each human being. Such biologising moves remain controversial within critical theory, although perhaps less so now than when Sedgwick and Frank first made their argument in the mid-1990s. Even so, the multi-perspectival character of Phillips's cosmopolitanism might prove similarly galvanising in a political-theoretical moment in which we still need to resist both 'binary homogenisation', where everything is reduced to a pair of opposing forces, and 'infinite trivialisation', where because things are different from each other, we think it is not worth paying detailed attention to *differences*, plural, in favour of just emphasising *difference*, singular. In addition, Phillips's many-valued cosmopolitan modelling might, in turn, helpfully challenge Sedgwick and Frank's hypothesis that the thought realm of '*finitely many* [...] *values*', where $n > 2$ but $<$ infinity, is available today *only* in relation to biological, rather than cultural geographical, models.[30]

Having explored Phillips's cosmopolitanism from the statistically rich *quantitative* perspective of a distant reading, the next section considers how

a close reading of the specific idioms he employs presents a *qualitatively* different view of his cosmopolitanism.

The mid-Victorian values of Phillips's cosmopolitanism: a 'close reading'

Just as Phillips makes some mainstream distinctions between Greek and Roman culture in the first, antique half of the guide, there is something equally mid-Victorian about many of the lessons he wanted his readers to glean from his modern Italian, French, German and English pantheon.[31] For example, like a good Liberal, Phillips was pro-industrial and mercantile. He praised the railway contractor Thomas Brassey as 'one of the highest examples we can offer to our generation, absorbed as we are in the production of great industrial undertakings, and, above all things, intent upon the pursuit of wealth'.[32] Phillips similarly characterised the temperance reformer Father Theobald Matthew as a 'modern crusader' who had 'drawn his spiritual sword against one of the deadliest foes to religion, civilisation and human happiness'.[33] And fearing that by sparing the rod, you spoil the child, Phillips criticised the way in which Byron had been 'sent into the world without discipline or training of any kind'. Had Byron been 'fairly dealt with in his childhood and youth', Phillips continued, the poet's life might have been happier and its 'course more equable'.[34]

By contrast, Phillips praised Benjamin Franklin as 'one of the most instructive and encouraging studies for youth', because of the way in which his 'usefulness', 'self-command', 'industry', 'frugality, perseverance' and 'independence' enabled him to overcome 'all the difficulties of fortune'.[35] If Phillips had been 'asked to single out from ancient or modern story one bright, unsullied example of true greatness', however, he would have selected George Washington. Even though England 'suffered by his acts', Phillips acknowledged, the English had 'reason to be proud of his surpassing glory; for he came from the common stock, and he wrought the liberty of his country by the exercise of virtues dear to all Englishmen [*sic*], and – let us dare to say – characteristic of their race'.[36]

Predictably absorbing an American president into a culturally capacious 'English' pantheon, an analysis of some of Phillips's other Anglo-American examples reveals the precise complexion of his transatlantic cosmopolitanism, and in particular his attitude to abolition and First Nations peoples.[37] For example, he suggests, *without comment*, that General Jackson's American presidency was characterised by a 'spirit of territorial expansion', tacitly at the expense of indigenous populations, and by the 'marked encouragement of the slave-holding interest'.[38] Phillips similarly documents the

way in which American statesman Daniel Webster, 'though no friend to slavery', 'carried on no bitter crusade against it': Webster's 'conciliatory policy' towards the 'unhappy institution' having the apparently happy effect of maintaining 'through difficulty and danger, the political Union' that contributed 'so largely to the strength and greatness of the American people'.[39] One page earlier, however, Phillips had thought fit to notice that English statesman Henry Brougham was 'one of the foremost' and most 'beloved' men in the country because of his 'eager anxiety to remove the shackles from the negro, and every disability from the limbs of his fellow-creatures nearer home'.[40] While Phillips's views here were far from exceptional in mid-Victorian Britain, his not unrelated belief that Harriet Beecher Stowe's *Uncle Tom's Cabin*, published two years before the *Guide*, represented little more than a 'violation of the rights of property' were far from a mainstream response to a novel very many Victorians found deeply affecting.

Phillips's attitude to England is also worth considering in detail. For example, he makes clear that his guide is primarily addressed to English citizens when he refers to 'our own' Charles I, Elizabeth I and Shakespeare.[41] In addition, when praising foreign nationals, Phillips repeatedly sugars the pill by drawing flattering English parallels. We learn that 'like Nelson', Abraham Duquesne was 'in private life admired for his gentleness and sterling worth'; while, 'as an agricultural writer', Albrecht Thaer was 'worthy of being placed' beside 'our own' Arthur Young.[42]

Perhaps equally unsurprising is the fact that the mid-Victorian Phillips is in favour of Italian unification, but hostile to Irish nationalism. For example, like the extended circle surrounding Dante Gabriel Rossetti and Algernon Charles Swinburne, Phillips mourns the early-modern 'fall of Florence' and, with it, the 'last breath of Italian independence',[43] and praises the 'one great aim' of Barthélémi Catharine Joubert's life as the 'dethronement of all the petty sovereigns of Italy, and the substitution of one great Italian republic'.[44] When referring to the 'sister kingdom' of Ireland, however, Phillips's views would have divided parliamentary politicians in the second half of the nineteenth century. For example, in the year in which both the Catholic University and National Gallery of Ireland were founded, Phillips's discussion of the Irish industrialist William Dargin comments that 'whilst too many of [Dargin's] fellow countrymen' were 'engaged in destroying – as far as in them lay – the elements of industry in Ireland', Dargin 'laboured to develop her resources, and to rouse the physical energy and the self-respect of all classes'. A 'patriot, not a partisan', Phillips's Dargin is a 'useful citizen' and 'loyal subject' who offered £20,000 towards the building of the Dublin Crystal Palace, and who had

gained, as a result, the 'affectionate gratitude of the Irish people' and the 'approving smiles of his sovereign'.[45]

Quite different, in Phillips's view, was Irish nationalist Daniel O'Connell who had used his 'extraordinarily powerful talents and influence' less for his 'afflicted' country's 'advantage and happiness' than for 'his own selfish ends', keeping Ireland in a 'ferment of discontent, discord, and semi-rebellion', and leaving behind him a 'name, which is not uttered with opprobrium – simply because it is already nearly forgotten' in the 'new epoch of tranquillity, order, and steady industry, upon which Ireland has entered'.[46] By contrast, and with an eye on both Catholic and Hebrew emancipation within Britain – as well, perhaps, as to pay a biographical debt – Phillips praised Sir Michael O'Lochlen, 'the first Roman Catholic created law officer of the Crown', a view that was certainly mainstream in 1854; and David Salomons, one of Phillips's earlier benefactors, as we have seen, the 'first Hebrew gentleman' to hold 'civic appointment' and to sit as an MP.[47]

Perhaps inevitably, the Sydenham Crystal Palace's sequence of portrait busts, even accompanied by Phillips's short biographies, combine to raise synecdoche as a pressing, ongoing question. Can busts stand in for bodies, biographies and lives? Can representative citizens stand for their respective countries? Rather than assuming that parts can effectively represent wholes, Phillips characteristically gestured towards the missing pieces, noting that many of the busts were fragments of larger works, and filling in details of the way in which, in real life, a subject's face was animated or a larger body appeared. For example, Phillips informed his readers that Linnaeus was 'strong', 'muscular' and 'in person below the middle height', his features 'agreeable and animated'.[48] Phillips similarly informed his readers that David Garrick was 'small in stature, but well built', his eyes 'dark, and full of fire'.[49]

The question of synecdoche is particularly pressing during Phillips's discussion of portrait busts, I would argue, because of two national-historical spectres: the English Civil War and the French Revolution. The execution of Charles I and scenes of guillotining in the terror made more or less decapitated busts an overdetermined medium in Britain in 1854, just six years after the year of European revolutions and the related, violent outbreaks of English radicalism in 1848. At the same time, they represented a sculptural genre whose carefully contoured stillness embodied Phillips's ideal stoical values beautifully, even amid such terrifying scenes. For example, Phillips's attitude towards a democratic British monarchy is characteristically mid-Victorian. The state-sponsored sculptural programme for the Houses of Parliament included full-sized, electrotype

statues of the barons who signed the Magna Carta, by James Sherwood Westmacott among others.[50]

We can see similar values in action when Phillips praised the comparatively 'enlightened' Edward III for his 'constitutional acts' and for increasing the power of the Commons and the law.[51] We can also detect Phillips's post-1832 politics in the way in which his portrait sequence ends with a bust of Victoria, 'whom God preserve' Phillips prayed, and with two busts of Albert, 'to whom the Crystal Palace at Sydenham' was 'indebted for its existence'.[52] By contrast, Phillips strongly criticised George III whose 'wilful persistence in the maintenance of what he conceived his royal prerogative, plunged England into war with America, and caused the premature loss' of 'that magnificent British colony'.[53]

Phillips really reserved his ire, however, for Charles I's 'obstinacy', 'wilfulness', 'untruthfulness', 'double-dealing', and 'exaggerated notions of prerogative' which fully 'justified the resistance of a people awakened to a sense of their rights, and roused to the vindication of their liberties'. And yet haunted, like many of his peers, by the French revolutionary terror – with Thomas Carlyle's *The French Revolution: A History* (1837) standing as, perhaps, the paradigmatic literary example – Phillips added that Charles was a 'man whose sorrows', 'dignified bearing in misfortune', 'private virtues, love of literature and art, and gentle demeanour' all rendered him an 'object of the deepest commiseration, and the most plaintive interest'.[54] Phillips then went on to assert his thanks that the 'catastrophe' of Charles's 'unhappy reign' need 'never be re-enacted' since the king's 'blood purchased' Britain's national security even when, as in 1848, much of the rest of Europe was 'in conflagration'.[55]

In contrast to Charles's dignified bearing, Phillips criticised Marie Jeanne Vaubernier for the way in which she 'betrayed great want of courage' at the scaffold;[56] and Condorcet for his lack of 'moral courage' when, having been imprisoned in 1791, he 'swallowed poison' rather than face his state-sponsored assailants.[57] Again like many of his mid-century peers, including Carlyle, however, Phillips idolised Marie Antoinette who, on her way to the scaffold in 1793, may have been 'for two hours reviled by a ferocious mob', but whose 'resignation and sweetness of demeanour only could be traced on her countenance'. Indeed, Phillips commented, the way in which her 'perfect heroism' shone through 'unsullied', in spite of her 'cruel persecution, horrible imprisonment, and ignominious death', made the 'murder of this unhappy lady' the 'most crimson spot in all the bloody time of the French revolution'.[58]

Haunted by the terror, Phillips's guide gratefully registered the happier era of Anglo-French relations that developed during the mid-nineteenth

century, especially in relation to then-recent threats of British radicalism. For example, Phillips sang the praises of Louis Napoleon who, while living in London during 1848, 'sallied forth with his neighbours', when 'special constables were enrolled for the preservation of menaced order', and 'performed street duty with the humblest'. On his triumphant return to 'tranquillised France', meanwhile, Phillips's Louis Napoleon planted his foot firmly 'upon the summit of power', and Phillips asked his readers to 'pray to Heaven in the interests of humanity, civilisation and peace' that Louis Napoleon would remain in control. After all, since his accession, Phillips documented, all Louis Napoleon's exertions had been directed to the 'development of the material resources of his country' and to the 'upholding of that good understanding among nations which is essential to the continuance of social prosperity'. Europe, therefore, lay 'under great obligations' to Louis Napoleon's 'sagacity', and England had 'cause to rejoice in his friendship'.[59]

Plaster casts and pussy cats:
The Portrait Gallery and the larger Sydenham ecology

Although Phillips's guide, therefore, offers contemporary scholars a remarkable resource to think about the precise character of mid-Victorian cosmopolitanism, it could never hope to represent an exhaustive census of the world-historical human population, and his criteria for inclusion reveals some straightforwardly crude biases. Women barely figure, and Phillips tellingly singles out, as a praiseworthy exception, British mathematician and astronomer Mary Somerville because of the way in which she held her own with her male peers, while 'deserting none' of her 'proper tasks' and 'forfeiting nothing' of her 'proper character' as a woman.[60]

Phillips's racism and anthropocentrism represent further obvious limitations. Among the sequence of 500 portraits, there is not a single person born outside Europe or America. Such mostly unnamed subjects are, by contrast, relegated to the categories of ethnographic specimens within the natural history courts. And even though there may have been little difference in comparative-anatomical method between looking at the precise details of posture and appearance in the portrait gallery and ethnographic courts, the separation of Euro-American subjects from the rest of the world is evidently a difference that makes a considerable difference.[61]

In the 'Introduction' to his guide, Phillips did briefly mention the 'hundred Chinese portraits of great antiquity' housed at the Parisian Imperial Library brought home by a 'well-known Jesuit missionary' – although the Palace directors did not see fit to copy and bring these to South London.[62]

Phillips also briefly discussed the 'individuality' of certain Egyptian por-
traits, located in the Egyptian Court rather than forming part of the por-
trait sequence, but his comparison of Rameses's 'aquiline nose' and 'thin
lips' with Amenoph's more 'African' [sic] 'turned-up nose and thick lips'
represents a characteristic mid-Victorian differentiation, in the person
of Rameses, of an effectively European Egypt that formed part of a clas-
sicised, circum-Mediterranean world and, in the person of Amenoph, a
more primitive and generalised Africa further south.[63]

In addition, and with the exception of the unnamed horses ridden by
the subjects of the equestrian portraits, animals are also almost entirely
absent from Phillips's account.[64] And yet, from a post-human perspective,
what precisely are the differences between the comparative-anatomical
method Phillips's readers were encouraged to employ when looking at
adjacent plaster cast busts in the portrait and ethnographic sequences and
comparing competing, named pedigree cats in one of Sydenham's famous
pet shows?[65] Indeed, the promotion of such comparative anatomies,
between and within categories of plaster casts and cats, represented one of
Sydenham's trademark orderings of things, especially when compared to
the Victoria and Albert Museum's rival and more straightforwardly art-
historical cast courts.[66] After all, unlike Sydenham, the V&A did not host
animal shows or maintain a hothouse ecological, rather than museological
environment, filled with flowers, goldfish, birds and bees, whose climate
was designed to remind viewers of southern Italy.[67] And, in more than
one of his biographical entries, Phillips encouraged his readers to think
about the crossover between different forms of portraiture and the related
classificatory systems undertaken by naturalists.[68] For example, he drew
his readers' attention to Cuvier's 'Tabular Arrangement of the Natural
History of Animals' and 'celebrated collection for the study of comparative
anatomy'.[69]

In the midst of his own six-nations cosmopolitan system, Phillips also
praised French Botanist Joseph Pitton de Tournefort for his work in plant
'classification' and 'geographical distribution'.[70] And encouraging viewers
to compare the portrait sequence with the nearby ethnographic and natu-
ral historical specimens, Phillips commended Buffon as 'one of the found-
ers of ethnological science' and as a writer who 'gave great prominence to
the history of man as an animal'.[71]

Rather than imagining such natural-cultural juxtapositions and inter-
sections as a 'comic mixture of objects',[72] in Jan Piggott's terms, and instead
of characterising ambitiously polymath visitors to Sydenham as provincial
plebeians because they were as captivated by the natural history and eth-
nographic courts as the Fine Arts Courts, scholars might do better, in the

current ecological crisis, to start their analyses of Sydenham, and Victorian culture more generally, from the relatively decentred perspective of animals.[73] Indeed, the Crystal Palace may represent an ideal case study for a *post-human* museology precisely because of the way in which it combined cultural- and natural-historical agendas in a single ordering of things.[74]

Conclusion

Instead of looking down on Sydenham, then, as shamefully provincial and politically despicable, as many scholars have been inclined to do, in concluding I want to suggest that at least some mid-Victorian visitors to Sydenham may have had more sophisticated and inclusive cosmopolitan and ecological interests than their mid-nineteenth-, late-twentieth-, and early-twenty-first-century commentators. After all, if anyone with real pretensions to being a citizen of the mid-Victorian world would probably not have been caught dead admitting that they had to take the shaming detour via provincial Sydenham to become more cosmopolitan, what might be gained rhetorically by my admitting that I would love to have been able to visit the Crystal Palace? Or that an embarrassing sense of provincialism, as well as real excitement, characterised my experience of reading about the 1500 locations mentioned in Phillips's guide – some just given and recognised, others unknown and helpfully located near somewhere more familiar – repeatedly reminding me of my own culturally cringe-worthy, provincial origins as a person educated at a state school in rural Lincolnshire and as one of the first members of his family to attend a university whose honest answer would have had to have been 'No' when a degree-level tutor asked him, with incredulity, in the first term, 'You do know that there are books about pictures, don't you, Jason?'

The Crystal Palace's greatest methodological and historiographical asset, then, may also be its greatest challenge: the way it requires us to do justice to its adjacent, often intersecting, encyclopaedic agendas – geological, botanical, entomological, zoological, comparative-anatomical, ethnographical, anthropological, physiognomical, phrenological, biographical, art-historical, industrial, astronomical and cosmological. Promoting an informed, self-conscious aesthetics of detection, dissection, differentiation, classification, tabulation and distribution, rather than sublime spectacle; and an interpersonal and international ethics comprising comparative moral and aesthetic evaluation, and sympathy as well as scrutiny, rather than commodified seduction; the Crystal Palace portrait sequence asks us to rethink what we think we know about Sydenham.

for Claire Westall

Notes

1 S. Phillips, *The Portrait Gallery of the Crystal Palace* (London: Bradbury & Evans, 1854). For more on distant reading, see F. Moretti, *Distant Reading* (London: Verso, 2013).

2 For an account of the commercial underpinnings of the Palace, see H. Atmore, 'Utopia Unlimited: The Crystal Palace Company and Joint-Stock Politics, 1854–1856', *Journal of Victorian Culture*, 9:2 (2004), 189–215. For a more sensitive analysis of working-class cultures at Sydenham, see D. S. Ryan, 'Staging the Imperial City: The Pageant of London, 1911', in F. Driver and D. Gilbert (eds), *Imperial Cities: Landscape, Display and Identity* (Manchester: Manchester University Press, 1999), pp. 117–35; P. Gurney, 'An Appropriated Space: the Great Exhibition, the Crystal Palace and the Working Class', in L. Purbrick (ed.), *The Great Exhibition of 1851: New Interdisciplinary Essays* (Manchester: Manchester University Press, 2001), pp. 114–45; and '"A Palace for the People?" The Crystal Palace and Consumer Culture in Victorian England', in J. Buzard, J. W. Childers and E. Gillooly (eds), *Victorian Prism: Refractions of the Crystal Palace* (Charlottesville and London: University of Virginia Press, 2007), pp. 138–50.

3 For a concise introduction to world systems theories, see I. Wallerstein, *World-Systems Analysis: An Introduction* (Durham: Duke University Press, 2004).

4 This offers a significant variant on the similarly macro sequence visitors encountered in the Fine Arts Courts, which ran from ancient Egypt and Assyria, through Greece, Rome and Pompeii, to Byzantine, Romanesque, Medieval and Modern Europe, alongside the Alhambra Court's more difficult-to-place detour to Islamic Spain.

5 I seek to draw together here two uses of the word cosmopolitan that are rarely brought into dialogue. The first is a social scientific understanding, which seeks to do justice to a world in which all human beings are equal. For a representative range of positions, see G. Wallace Brown and D. Held (eds), *The Cosmopolitanism Reader* (London: Polity, 2010). The second is concerned with cosmopolitanism in a more humanities sense, as a high-cultural class distinction, and as opposed to something we might caricature as the provincial. My thinking here derives from E. Kosofsky Sedgwick's account of the urbane and provincial in *Epistemology of the Closet* (Los Angeles: California University Press, 1990), pp. 97–100; and from J. Litvak, 'Vulgarity, Stupidity, and Worldliness in *Middlemarch*', in S. David Bernstein and E. B. Michie (eds), *Victorian Vulgarity: Taste in Verbal and Visual Culture* (Aldershot: Ashgate, 2009), pp. 169–84.

6 Martha Nussbaum might be an exception here, writing eloquently on political cosmopolitanism and on animals. For more, see her 'Kant and Cosmopolitanism', in Brown and Held (eds), *The Cosmopolitan Reader*, pp. 45–60; and 'The Moral Status of Animals', in L. Kalof and A. Fitzgerald (eds), *The Animals Reader: The Essential Classic and Contemporary Writings* (London: Berg, 2007), pp. 30–7.

7 H. Martineau, 'The Crystal Palace', *Westminster Review*, 62:122 (1854), 537, 540. For more on Martineau's attitude to race and class, see E. Dzelzainis and C. Kaplan (eds), *Harriet Martineau: Authorship, Society and Empire* (Manchester: Manchester University Press, 2010).

8 For an example of citing Martineau straight, see J. A. Secord, 'Monsters at the Crystal Palace', in S. de Chadarevian and N. Hopwood (eds), *Models: The Third Dimension of Science* (Stanford: Stanford University Press, 2004), pp. 138–69; 138.

9 Martineau, 'Crystal Palace', 537.

10 *Ibid.*, 538.

11 *Ibid.*, 544.

12 *Ibid.*, 546, 548–9.

13 *Ibid.*, 545.

14 For example, we find nearly thirty comparative, adjacent pairs of busts of the same sitter; more disparate pairs of Hadrian and Livia Drusilla; a disparate trio of Scipio Africanus and adjacent trio of Glucks and Napoleons; and no less than four versions of Julius Caesar.

15 Phillips, *Portrait Gallery*, p. 75.

16 *Ibid.*

17 *Ibid.*, p. 111.

18 *Ibid.*, p. 172.

19 *Ibid.*, p. 180.

20 *Ibid.*, p. 178. For more on Victorian physiognomy, see M. Cowling, *The Artist as Anthropologist: The Representation of Type and Character in Victorian Art* (Cambridge: Cambridge University Press, 1989).

21 Phillips, *Portrait Gallery*, pp. 18, 22.

22 *Ibid.*, p. 17.

23 *Ibid.*, p. 24.

24 *Ibid.*, p. 32.

25 *Ibid.*, p. 44. On the ambiguities of the Roman Empire at Sydenham, see K. Nichols, *Greece and Rome at the Crystal Palace. Classical Sculpture and Modern Britain 1854–1936* (Oxford: Oxford University Press, 2015).

26 For more on the characterisation of classical antiquity at Sydenham, see D. Challis, 'Greece at the Great Exhibition and the Crystal Palace', in J. Auerbach and P. H. Hoffenberg (eds), *Britain, the Empire, and the World at the Great Exhibition of 1851* (Aldershot: Ashgate, 2008), pp. 173–90; S. Hales, 'Re-casting Antiquity: Pompeii and the Crystal Palace', *Arion*, 14:1 (2006), 99–133; and K. Nichols, 'Marbles for the Masses: The Elgin Marbles at the Crystal Palace', in V. Coltman (ed.), *Making Sense of Greek Art: Ancient Visual Culture and its Receptions* (Exeter: University of Exeter Press, 2011), pp. 179–201.

27 Phillips, *Portrait Gallery*, p. 71.

28 Compare this with the mere 41 surviving cities listed in the mural decoration of the V&A cast courts.

29 E. Kosofsky Sedgwick and A. Frank, 'Shame in the Cybernetic Fold: Reading

Silvan Tomkins', in E. Kosofsky Sedgwick, *Touching Feeling: Affect, Pedagogy, Performativity* (Durham: Duke University Press, 2003), p. 111.

30 *Ibid.*, pp. 109, 111. While I suggest that this challenges Frank and Sedgwick's biologising hypothesis, my thinking was profoundly inspired by their suggestion that we think about the realms of n>2 in relation to 'dimensions … on a map: north, south, east, west' and their sense of the richness of geography, anthropology, and ecological or systems approaches as conceptual terrains (pp. 108–9).

31 Phillips, *Portrait Gallery*, p. iii.

32 *Ibid.*, p. 200.

33 *Ibid.*, p. 219. For more on the problematic status of alcohol at Sydenham, see J. R. Piggott, *Palace of the People: The Crystal Palace at Sydenham 1854–1936* (London: Hurst & Co., 2004), pp. 57–9.

34 Phillips, *Portrait Gallery*, p. 187.

35 *Ibid.*, p. 191.

36 *Ibid.*, p. 204.

37 Phillips's 'English' portraits also include the Welsh-born, Anglo-Roman sculptor John Gibson, the Irish Oliver Goldsmith, Daniel O'Connell and Edmund Burke, the Scottish Robert Burns and Walter Scott, and the Canadian Judge Haliburton.

38 Phillips, *Portrait Gallery*, p. 209.

39 *Ibid.*, p. 214.

40 *Ibid.*, p. 213.

41 *Ibid.*, pp. 110, 129, 149. In spite of its explicit address to British readers, Phillips's guide is significantly, if intermittently, polyphone, within an overall continental frame. For example, having provided an English translation of a specific text, Phillips acknowledged that the 'Italian syllables are yet stronger'. He also cited texts in French, and single German and Russian words, before translating them into English (*Portrait Gallery*, pp. 83, 96, 123, 135, 167–8, 198).

42 Phillips, *Portrait Gallery*, pp. 112, 152.

43 *Ibid.*, p. 61.

44 *Ibid.*, p. 119.

45 *Ibid.*, pp. 200–1.

46 *Ibid.*, p. 212.

47 *Ibid.*, p. 216.

48 *Ibid.*, p. 102.

49 *Ibid.*, p. 170.

50 For more, see Greg Sullivan's entry on Saher de Quincy, Earl of Winchester, in M. Droth, J. Edwards and M. Hatt (eds), *Sculpture Victorious: Art in an Age of Invention* (New Haven, CT and London: Yale University Press, 2014), pp. 149–51.

51 Phillips, *Portrait Gallery*, p. 220.

52 *Ibid.*, p. 225.

53 *Ibid.*, p. 224.

54 *Ibid.*, p. 223.

55 *Ibid.*, p. 223.

56 *Ibid.*, p. 98.

57 *Ibid.*, p. 104.

58 *Ibid.*, p. 131.

59 *Ibid.*, p. 134.

60 *Ibid.*, p. 197. In addition to Marie Antoinette, instances of the 'few women who step out from the limits which seem naturally assigned to their intellectual avocations, to compete with men in theirs' include Aspasia, Julia Mesa, Sabina and others in the 'Court of the Roman Ladies'; Maria Felicitas Malibran, Guilia Grisi, Marie-Anne-Botol Dangeville, Mademoiselle Clairon, Eleanor of Castile, Marie de' Medici, Mary Stuart, Fanny Butler and Grace Darling. Phillips also praises the 'masculine spirit', 'unbounded zeal, patriotism and heroism' of that 'true Englishwoman', Elizabeth I (Phillips, *Portrait Gallery*, pp. 221–2). For more on the status of women at a parallel mid-Victorian institution, see L. Perry, *History's Beauties: Women and the National Portrait Gallery, 1856–1900* (Aldershot: Ashgate, 2006).

61 For more on the ethnographic courts, see R. Gordon Latham and E. Forbes, *Handbook to the Courts of Natural History* (London: Bradbury & Evans, 1854); A. Hassam, 'Portable Iron Structures and Uncertain Colonial Spaces at the Sydenham Crystal Palace', in Gilbert and Driver (eds), *Imperial Cities*, pp. 174–93; S. Qureshi, 'Robert Gordon Latham, Displayed Peoples and the Natural History of Race', *Historical Journal*, 54:1 (2011), 143, 166; E. Edwards, 'Photography, Race and Popular Darwinism', in D. Donald and J. Munro (eds), *Endless Forms: Charles Darwin, Natural Science and the Visual Arts* (New Haven, CT and London: Yale Centre for British Art, 2009), pp. 167–94.

62 Phillips, *Portrait Gallery*, pp. vii–viii.

63 *Ibid.*, p. vii.

64 Phillips does, however, make clear that we are not to imagine as exemplary a Caligula who raised his 'favourite horse' to 'the Consulship' (*Portrait Gallery*, p. 32). Similarly disreputable is Sabina-Poppaea, whose 'mules were shod with gold', and who travelled with 'five hundred asses, whose milk furnished a bath to preserve her complexion' (*Portrait Gallery*, p. 46). Phillips also described how French author Prosper Jolyot de Crèbillon 'withdrew from the world, and passed a life of abstinence amidst a large number of cats and dogs, whose attachment, he said, consoled him for man's ingratitude' (*Portrait Gallery*, p. 95).

65 For more, see C. Wolfe, *What is Posthumanism?* (Minneapolis: University of Minnesota Press, 2010). The *Illustrated London News* found Sydenham's animal shows captivating. First illustrating a poultry show on 22 August 1857, there are nearly thirty separate illustrations before 1900, including parrots, rabbits, cats, dogs, goats, pigeons, donkeys and ducks.

66 For more on the cast courts at the V&A, see M. Baker, *The Cast Courts* (1982), www.vam.ac.uk/collections/sculpture/sculpture_features/cast_collection/cast_courts_masterpiece/index.html (accessed 14 August 2014).

67 Piggott, *Palace of the People*, p. 31.
68 Darwin's *The Expression of Emotion in Man and Animals* was not published until 1872, but it drew on debates that had been raging throughout the nineteenth century.
69 Phillips, *Portrait Gallery*, p. 107.
70 *Ibid.*, p. 101.
71 *Ibid.*, p. 102.
72 Piggott, *Palace of the People*, pp. 21, 50.
73 Good places to begin such an analysis might be the taxidermic animals in the Natural History Courts, as well as the aviaries and the aquarium, particularly given the significant parallels between the ribbed Crystal Palace and the bars of the birds' cages, or between Sydenham's thousands of transparent glass panes and the similar panes making up the tanks of tropical fish.
74 For more on nature-culture, as a single hermeneutic category, see D. J. Haraway, *When Species Meet* (Minneapolis: University of Minnesota Press, 2008).

4

The armless artist and the lightning cartoonist: performing popular culture at the Crystal Palace *c.*1900

Ann Roberts

Discussions of art at the Crystal Palace have largely focused on historic sculpture and architecture contained in its Fine Arts Courts. Exemplified by the series of official guides produced by the Crystal Palace Company from 1854, its commitment to 'preserve the high moral and educational tone' of the original Hyde Park enterprise is clear.[1] The Palace's General Manager, Henry Gillman, for example, writing in the 1899 *General Guide to the Crystal Palace* noted that the exhibits 'are designed to convey a practical lesson not otherwise attainable by the masses', demonstrating its continued role as educator of public taste throughout the nineteenth century.[2] The role of fine art was further exemplified at the Crystal Palace by the provision of a formal School of Art, a Picture Gallery and access to the Crystal Palace Art Union.[3] Despite such pretensions to high art, however, the Crystal Palace operated on a highly commercial basis and it was this foundation that helped to shape its subsequent evolution as both public educator and provider of entertainment and spectacle that crossed the boundaries between fine art, visual display and consumer culture. Thus, by 1900 the role of art at the Crystal Palace was perhaps defined as much by the artistic demands for scenic art required for its many popular theatricals and pantomimes, and for its huge and varied exhibitions and displays (such as the panoramic trip through the Bay of Naples of 1900 and the Naval and Military Exhibition of 1901), as by its permanent Fine Arts Courts in the North Nave.[4]

This chapter considers two artists working at the Crystal Palace around 1900 who provide an insight into the more commercialised and commodified role of art during this period. Bartram Hiles (1872–1927) lost both arms in a childhood accident in 1880 in his home city of Bristol but taught

himself to paint by holding a brush in his mouth, eventually winning a national scholarship to study art and design at the National Art Training School at South Kensington from 1890 to 1892. By 1900, as a professional artist looking for temporary exhibition space, Hiles was drawn to the Crystal Palace with its promise of large audiences and greater visibility for his work. Herbert Beecroft (1864–1951) had trained as a lithographer and book illustrator eventually becoming a 'lightning cartoonist'; a stage act he adapted for the Crystal Palace venue that also included amusing verbal commentary and lectures.

Taking a different trajectory to the official guidebooks, this chapter draws on the ephemeral nature of the Crystal Palace's daily programme of events, the *Crystal Palace Magazine* (as the Palace's own in-house publication) and on journalism of the period to contextualise Hiles's and Beecroft's tenure at the People's Palace at the turn of the century. Drawing on such material supports a comprehensive and subtle analysis of the consumption of art available at the Crystal Palace that bypasses the more structured representations produced by the Palace management's publications. This chapter locates the Crystal Palace as a cultural experience in which a mass audience could engage with both the eternal nature of beauty expressed in the classicism of Greece and Rome, for example, and the transient nature of the art produced by the fleeting contributions of a more popular culture provided by Hiles and Beecroft. As the nineteenth-century poet Charles Baudelaire suggested, all forms of beauty consisted of an element of the eternal and of the transitory, 'of the absolute and the particular'.[5] Baudelaire was seeking the inherent beauty of the new urban spaces of Haussmann's Paris as an experience of nineteenth-century modernity. In his essay, 'The Painter of Modern Life', he defined that modernity as an encounter with 'the ephemeral, the fugitive, the contingent, the half of art whose other half is the eternal and the immutable'.[6] Baudelaire's concerns for the role of modern life in art can be usefully employed as a framework in which to understand the particular nature of the Crystal Palace by 1900 for artists such as Hiles and Beecroft. Neither artist remained long at the Crystal Palace; their contributions to its artistic life exemplify a category of worker who was attracted by its possibilities for short-term rewards. Seen in this way, we can envisage the Crystal Palace as Baudelaire's modern work of art in which Hiles and Beecroft represented its more ephemeral characteristics.

The Crystal Palace by 1900: the imperatives of commerce

For the directors of the Crystal Palace, the appeal of artists like Hiles and Beecroft lay in the need to maximise visitor attendance in a period of difficult trading conditions. Towards the end of the nineteenth century the Crystal Palace Company entered a period of financial uncertainty. Declared insolvent in 1877 but bailed out by a parliamentary bill that raised further capital, the Palace had, however, experienced its first loss by 1899.[7] Its involvement, for example, in the development of villa housing in the Crystal Palace Park that began in the 1870s was an ambitious project that eventually compromised the company's balance sheet. This was an ill-judged venture as such domestic housing was already considered too large for average middle-class households and the villas became difficult to lease.[8]

In spite of its underlying financial concerns, the Crystal Palace remained a popular suburban destination and appears to have been well served by its general manager, Henry Gillman. The *Sketch* newspaper described him as 'astute and devoted' and credited him with playing a trump card when he secured the services of successful military commander Earl Roberts to open the Naval and Military Exhibition in May 1901. The *Sketch* praised Gillman's commercial acumen, noting that, 'His experience teaches him what is most likely to draw the public in their thousands, and his judgement may be relied upon to frame the programme of amusements calculated to be most attractive.'[9] The comments suggest that Gillman's commercial expertise and his abilities extended to both grand, national events and day-to-day entertainments and amusements. It is likely therefore that endeavours such as those of Hiles and Beecroft at the Crystal Palace were a welcome addition to the variety of commercialised visitor attractions that its management hoped would contribute to its future financial viability.

The daily programmes produced by the Crystal Palace are rare survivors of this period, and sit tangentially to the grand narratives of the official guides with their emphasis on art embodying both moral purpose and educational pursuit. Produced on cheap paper, usually on a Thursday of each week, they detail the diverse attractions on offer to the visitor in addition to the Fine Arts Courts. Evidence from a surviving daily programme of 1898 suggests that these were functional with the front cover relieved only by a black and white photograph of the Crystal Palace produced by Negretti and Zambra as official photographers to the Crystal Palace Company.[10] Announcing the contents as containing 'all the arrangements of the day', the front cover also included inexpensive,

text-only advertisements for 'Epps's Cocoa' and 'Kops Ale and Stout', which could be obtained in the Crystal Palace bars.

By 1902, however, the daily programme was an eye-catching and colourful example of modern chromolithographic printing technologies (figure 4.1).[11] The programme still consisted of twelve pages and remained the same size but there were substantial changes to its visual impact. Advertising on the front cover was no longer included as the Crystal

4.1 Crystal Palace Programme, Thursday, 18 September 1902.
Author's collection.

Palace management sought a more modern and professional approach to promoting the attractions of its venue. The functional but dull photograph of the Palace by Negretti and Zambra has been replaced by an artist-drawn image of an attractive young woman with a specific gendered appeal to the female, middle-class visitor. The Crystal Palace management was self-consciously shifting its target audience in this period by focusing on those with the leisure and disposable income to spend on shopping and entertainment. The image of the young woman in a smart, colourful pink outfit edged with grey, her gloved hand clutching a fan is placed centrally, while the Palace building and exotic gardens in the background is key to the suggestion that the Crystal Palace at Sydenham was a fashionable destination for those patrons with a keen sense of what modernity had to offer.

Reasonably priced at twopence, the 1902 programme lists the exhibitions and attractions available on the day and helps to locate both Hiles and Beecroft in the cultural milieu of the Palace. Both artists were situated in the South Nave where the 'exhibitions and attractions' for 18 September 1902 included the 'Natural History Tableaux and Jungle', 'Distorting Mirrors' in the Caricature Salon and the 'Royal Exhibition of Working Ants' in the Clock Gallery. 'Biograph Entertainment' in the Music Court of the South Nave together with 'The Coronation Procession' in animated pictures in its Electric Theatre demonstrated the new technologies of early film. The day's organ recital featuring music by Verdi and Wagner and a variety of military bands playing at different locations around the Palace Gardens, signified the multiple attractions and experiences on offer to its visitors.

As a space of cross-class intermingling, the Palace became, by 1900, many things to many people as the visual spectacle of classical statuary and decorative courts was juxtaposed with increasingly commercialised ventures in a period characterised by less stratified forms of popular entertainment. Despite the specific appeal of the fashionable image of the young woman on the cover of the 1902 daily programme, what was on offer once inside the Crystal Palace was underpinned by more complex responses to popular and élite culture. As Peter Bailey has observed of the Victorian city, the constituency for popular culture fluctuates and recomposes in this period resembling a 'sprawling hybrid' that is not co-terminal with any one class.[12] Instead, forms of popular culture draw their characteristics (as at the Crystal Palace) from both custom and ritual, and from the newer and slicker forms of mass and middle-brow commerce while readily appropriating élite culture. Organised around the impact of visual display, its attractions relied on scopic regimes that mirrored what Tom

Gunning, in his analysis of the interactions between audience and early film, describes as 'the chaotic curiosity shop of early modern life'.[13] Given this context, the role of art at the Crystal Palace was variously experienced by its audiences and consumers as a lesson in art and sculpture from the classical period to the present day, and also as part of the commodified leisure pursuits offered by Hiles and Beecroft.

Performing the armless artist

Bartram Hiles may well have responded to the Crystal Palace Company's self-conscious promotion of commerce, but his reasons for opening a studio in the South Nave in late 1900 were also predicated on a more complex reading of the market for art at the beginning of the twentieth century. Having completed his training at the National Art Training School, Hiles spent a brief period studying art in Paris and on his return exhibited his watercolour drawings at Frost and Reed's gallery in Bristol in December 1893. Despite the success of this exhibition, Hiles judged that his future lay in London, and the opportunities it offered to maintain a career in art and design while he worked towards his ultimate objective of concentrating on landscape painting. A demanding economic climate from the later 1880s, however, had adversely affected the sale of paintings.[14] At the same time, the fashionability of art as a career created an excess of supply over demand for artists and their works.[15] In 1894, the art critic Marion Spielmann had nervously noted a colleague's observation that there were now approaching 1,700,000 people who called themselves 'art students'.[16] Moreover, Spielmann's informant also remarked on the competition from photography, which was able to reproduce paintings to such a high standard that he had believed they were true watercolours.

Given these pressures of a changing and fluid art market, Hiles faced fierce competition from many painters who displayed similar works in the crowded professional societies and commercially led exhibition spaces in London as artists sought representation outside the Royal Academy. For this reason, by the late nineteenth and early twentieth centuries artists began to seek innovative ways of exhibiting their work in order to maximise their earnings and gain recognition as competition intensified.[17] Hiles pushed boundaries that were already being re-drawn by the growth of the commercial gallery in the later nineteenth century by electing to open a studio at the Crystal Palace. Knowledge of how and where art was being exhibited and viewed outside more formal institutions such as the Royal Academy in this period is scattered.[18] New exhibition spaces came to include artists' studios and department and furnishing stores, dem-

onstrating the flexibility with which art was not only exhibited, but also offered for sale as commodity rather than for aesthetic value. Given these conditions, Hiles had experienced a varied career during the 1890s as an independent art worker selling his wallpaper and frieze designs where he could, producing illustrations for the periodical press and exhibiting work at the Dudley Gallery Art Society. In a move which he would thus have seen as part of the contingencies of an artistic career in progress, the Crystal Palace offered a commercial opportunity which Hiles took to sell his artworks and designs and to maintain public visibility by encouraging personal visitors to his studio through advertisements in the medium of the periodical press.

From the outset of his career, Hiles's unconventional method of painting by mouth had excited the interest of journalism while the artist himself had become adept at inviting and creating press attention. Being associated with the Crystal Palace was always newsworthy and Hiles was careful to ensure that publicity was encouraged. It is clear from a reference in the popular magazine, *Truth*, that its journalist had been informed of Hiles's new venture by the committee responsible for hanging art works at the Crystal Palace. *Truth* had been made aware that, despite being painted by mouth, Hiles's achievements 'surpass in quiet earnestness and noble perseverance the feats of any of his predecessors'.[19] The Palace's publicity machine was clearly in contact with the press to assist Hiles's professional visibility and the art critic, Marion Spielmann, who had already taken an interest in his career, gave his personal endorsement. In a brief paragraph in his well-known 'Artistic Causerie' column in the *Graphic* newspaper, Spielmann wished Hiles well with his new enterprise at the Crystal Palace.[20] Similarly, the *Sphere* magazine featured a drawing of Hiles painting by mouth in his studio at the Palace, together with a short textual description that gave aspiring visitors a brief biography. It also furnished the essential information of where and when to locate him, announcing that 'Mr Hiles may be seen daily at work in his studio of the South Nave of the Crystal Palace'.[21]

It is, however, an article in the *Morning Leader* which provides an insight into what Hiles's studio space at the Crystal Palace offered the visitor. Introducing him as 'An Artist of the Lips', the article is bordered by examples of his black and white illustrations (figure. 4.2). The opening paragraph describes the potential for a personal encounter with the artist in intimate, aesthetic surroundings:

> Fireworks and fancy jewellery seem, in the popular mind, to be more closely associated with the Crystal Palace than Art with a Big A: yet just

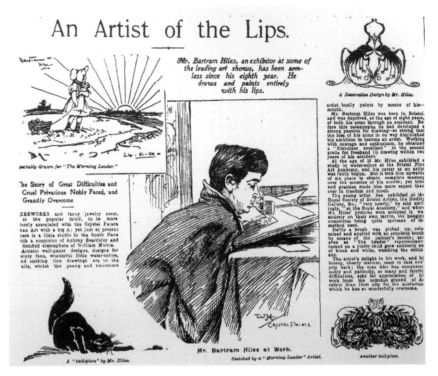

An Artist of the Lips.

Mr. Bartram Hiles, an exhibitor at some of the leading art shows, has been armless since his eighth year. He draws and paints entirely with his lips.

A Decorative Design by Mr. Hiles.

specially drawn for "The Morning Leader."

The Story of Great Difficulties and Cruel Privations Nobly Faced, and Grandly Overcome

FIREWORKS and fancy jewelry seem, in the popular mind, to be more lovely associated with the Crystal Palace than Art with a big A; yet just at present there is a little studio in the South Nave with a suspicion of Aubrey Beardsley and decided atmosphere of William Morris. Artistic wall-paper designs, designs for dainty fans, wonderful little water-colours, and striking line drawings are on the walls, whilst the young and handsome

artist busily paints by means of his mouth.

Mr. Bartram Hiles was born in Bristol, and was deprived, at the age of eight years, of both his arms through an accident. Before this catastrophe he had developed a strong passion for drawing—so strong that this loss of his arms in no way diminished his ambition to become an artist. Working with courage and enthusiasm, he obtained a "first-class excellent" in the second grade for freehand (!) drawing within two years of his accident.

At the age of 18 Mr. Hiles exhibited a study in water-colors at the Bristol Fine Art Academy, and his career as an artist was fairly begun. But it took him upwards of six years to obtain complete mastery over the muscles of his mouth; yet time and practice made him more expert than ever in freedom and touch.

The young artist has exhibited at the Royal Society of Bristol Artists, the Dudley Gallery, &c., "very nearly," he said smilingly, "at the Royal Academy," and when Mr. Hiles' pictures were accepted it was entirely on their own merits, the hanging committee being quite ignorant of the method used.

Deftly a brush was picked up, colour mixed and applied with an exquisite touch by means of the painter's mouth; and even as "The Leader" representative looked on a rustic child grew suddenly out of black and white, watching the setting sun.

The artist's delight in his work, and his breezy, cheery manner, seem to cast one pity back; the man who has conquered nobly and patiently, so many and terrible difficulties, asks for appreciation of his work from the common ground of Art rather than from pity for the misfortune which he has so wonderfully overcome.

A "tail-piece" by Mr. Hiles. Mr. Bartram Hiles at Work. *Sketched by a "Morning Leader" Artist.* *Another tail-piece.*

4.2 'An Artist of the Lips', *Morning Leader*, 27 November 1900, p. 5. © The British Library Board.

at present there is a little studio in the South Nave with a suspicion of Aubrey Beardsley and a decided atmosphere of William Morris. Artistic wall-paper designs, designs for dainty fans, wonderful little watercolours, and striking line drawings are on the walls, whilst the young and handsome artist busily paints by means of his mouth.

In promoting Hiles's work as 'Art with a Big A', the *Morning Leader*'s journalist clearly favoured the artist's work as associated with fine art, and as distinct from the more commercial aspects of the Palace. Hiles was certainly a talented and professional artist and designer who had done well as a national scholar at South Kensington despite his novel method of producing artworks. Always keen to be in control of his public image, he had worked hard to create an artistic space in the intimate surroundings of his studio that suggested genuine artistic merit. Enclosed in the South Nave of the Crystal Palace among so many sights of spectacle and entertainment, however, suggests that Hiles's unconventional method of producing his artworks could be received ambivalently by a wider audience; a fine line

between curiosity and artistic legitimacy which underpinned much of his working life.

As an illustrated article, the *Morning Leader*'s feature on Hiles was lively, eye-catching, popular journalism at its best. Its use of black and white illustration, not only of Hiles's own work, but also of the striking pen and ink image of the artist himself, marked it out as among the most innovative and contemporary forms of modern hand-drawn illustration. Unlike photography, which was serial, anonymous and reproduced in the new half-tone photomechanical processes of the 1890s, pen and ink images were reproduced by a line process. The lines of the text are congruent with the lines of the drawing. This was a graphical technique that suggested the illustrator's ability to communicate directly with the reader.[22] The author of the pen and ink drawing was acknowledged by his initials 'W.H.' (William Hartley), and together with the recording of its place of execution as the Crystal Palace, promoted the actuality and immediacy of the image. As an exercise in furthering interest in Hiles's work, using one artist to depict another in a signed original image was a clever graphical device. It suggested that the *Morning Leader*'s response to such newsworthy items was both timely and sincere since it did not rely on the photographs of Hiles already in circulation by this time.[23]

While the article was not featured in the *Leader*'s arts section and indeed drew on Hiles as the source of a popular human interest narrative, there was as much emphasis on the quality and range of his black and white drawings and watercolours as on his appearance. Caught up in the actuality of the journalism of the *Morning Leader*, the Crystal Palace itself also emerges as a feature of contemporary print culture which promoted it as a modern space where visitors could meet and interact with its resident celebrities in person.

Hiles re-worked the possibilities for the Crystal Palace as a site of consumption, and his artworks as part of a modern retailing experience. In contrast to the vast space of the Crystal Palace and its massive exhibits, Hiles's studio offers the opportunity for perusal of both the artist and his art in small and intimate surroundings. Working in his studio, Hiles is woven into this visual experience since both he and his art are exhibits; painting by mouth, predicated on Hiles's physical difference, was the source of a performance and a theatre of the self which was available for public consumption. Draped in a cloak to protect his clothing while painting, Hiles's physical difference is masked, concentrating the viewer's eye on the physicality of his mouth-painting technique. Hiles performs for his patrons and presumably produced works on the spot if requested, affording visitors the opportunity to gaze closely on the artist at work. The

Leader's enthusiastic text reflects the fascination that late Victorian audiences felt for the bodily adaptability inherent in Hiles's method of painting by mouth. With an almost cinematic sense of the visual the journalist notes: 'Deftly a brush was picked up, colour mixed and applied with an exquisite touch, by means of the painter's mouth; and even as the *Leader* representative looked on a rustic child grew suddenly out of black and white, watching the setting sun.' The blurred boundaries of illusionary theatrical space and serious artistic endeavour are thus negotiated in the wider drama of the South Nave and all that it had to offer in feeding the appetite for novelty and spectacle.

Artists such as Hiles who sought to exhibit independently without representation by dealers or the support of professional societies had to rely on techniques of self-promotion and on the identification and availability of commercial spaces. In this sense the Crystal Palace operated as an ideal suburban location for an artist without a dealer; well served in this period by train and tram services. Knight, Frank and Rutley's 1911 sale catalogue for the Crystal Palace emphasises its role as commercial shopping mall in its description of the interior spatial textures that support the consumption of its products and exhibits:

> Here at all seasons under a lofty glittering roof unconscious of fog, or rain or wind, the visitor may saunter pleasantly through many shops filled with artistic, useful, and ornamental productions. There is no obligation to purchase because one comes to inspect. Most things that minister to human wants are to be found … not only for the casual visitor who buys because he encounters some beautiful or desirable object haphazard.[24]

The 1902 daily programme (figure 4.1) lists among the attractions it promotes 'The Crystal Palace Arcade' situated in the Clock Gallery of the South Nave, describing it as 'the most attractive Fancy Fair in London'.[25] From both these descriptions, it is clear that the management of the Crystal Palace was keen to promote it as a shopping venue both as an alternative to, and in competition with, developments in the West End of London that were being shaped by a largely female consumer culture. The Crystal Palace as it appears here can be put into productive dialogue with Walter Benjamin's descriptions of Parisian arcades of the early nineteenth century. In Benjamin's arcades, the attractions of diverse commodities turn shopping into an aesthetic event, creating new modes of behaviour such as distraction, the display of the self and the seductive possibilities of the commodity.[26] Benjamin's particular fascination is with the arcade as a world in miniature and the range of diverse small objects on view within them.[27]

Working on small pieces of art had many practical advantages for

Hiles, enabling him to produce several pieces in a short space of time. The *Morning Leader*'s article suggests that he produced his works following the fashion for pen and ink drawings, the aesthetic painted fan and small watercolours, linking his studio space to the commercial shopping for goods and the production of art. The miniature artworks he produced, however, could offer more than mere buying and selling. As Susan Stewart observes in her meditation on the psychological process of 'longing', the objectification of desire has two particular devices in the form of the souvenir and the collection. Of these it is the souvenir that serves to meet the insatiable demands of nostalgia linking it to a desire to possess a memory of a time and a place. In this sense Hiles's small artworks provided his clients with a memory of their encounter with the artist in the private space of his studio, and perhaps also of their visit to the Palace.[28] The complex pleasures associated with shopping bring with it the opportunity for the visual enjoyment of looking and browsing, an activity that locates it as a particularly contemporary, though feminised, form of urban enjoyment.[29] The use of glass and electricity had meanwhile altered the social universe of mass consumption, investing everyday life with glittering and fabulous qualities.[30] Details of Hiles's clients were not recorded but the descriptions of the studio and works on view suggest a feminised domestic space attractive to a female patronage especially in its use of adjectives such as 'dainty' and 'exquisite'. With the *Leader*'s description of his handsome features and his youth, the chance to meet the artist and possess one of Hiles's small artworks suggests its allure for the female shopper.

In encompassing the processes of gazing and looking, cultures of promenading and shopping overlapped with other complex cultural positionings at work across the nineteenth century by those involved in the formation of spectacle and consumption. Bodily deformity, for example, fascinated many Victorians as freak shows and side shows became highly popular forms of entertainment both in London and the provinces. Involving audiences as observers in the visual display of almost any form of physical anomaly, such shows also exhibited non-European peoples as examples of bodily difference and otherness, both for profit and/or educational purposes.[31] This sustained interest in ethnography and bodily display across the nineteenth century formed part of the cultural legacy of the Crystal Palace itself and occurred in the ambivalent context of science, race and empire.[32] The Palace had included ethnographic displays featuring models of non-European peoples from 1854 in its Courts of Natural History, managed by Robert Latham as the director of its new Ethnological Department.

The exhibition of native peoples took the form of realistic models but

stopped short of exhibiting human life at this point. By the later nineteenth
century, the Crystal Palace had housed several small colonial exhibitions
and established the Australasian Museum in 1873/74.[33] In 1895 the Africa
Exhibition at the Crystal Palace had included live performances by native
Africans from Somalia, headlined by the *Daily News* as 'The Sydenham
Somalis'.[34] The displays of foreign peoples at the Palace were designed to
demonstrate human and racial difference, inviting audiences to become
involved in visual narratives of otherness. The Crystal Palace thus created
a space for the exercise of the ethnographic gaze – the cultural practice
of observing racial difference in the context of the colonial exhibition and
display. While visitors to Hiles's studio certainly gazed and looked upon
human difference, its cultural trajectory was, however, underwritten by
narratives of modern celebrity culture bolstered and shaped by the 'new
journalism' of the late nineteenth century. Hiles worked hard at develop-
ing his public persona and used journalism to deflect interest in his dis-
ability, promoting himself instead as an urban figure of modern celebrity
in which an altered physical state was a positive and powerful force.

Journalism of this period was characterised by an interest in the per-
sonal lives of well-known men and women as part of the process by which
celebrity came to stand for individual achievement and the development
of selfhood.[35] As a new practice imported from America in the 1880s,
and notably associated with the then editor of the *Pall Mall Gazette*, W. T.
Stead, it was the mechanism of the personal interview that helped reveal
the celebrity figure to the readership of the periodical press. Hiles's story
of the effects of accident and trauma, and evidence of his skill in managing
his disability made him a ready subject for an enthusiastic audience who
wanted to know more about the artist who had a studio at the Crystal
Palace.

The Palace's own in-house magazine, begun in 1900, enthusiastically
drew on this format which, though it could be difficult for interviewees,
was popular with the reading public. The *Crystal Palace Magazine* was edited
by Austin Fryers, the pseudonym of William Edward Clery, a journalist,
author and dramatist who was also active in the trade union movement.[36]
Hiles was interviewed for the magazine in January 1901, to which Fryers
devoted some two pages of illustrated copy. Adopting the intimate style
of 'new journalism', the interview was entitled 'A Chat with Mr Bartram
Hiles' for which the artist obligingly produced a self-portrait which has
proved to be a good likeness (figure 4.3).[37] Despite his disability, Hiles was
young and physically attractive as several newspapers were keen to point
out. Practised at the process of interview by this stage, he used its format to
recount the story of his loss of arms and his subsequent mastery of drawing

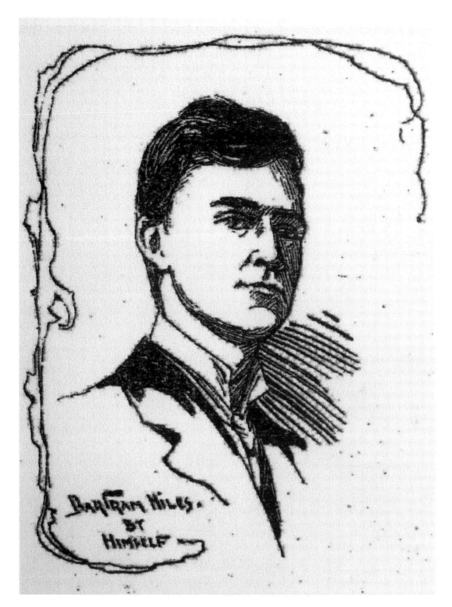

4.3 Self-portrait of Bartram Hiles, *Crystal Palace Magazine*, January 1901, p. 101.
© The British Library Board (P.P. 6018.fg).

and painting by mouth. As a form of self-advertisement for his art, Hiles produced examples for the magazine's readership of the work that visitors could purchase in his studio, which had a strong emphasis on an appeal to children (figure 4.4). The article also included examples of his decorative

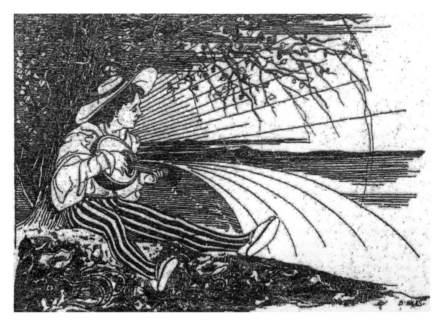

4.4 Untitled black and white illustration by Bartram Hiles, *Crystal Palace Magazine*, January 1901, p. 102. © The British Library Board (P.P. 6018.fg).

designs for wallpaper which demonstrated his dexterity and his ability to master the complex pattern repeats of late nineteenth-century design.

The format of the interview, interspersed with descriptive text but also direct quotations, enabled readers, as potential visitors to Hiles's studio, to become acquainted with his story of courage and heroism. The magazine contained snippets of information about the exhibitions and entertainments currently available but also served to promote those like Hiles who worked at the Palace as their own in-house celebrities. Newspaper journalism of this period was characterised by this sense of 'knowingness' which underpinned the intimate focus of Hiles's interview with Austin Fryers. 'Knowingness' was the sense attributed to readers of the press of a communal and pleasurable assembling of fragmentary information in order to feel that they knew what was happening.[38] In this way, readers picked up fragments of Hiles's story and became acquainted with the young boy who had lost his arms and who had grown into the handsome artist whose works they could now buy. The interview in the *Crystal Palace Magazine* was part of the commodity culture of the period which was designed to encourage visitors to his studio and, in so doing, to become involved in the story of the armless artist who painted by mouth. Disability was presented in an acceptable setting and painting by mouth as a fascinating process in

a deliberate staging of artist and his art. In this way, Hiles had used the Crystal Palace's news and publicity machine to present his studio space not as the site for the ethnographical gaze of difference and otherness, or freakish bodily anomaly, but as the location of an intimate, artistic experience which represented a chance to meet the artist as celebrity. The publicity photograph of Hiles in circulation at this time pictured him at work at his easel, brush in mouth and was signed by the artist.[39] Anyone visiting his studio at the Crystal Palace and purchasing an artwork would surely have left with a signed photograph of 'the armless artist'.

Qik: the lightning cartoonist

In 1901 Hiles was interviewed for the *Golden Penny* magazine in his studio at the Crystal Palace.[40] The article was accompanied by a line drawing of Hiles by Herbert Beecroft whose studio was also located in the South Nave of the Palace and it is reasonable to assume that this is where the two artists met. Beecroft's quick sketch is typical of the work that he undertook at the Crystal Palace despite his formal training as a lithographer and book illustrator. The daily programme for 18 September 1902 (figure 4.1) locates him in the Red Studio of the South Nave. Styling himself as 'Qik: the lightning cartoonist', Beecroft was installed in what he referred to as 'rooms' at the Crystal Palace, that also included a studio. An interview with a journalist from the *New Penny Magazine* in 1902 gives an insight into the studio space which Beecroft used at the Palace.[41] Beecroft kept his 'properties' in the Music Court of the South Nave, and these included busts of famous people required for his cartoons. His wife, Dulcie, painted flower panels in oils in the Music Court, while Beecroft's adjacent studio was a separate space with a sitting room at the rear; hence his advertising refers to having 'rooms at the Crystal Palace'.

There is no surviving visual record of Hiles's and Beecroft's studios at the Crystal Palace. Hiles may have had the use of a studio in Beecroft's suite of rooms but they certainly worked in close proximity in the South Nave.[42] Given the flexibility required to house its changing exhibits, the construction of Beecroft's 'rooms' was well suited to the original vision for the Crystal Palace building as an adaptable and modern space that could cater for frequent changes of use.

Beecroft's other promotional material from this period shows that his work consisted of cartoon and caricature presented in the form of a lecture with 'recitals, remarks and short stories' (figure 4.5). As a lightning cartoon-ist, he specialised in producing caricatures of famous names from litera-ture at speed, such as the Dickensian characters, Mr Pecksniff and Smike,

Coloured . .

Sketching Lectures & Entertainments

. . BY . .

HERBERT BEECROFT,

OF THE CRYSTAL PALACE, LONDON. - -

❊ ❊ ❊ ❊

THE SKETCHES . .

are rapidly made in colours in
full view of the audience,
interspersed with recitals, remarks,
and short stories.

❊ ❊ ❊ ❊

*Particulars as to Dates and Terms
on application.*

Postal Address :—

Herbert Beecroft . . 61, Whiteley Road,
 Upper Norwood, London, S.E.

 or South Nave Studio, Crystal Palace,
 London, S.E.

4.5 Programme Cover for one of Herbert Beecroft's 'Sketching Lectures and
Entertainments'. Courtesy of the Randwick and District Historical Society,
NSW.

often producing his portraits upside down to heighten the entertainment
for audiences. Drawing on both the format of Charles Dickens's touring
lectures of the mid-Victorian period and the lightning cartoon as a well-
known theatrical act during the 1890s, Beecroft mixed popular art forms
with pure entertainment 'in full view of the audience' as his promotional
literature boasted. Known photographs of him always picture him in

white tie and tails as if he were continually dressed for an evening theatrical performance. With an alarming head of hair, which appeared to stand upright, Beecroft seems to become almost one of his own caricatures. The small portraiture from life that he produced and sold at the Crystal Palace, on which he spent approximately ten minutes per picture, had naturally grown out of his lightning cartoon work which he practised at venues around Sydenham. The portraits were distinguished by their use of a type of coloured crayon which Beecroft had developed using his own method of production.[43] The illustrations which accompanied his interview for the *New Penny Magazine* demonstrate the development of a caricature captured at intervals during the ten minutes and showed the importance of timing as a crucial element in his interaction with his audience. Timed to perfection, it was clearly a highly theatrical experience for both artist and sitter.

As a caricaturist, Beecroft's depiction of the human form was derived from his interest in the proportions of the face which indicate human type, and in its lines as indicators of character. As he confirmed to the journalist of the *New Penny Magazine* in 1902, elderly subjects were the easiest to draw as the deeply cut and unmistakable lines of the face were the most distinctive of a subject's character; or as he expressed it, 'the proportions of a face may indicate a type, but the lines indicate the character'.[44] Beecroft's artwork also drew its references from a particular style of journalism and print culture popular in the late nineteenth century. The use of the social caricature was a significant element of the popular press which concentrated on 'city types' – clerks, Jewish people, street musicians and hawkers – as the regular fodder for such journalistic attention. Captured in the caricatures of Phil May, for example, and known to *Punch* illustrators as 'socials', they reduced urban dwellers to typical characters in everyday situations. This journalistic style, which was often underpinned by the use of humour, is clearly referenced in Beecroft's drawings of the 'Local JP' and the 'Jack Tar' (figure 4.6).

Beecroft referred to his use of this art form as 'character in art' but his 'qik' caricatures correspond to wider cultural references at play in the nineteenth century. The interest in the analysis of 'surface sciences' such as handwriting, phrenology, craniology, physiognomy and anthropometry were regarded in this period by many as legitimate methods of revealing human physical characteristics and thus human character. The Palace portrait gallery, explored by Jason Edwards in Chapter 3, employed several of these surface sciences in its exhibition of historical characters. Such processes paralleled the huge cultural interest in mapping, collecting, measuring and classifying the natural world, exemplified by the Crystal Palace itself. Significantly, these included native peoples from a range of

THE LOCAL J. P. A JACK TAR.

4.6 'Lightning' sketches by Herbert Beecroft, 'Qik, The Lightning Colour Cartoonist', *New Penny Magazine*, 1902, p. 278. Author's collection.

colonised cultures as ethnographic exhibits who appeared in the exhibitions and world fairs of the nineteenth and early twentieth centuries; as discussed, the Sydenham Palace included ethnographic displays as part of its intertwined educational and entertaining mission.

The exotic staging of racial difference helped the Palace's visitors to imagine the colonial experience and did so by creating visual narratives that relied on the opportunity to look and to gaze. The ethnological tableaux were a regular, if not permanent, attraction for visitors to the Crystal Palace by the end of the nineteenth century.[45] As Beecroft astutely noted, the unique feature about the Crystal Palace was that it provided further opportunities for observing humanity because of its attraction to a cosmopolitan audience. Open seven days a week, the Palace provided a continual venue to observe its many visitors of different races and nationalities, a feature of the Palace which Kate Nichols also explores in Chapter 5. Beecroft bluntly acknowledged in his interview in 1902 that sketching in the Crystal Palace had 'afforded unbounded opportunities for studying different races and types. I get all nationalities in this studio. You would be surprised. African, Austrian, Canadian, Indian, Japanese, Maltese, Norwegian, Russian, Tasmanian and Turkish subjects call in for a ten-

minutes' portrait.'[46] Beecroft's rationale for producing his artworks clearly linked the Crystal Palace at the end of the nineteenth century to multiple practices of viewing.

Transient lives

Analysing the contributions of two artists at the Crystal Palace *c.*1900 tells us much about its cultural and commercial life at this time. Presented as part of the dual nature of the Palace's attractions, Hiles and Beecroft represent the more commodified and popular forms of art of the period. Working in their studios in the South Nave within the displays of architecture, design and classical statuary, their artistic output contested the Palace's pretentions to provide an education in fine art with a high moral purpose for its mass audience.

As two artists brought together in the early years of the twentieth century, their artistic output demonstrates the interplay of audience, performance and spectacle in the unique setting of the Crystal Palace. The conditions in which their art was produced included the requirement for both of them to perform. Their method of interacting with their audiences perhaps paralleled the experiences of early film production and provides us with a framework of understanding. Tom Gunning notes in 'Cinema of Attraction' that audiences and spectatorship were the centralising focus of new cinematic technology from 1893 to 1906.[47] Early forms of film presentation stimulated audiences to engage with their purely exhibitionary aspects, a cinema based on spectacle, shock and sensation, by directly interacting the viewers with the images they saw. More recently, Jonathan Auerbach has recalibrated this idea, arguing instead that the human body forms a central organising principle because of its very lack of narrative and plot on which the model of the 'Cinema of Attraction' largely relies.[48] The visual logic of this theory of the interaction of audience and spectatorship is therefore less about who is looking than what is being looked at.

The Crystal Palace was an ideal location for the multiple practices of viewing that encompassed looking, browsing, glancing, gazing and observing. In the case of Hiles, the intimate nature of his studio and the masking of his body in the folds of his cape invited audiences to concentrate on the technique of painting by mouth as a bodily performance. Hiles had employed the cultural trope of difference and otherness suggested by ethnographic tableaux and the freak shows of the nineteenth century, and re-worked it into a form of modern celebrity and theatre of the self. Unlike formal portraiture, Beecroft's 'qik' sketches and caricatures were delivered with verbal commentary and animated bodily movements as he worked at

lightning speed to complete his drawings in ten minutes. In this way, both artists placed embodied practice at the centre of their art at the Crystal Palace. Observation of the human figure in motion thus became a key part of the attraction for their audiences, in contrast with the static displays of the art of antiquity in the North Nave.

The role of popular journalism in shaping the artistic careers of both Hiles and Beecroft while at the Crystal Palace is also a key part of understanding their lives as artists in the early years of the twentieth century. Both capitalised on the huge public interest in artists in this period in both formal biography, and as captured in the periodical press.[49] Hiles's brief period at the Crystal Palace was noted in several newspapers and cleverly promoted in the Palace's own in-house publication, the *Crystal Palace Magazine*. It was, however, the article in the London-based *Morning Leader* (figure 4.2) which gave him, and the Crystal Palace, maximum public exposure. As such, it appears to have been a format whose combination of text and image was striking enough for the *Chicago Daily Tribune* to reproduce it almost exactly using its own drawing of Hiles based on the *Morning Leader*'s original image.[50] Beecroft's interview for the *New Penny Magazine* was part of the stable of inexpensive periodicals published by Cassell and Co. Drawing on the techniques of modern photo-journalism, it brought the work of 'Qik, the lightning cartoonist' to the attention of a mass audience who could also see him at work in the Crystal Palace.

For a brief period at the beginning of the twentieth century, both Hiles and Beecroft were part of a varied schematic offering of art and artistic practice at the Crystal Palace. While some workers, entertainers and artists remained at the Palace for several years, many, like Hiles and Beecroft, were as ephemeral as the advertising and journalism that described what they had to offer. Hiles was there for twelve months at most before he took up the next strand of his varied and commercially driven career, subsequently returning to Bristol in 1906 to dedicate himself to landscape painting. He eventually became a pillar of the artistic life of the provincial city, exhibiting his landscapes at the Royal Academy and the Royal West of England Academy. Beecroft and his wife, Dulcie, suddenly left for Australia in 1904, never to return.[51] It was here that Beecroft carved out a successful career for himself as an artist. Still influenced by the ethnographic gaze and his interest in the characteristics of different races, he produced accomplished and sensitive portraits in pastels, oil and watercolour of aboriginal people. By 1904 both Hiles and Beecroft were gone from the Crystal Palace, leaving behind its grand antiquities as at least an illusion of that other half of art that Baudelaire had identified in his definition of modernity – the eternal and the immutable.

Notes

1 J. R. Piggott, *Palace of the People: The Crystal Palace at Sydenham* (London: Hurst & Co., 2004), p. 37.

2 H. Gillman (ed.), *General Guide to Crystal Palace* (London: J. J. Keliher & Company, *c*.1900), p. 1.

3 The Crystal Palace School of Art, Science and Literature was established from 1859. It included instruction by lectures and classes; Piggott, *Palace of the People*, pp. 56–7. By the late nineteenth and early twentieth century, it operated as The Crystal Palace School of Art for Ladies, boasting new studios in the south wing and projecting in its advertising a modern formal art education for women. See A. C. R. Carter, *The Year's Art 1902* (London: Virtue & Co., 1902), pp. 146, 440. The Crystal Palace Art Union was operational by 1859 and was a response to this popular nineteenth-century method of providing art patronage, particularly from middle-class audiences. See, for example, 'Crystal Palace Art Union', *The Times* (10 January 1859), p. 8. Though little heard of towards the end of the nineteenth century, it was still in evidence by 1900; 'St George's Hall', *Standard* (5 February 1900), p. 6. The Crystal Palace Picture Gallery established in 1856 was one of several free permanent exhibitions available at the Palace. Typically, it consisted of an exhibition of 'Modern Oil and Watercolour Paintings by Eminent British and Foreign Artists', which were offered for sale, 'Crystal Palace Programme' (9 January 1896), not paginated, John Johnson Collection of Printed Ephemera, http:// johnjohnson.chadwyck.co.uk (accessed 2 April 2014).

4 The extent of this contribution to popular culture is exemplified by the work of John England, scenic artist, and his team of scenic painters at work in the Crystal Palace workshops in the late Victorian and Edwardian period. England worked, for example, on the design and scenic landscape for the Festival of Empire in 1911. England and his family also ran the Palace Theatre of Variety at the Crystal Palace which demanded extensive scenic art. 'John England, Crystal Palace Scenic Artist', *Crystal Palace Matters*, 52 (Spring 2009), 5–14.

5 C. Baudelaire, 'The Salon of 1846', in J. Mayne (ed.), *Art in Paris 1845–1862. Salons and other exhibitions reviewed by Charles Baudelaire*, trans. J. Mayne (London: Phaidon, 1965), pp. 116–20.

6 C. Baudelaire, 'The Painter of Modern Life', in J. Mayne (ed.), *The Painter of Modern Life and Other Essays*, trans. J. Mayne (London: Phaidon, 1964), pp. 12–15.

7 Piggott, *Palace of the People*, p. 173.

8 A. C. Kay, 'Villas, Values and the Crystal Palace Company, *c*.1852–1911', *London Journal*, 33:1 (2008), 21–39.

9 'The Crystal Palace Manager', *Sketch* (29 May 1901), p. 211. The *Sketch* recorded that Gillman had served the Crystal Palace for some twenty years. He died suddenly in December 1902 after a short illness but had already contributed

to the successful set-up of the first Automobile Show held at the Crystal Palace from 30 January to 7 February 1903.

10 Description based on an example from author's copy of a *Crystal Palace Programme* dated 'Good Friday, April 8th, 1898'. The programme measures 17 × 21 cm, or approximately A5 standard paper size. A further example from 1896 referenced in note 3 shows the same cover and printed layout suggesting there was little attempt to change the format until the introduction of colour around 1902.

11 It has not been possible to reproduce this image in colour.

12 P. Bailey, *Popular Culture and the Victorian City* (Cambridge: Cambridge University Press, 2003), pp. 10–11.

13 T. Gunning, 'Animated Pictures: Tales of Cinema's Forgotten Future', *Michigan Quarterly Review*, 34:4 (1995), 469.

14 Historians have rightly rejected depictions of the 'Great Depression' of 1873–96 as a permanent economic climate associated with falling prices. H. Perkin, *The Rise of Professional Society: England Since 1880*, 2nd edn (London: Routledge, 2002), pp. 37–8. Perkin, however, does concede there were particularly bad years, such as during 1892–95.

15 J. Codell, 'Artists' Professional Societies: Production, Consumption and Aesthetics', in B. Allen (ed.), *Towards a Modern Art World* (New Haven, CT: Yale University Press, 1995), p. 169.

16 'Art Notes and News', *Westminster Gazette* (21 February 1894), p. 3.

17 P. Fletcher and A. Helmreich (eds), *The Rise of the Modern Art Market in London: 1850 – 1939* (Manchester: Manchester University Press, 2011), pp. 7–9.

18 *Ibid.*, pp. 12–15.

19 'Art', *Truth* (27 December 1900), p. 1629. The reference to Hiles's 'predecessors' includes notably the armless artist, Sarah Biffen. Though she had died in 1850, journalists often referred to her when writing about Hiles, though the artist himself never made any such acknowledgements.

20 'An Artistic Causerie', *Graphic* (1 December 1900), p. 80.

21 'An Artist Who Paints With His Mouth', *Sphere* (16 March 1901), p. 280.

22 G. Beegan, *The Mass Image: A Social History of Photomechanical Reproduction in Victorian London* (Basingstoke: Palgrave Macmillan, 2008), p. 18.

23 The *Leader*'s use of black and white drawing by staff artists was a specialism of its editorial policy during this period. While many newspapers and periodicals were developing and favouring the use of photomechanical techniques, the *Morning Leader* utilised such hand-drawn and signed images. L. Hughes, 'Aestheticism on the Cheap: Decorative Art, Art Criticism, and Cheap Paper in the 1890s', in L. Brake and M. Demoor (eds), *The Lure of Illustration in the Nineteenth Century: Picture and Press* (Basingstoke: Palgrave Macmillan, 2009), p. 226.

24 *Crystal Palace, Sydenham. To be Sold by Auction* (London: Hudson & Kearns, 1911), p. 29.

25 *Crystal Palace Programme* (18 September 1902), author's collection.

26 E. Leslie, *Walter Benjamin: Critical Lives* (London: Reaktion Books, 2007), pp. 84–5.

27 W. Benjamin, *Arcades Project*, trans H. Eiland (Harvard, MA: Harvard University Press, 1999), p. 3.

28 S. Stewart, *On Longing: Narratives of the Miniature, the Gigantic, the Souvenir, the Collection* (New York: Duke University Press, 1993), p. 136. On souvenirs of the Crystal Palace, see also Hunt (Chapter 2) in this volume.

29 E. Rappaport, *Shopping for Pleasure: Women in the Making of London's West End* (Princeton, NJ: Princeton University Press, 2000), p. 5.

30 I. Armstrong, *Victorian Glassworlds: Glass Culture and the Imagination 1830–1880* (Oxford: Oxford University Press, 2008).

31 E. O'Connor, *Raw Material: Producing Pathology in Victorian Culture* (Durham and London: Duke University Press, 2000), pp. 148–52; see also B. Lindfors, 'Ethnological Show Business: Footlighting the Dark Continent', in R. G. Thomson (ed.), *Freakery, Cultural Spectacles of the Extraordinary Body* (New York: New York University Press, 1996), pp. 207–18.

32 S. Qureshi, *Peoples on Parade: Exhibitions, Empire, and Anthropology in Nineteenth-Century Britain* (Chicago: University of Chicago Press, 2011), pp. 193–221.

33 Piggott, *Palace of the People*, pp. 126–8; 174–5. See also, R. Corby, 'Ethnographic Showcases, 1870–1930', *Cultural Anthropology*, 8:3 (1993), 341. Corby notes that the Paris World Fair of 1878 was the first at which many people from non-Western cultures were exhibited. A troupe of Aborigines from Queensland did appear at the Crystal Palace in 1884 promoted by the showman, R. A. Cunningham, but took part in a concert at which they performed dance and boomerang throwing. See, 'Crystal Palace – Easter Monday Long Holiday Programme', *Daily News* (12 April 1884), p. 4; Cunningham's activities as showman in relation to this Aboriginal group are described in R. Poignant, *Professional Savages, Captive Lives and Western Spectacle* (New Haven, CT and London: Yale University Press, 2004).

34 'The Sydenham Somalis', *Daily News* (9 May 1895), p. 7.

35 C. Ponce de Leon, *Self-Exposure: Human Interest Journalism and the Emergence of Celebrity in America* (Chapel Hill, NC: University of North Carolina Press, 2002), p. 13.

36 The first issue appeared in October 1900. Only a short run of this magazine has survived and is held by the British Library. The copies run to June 1901.

37 'An Armless Artist: A Chat with Mr Bartram Hiles', *Crystal Palace Magazine* (January 1901), 101–2.

38 Beegan, *Mass Image*, pp. 21–2.

39 A. Roberts, 'Painting by Mouth: Art, Modernity and Disability, Bartram Hiles 1872–1927' (PhD dissertation, Falmouth University/University of the Arts London, 2013), pp. 220–4.

40 'An Armless Artist: An Interview with Mr Bartram Hiles', *Golden Penny* (19 January 1901), p. 48.

41 'Qik, The Lightning Colour Cartoonist', *New Penny Magazine* (1902), 276–9.

42 There is a suggestion of shared space in Hiles's interview with Austin Fryers. See, 'An Armless Artist', p. 102.

43 'Qik, The Lightning Colour Cartoonist', 277.

44 *Ibid.*, 276.

45 The Crystal Palace programme for 18 September 1902 (figure 4.1) includes 'Ethnological Tableaux' as a listed attraction in the North-East Gallery.

46 'Qik, The Lightning Colour Cartoonist', 276.

47 T. Gunning, 'The Cinema of Attraction: Early Film, its Spectator, and the Avant-Garde', in R. Stam and T. Miller (eds), *Film and Theory: An Anthology* (London: Blackwell, 2000), pp. 229–35.

48 J. Auerbach, *Body Shots: Early Cinema's Incarnations* (California: University of California Press, 2007), pp. 2–12.

49 J. Codell, *The Victorian Artist: Artists' Lifewritings in Britain, c.1870–1910* (Cambridge: Cambridge University Press, 2003).

50 'Artist Draws with his Lips', *Chicago Daily Tribune* (13 January 1901), p. 55.

51 E. Waugh, *Lawrence Herbert Beecroft: An Entertaining Artist* (Randwick: Randwick & District Historical Society, 1997), p. 10.

5

'[M]anly beauty and muscular strength': sculpture, sport and the nation at the Crystal Palace, 1854–1918

Kate Nichols

One of the most obvious surviving manifestations of the Crystal Palace today is so familiar (to a British audience at least) that, despite its name, its connection with the glass and iron building is easily overlooked. Crystal Palace Football Club was founded in 1905, and played in the Palace grounds until 1915, when it was forced to find a new home after the building and gardens were handed over to the Royal Naval training division, a subject to which I will return.

Football was just one of the astonishing variety of physical activities on offer to men and women at the Palace, from bowls to bodybuilding, ice skating to cycling, tightrope walking to motor racing. In a late nineteenth/ early twentieth-century society newly enamoured with both watching and participating in sports, the Palace hosted national and international rugby, wrestling, badminton and athletics meets, as well as short-lived sports fads like the American college game 'pushball'.[1] Sporting recreation physically occupied a significant amount of space in early twentieth-century Sydenham, and was marketed as a key attraction; the boating lake, football and polo pitch, cycle track and dancing terrace are proudly marked on figure 5.1, a plan of the Palace grounds from 1906. Today the Palace park continues to be a major hub for a similarly broad range of physical activity. As well as offering an open green space to scores of joggers, since 1964 it has housed the Crystal Palace National Sports Centre, a public leisure centre that also hosts international swimming, athletics and weightlifting competitions, offers an outdoor beach sports facility and, most importantly for an exploration of the legacy of the Crystal Palace venture, boasts that it is 'the spiritual home of British Athletics'.[2]

The 'manly beauty and muscular strength' of my title comes, however,

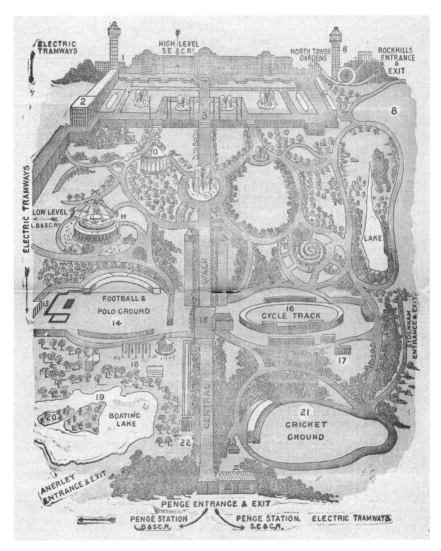

5.1 Plan of the Crystal Palace Park, from *Crystal Palace Programme*,
18 August 1906 © Bromley Local Studies and Archives.

not from a sporting review, but an 1850s guidebook describing the *Discobolos*
and *Fighting Gladiator* sculptures in the Greek Court; the *Venus de Milo* rep-
resented 'female grace and loveliness'. As I explore here, throughout the
Palace's life, these gendered visions of sculpture were related to the physical
potential of men and women.[3] This chapter connects the sporting history
that took place in the Palace grounds with the art historical and anthro-
pological lessons offered by the Fine Arts Courts and Natural History

Department in its glass interior. It contests a division between entertainment and education mapped respectively onto the outside and inside of the Palace, instead arguing that the Palace venture attempted to combine leisure and learning across its exhibits and attractions. The gardens thronged with sculpture, and sporting activity was not just limited to the grounds; throughout June 1861, a total of 1.8 million people watched the French acrobat Blondin walk a tightrope (blindfolded) strung across the central transept; by 1905 an asphalt roller skating rink and the headquarters of the national skating association could be found in the north nave alongside the Fine Arts Courts, while the central transept hosted gymnastics, 'an exhibition of the American game of net ball by ladies', and wrestling.[4]

It is not the physical proximity between exercise and sculpture that interests me, so much as the ways in which the Sydenham site – with its new mass audience and unprecedented spread of sculpture and sports facilities – relates to early twentieth-century British discussions and observations of the human body. This chapter builds on recent research on the intersections between sport and art histories to address the relationship between ancient artistic representation, and modern social ideas and ideals of bodily appearance and action.[5] It recovers three episodes in the physically active history of the Crystal Palace in the later nineteenth and early twentieth century; the Crystal Palace School of Physical Culture founded by entrepreneurial strongman Eugen Sandow in 1899, the 1911 Inter-Empire Games, and the occupation of the Palace by the Royal Naval training division from 1915 to 1919. It explores how contemporaries related the bodies of participants in these episodes to the sculpture in its Fine Arts Courts. It begins, however, by situating these moments in the context of ideas about the body, nation and empire manifested in the 1850s Fine Arts Courts, showing how the Greek and Roman courts in particular were received in changing ways across Victorian and Edwardian culture.

Exhibiting bodies, 1854–99

The Fine Arts Courts at the Crystal Palace assembled a vast array of plaster casts of sculpture from museum collections across Western Europe. It was one of the first exhibition spaces in Britain to display the unclothed human form to a truly mass audience, and occupies a significant position in the normalisation of the unclothed human body into a socially acceptable art form.[6] Before the Palace had even opened, protests over the nudity of sculpture in the Greek and Roman Courts rapidly brought these sculpted bodies to national attention – and kept them there throughout the century. During parliamentary discussions in August 1857 about the

definition of 'obscenity' for the Obscene Publications Bill, two different discussants refer to 'the memorable Crystal Palace controversy', which appears as an extreme example of artworks that the bill might deem obscene.[7] When anxieties arose in the 1880s about the public display of nudes in galleries, the 1854 disputes over the Palace sculptures were once again a point of reference.[8] The Palace debate became part of the Victorian vocabulary for examining ideas about public interactions with the naked human body as an art form. The case for their acceptability in the 1850s rested on the perceived aesthetic, moral and social benefits that Victorian people might accrue from looking at Greek sculpture.[9] In the later nineteenth century, as I explore through Sandow's School of Physical Culture, these purported benefits took on increased physical, racial, national and imperial valences.

However, Greek and Roman sculptures were not the only naked human bodies on show at Sydenham. From the Palace's inception in 1854, the Natural History Department in the south nave boasted models of bodies of extra-European, and, as the century wore on and the scramble for overseas territory gathered pace, increasingly colonised peoples, arranged in tableaux with taxidermied animals, and engaged in purportedly 'characteristic' activities.[10] These models – like the other sculptures in the Palace – were made from plaster, and many were life casts taken from resident exhibited peoples on the London show scene.[11] In art historical writing from the 1760s onwards, and ethnological writing of the 1840s–1860s, the bodies of Greek sculpture were regularly identified as accurately representing the bodies of ancient Greek people. As Debbie Challis has explored, Greek sculpture also regularly stood in for modern Europeans, particularly in ethnological comparison with African peoples.[12] In the Palace's opening years, contemporaries regularly compared the 'Greek bodies' on show in the Fine Arts Courts with the extra-European bodies on display in the Natural History Department. The ethnological models (and especially those of Southern African and Australasian peoples) were seen as representing early, less evolved humanity, while the apparently Greek bodies of classical sculpture represented human 'beauty' and 'perfection'.[13]

An 1854 engraving from the *Illustrated Crystal Palace Gazette* (figure 5.2), shows visitors of varying ethnicity looking intently at the unclothed bodies of sculpture in the Roman Court – but equally as keenly at each other. The contrasts (and sometimes the similarities) between the Palace's audience and the unclothed bodies of the Natural History Department models were similarly widely illustrated in satirical publications, and remarked upon in the press.[14] Middle-class writers and illustrators of the 1850s lauded the unprecedented international and cross-class mix of peoples

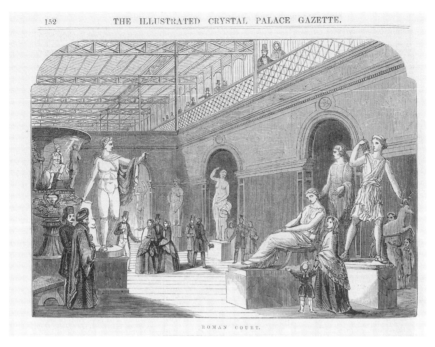

ROMAN COURT.

5.2 Visitors in the Roman Court, 1854. 'Roman Court, *Illustrated Crystal Palace Gazette* (1854), p. 152 © Victoria and Albert Museum, London.

that the Palace attracted, and its seemingly limitless capacity to house large numbers of visitors (newspapers reported over 100,000 on bank holidays). Commentators spilt as much ink on detailed observations of working-class visitors' movements, posture and clothing as on the astonishing array of objects that the Palace displayed.[15] By the 1860s, the Crystal Palace was well established as a site for looking at bodies, where in a few steps visitors might encounter sculpted Greeks and Romans, models of Aboriginal Australians, as well as other Londoners – or, as Lady Eastlake put it, 'multitudes of our fellow creatures, otherwise too seldom met by us except in some form that appeals to pity or censure'.[16]

As Ann Roberts explores in this volume (Chapter 4), by 1900 a new array of bodies were part of the spectacle at Sydenham, from disabled British painters to villages of Somalis. But, as Roberts suggests, it would be reductive to assume that these displayed peoples and/or performing artists entirely lacked agency over their representation. The 'Amazon warriors of Dahomey', female warriors from what is today the Republic of Bénin, were exhibited in 1893. They were certainly subject to a colonising, sexist, racist gaze – but were in some ways more physically liberated and

capable than their Victorian female spectators.[17] And as Saloni Mathur has argued, 'bodies on display have their own biographies, strategies, journeys and itineraries that refuse their containment as mere ethnic objects'.[18] Press comment unanimously celebrates – and reifies – the Dahomeyan womens' bodies and their physical strength; 'well formed, athletic and muscular', 'Tall, graceful, with a figure such as Phidias or Praxiteles need not have disdained to model'.[19]

By referring to the two most celebrated classical Greek sculptors, the press makes the Dahomeyan women's bodies transcend racial boundaries. In the late nineteenth century, the real ancient Greek bodies that many believed to be represented in ancient Greek sculpture were connected to European (and regularly British) biological heritage, ideas which were championed as much by artists and archaeologists as anthropologists.[20] But a physically strong body could in some instances make Greek (thus – to many Victorians – European, cultured, moral and beautiful) 'these dusky ladies who handled sword and musket with such dexterity'.[21] The healthy body had a new role to play in re-forming understandings of race, sculpture and 'Greekness'.

At the same time that disabled and black bodies became part of the show at Sydenham, the Palace became a site for the self-determined display of a variety of other newly sanctioned 'healthy' bodies, and often of middle-class British women. In 1894, orientalist painter Mrs Murray-Cookesley performed 12 'living pictures' to a large audience at the Palace, dressed variously as a vestal virgin, Andromeda, Cleopatra, and Circe. While the *Standard* noted the 'historic and classical interest' of Murray-Cookesley's show, the *Sketch* noted the challenges of maintaining 'Propriety' in an exhibit based around looking at a woman's body.[22] Such respectability had not, however, been a matter of concern when the Dahomey 'Amazons' were posing semi-naked in the park. Despite their apparent physical 'Greekness', the Dahomeyan women were nonetheless presented as bloodthirsty 'savages', existing outside of any norms of respectability. Figure 5.3 shows a drawing for the periodical the *Graphic* of 'A charming and graceful exhibition of skilful cycling', performed by women at the Palace in 1899. It safely transforms the bicycling, trouser-wearing, norm-defying feminist figure of the 1890s New Woman into a 'very pretty' display for Palace spectators.[23] But nonetheless these are women making an exhibition of themselves, occupying public space, and taking a most modern form of exercise.

From the outset, an array of commentators suggested that both the location and facilities provided by the Palace were a potential cure for an unhealthy urban population of 'sallow, narrow-chested Londoners, with

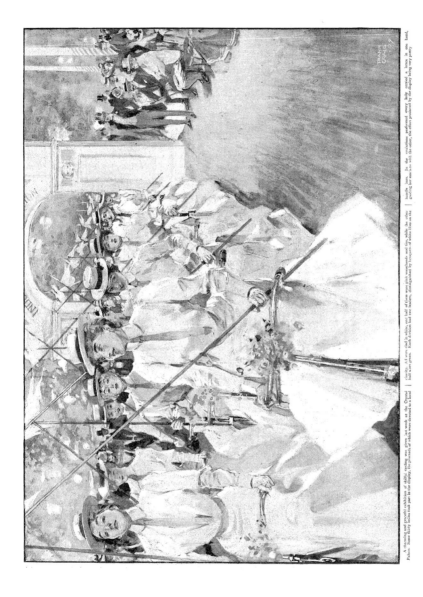

5.3 Frank Craig, 'A Novel Bicycle Display by Ladies at the Crystal Palace', *Graphic* (12 August 1899). p. 214. Author's collection.

small shrew faces'.[24] Medics believed that the Palace's hill-top site outside London provided the fresh air essential for recovering consumptives, while the large space that the glass building encompassed enabled exercise in all weathers. It was, moreover, the combination of physical and intellectual stimulation – exercise and sculpture – that made it a place particularly suitable for holistic wellbeing.[25] One 1870s report on the future of the Crystal Palace suggested that the physically and mentally stimulating resources of the Palace were essential to preserve 'the physical type of the robust, hardy Englishman'. It goes on to ask: 'if the race thus degenerates, what will be the ultimate fate of the nation?', characteristic of late Victorian fears about national and racial degeneration, and demonstrating how widely these anxieties permeated culture, seeping into reports on the future of leisure ventures.[26]

The Crystal Palace was established by the late nineteenth century as a place to encounter and compare healthy as well as deviant bodies, clothed and naked, living or cast in plaster, while its site purported to offer the means by which these healthy bodies might be emulated, and unhealthy bodies reformed. The bodies of British men and women came under ever closer national scrutiny in the early twentieth century. Debate about the apparent deterioration of the 'national physique' intensified after a large number of military recruits were rejected from serving during the 1899–1902 Boer War, resulting in the appointment of a government Interdepartmental Committee on Physical Deterioration, reporting in 1904. Physical culturists in Britain presented the reformation of the body and mind through exercise as a patriotic and imperial duty.[27] Sculpture became implicated in this new culture of the body, and in what follows, I examine how the plaster cast bodies at Sydenham figured in early twentieth-century visions of the 'national physique'.

Sandow's School of Physical Culture, 1899–1908

In November 1899, the 'father' of British physical culture, Eugen Sandow, opened a School of Physical Culture under the North Tower of the Crystal Palace (number 7 on figure 5.1). Sandow had opened his first school at 32a St James Street, Piccadilly, in the summer of 1897; its décor aped the opulence of the surrounding gentlemen's clubs, as did its hefty joining fees. Schools aimed at lower middle-class office workers soon opened in Victoria, Tottenham Court Road, and Walbrook in the City.[28] Crystal Palace was Sandow's first suburban school, and the advantages of the clean air and spacious grounds provided by its out of town location were celebrated and promoted as making the Palace School quite distinct

from the existing enterprises.[29] Suburbia also brought a new clientele. According to *Sandow's Magazine of Physical Culture*, it was a particularly welcoming environment for 'lady patrons', with an entire suite of rooms and separate classes for women. In addition, the Palace School offered holiday classes for children, which, apparently, were very popular with 'parents in the neighbourhood'.[30] This early gym had a social role in suburban Norwood – but Sandow's aims for physical culture were somewhat more grandiose than providing babysitting.

Sandow sets out his manifesto in the opening article of the first (1898) edition of *Sandow's Magazine*: 'Physical Culture: What is it?' Sporting activities, like cricket and football 'and every other form of manly sport' were part of physical culture, but 'Physical Culture is something wider in its scope and more lofty in its ideals!'[31] In all his interviews, Sandow stressed the intellectual side of physical culture; 'It is mental culture first, physical afterwards.'[32] According to Sandow, modern life – from modes of work to laws protecting the weak from the strong – had rendered the body irrelevant, and as such modern physiques were puny and underdeveloped. Physical culture sought to return the human body to centre stage, to 'undo the evil which civilisation has been responsible for, in making man regard his body lightly'. Sandow's ideas fit very obviously into fin-de-siècle anxieties about the purported 'degeneration' of modern Western civilisation, and he was keen to emphasise the importance of physical culture for the British 'race'.[33] Despite his reference to 'manly' sports, he advocated that women should participate in physical culture – partly, no doubt, to expand his paying customer base, but also as part of his interests in healthy women as mothers of a healthy race, an idea which intensified in the wake of the Boer War and the 1904 report of the Interdepartmental Committee on Physical Deterioration.[34]

Greek sculpture was fundamental to Sandow's system, and was central to the broader physical culture movement. The goal for male and female physical culturists was to reshape their bodies to look like classical statuary.[35] In a widely repeated and reprinted story, Sandow himself claimed to have been inspired to take up physical culture when he encountered a sculpture of Hercules in Rome.[36] Sandow regularly posed as Farnese Hercules or the Dying Gaul; he was photographed in these poses, and these images were widely disseminated as postcards, *cartes de visites*, and within his publications.[37] Looking like a Greek sculpture was not simply a matter of outer appearance, but of inner moral and intellectual wellbeing; 'I became morally and mentally awakened', claimed Sandow, on his childhood encounter with Hercules in Rome. Greek sculpture stood as demonstrable evidence, Sandow argued, of the Greek 'culture of the

body', where athletics was not simply a competition, but a display of beautiful bodies for the greater moral good of the nation.[38]

None of these claims for classical sculpture were new – they are long-standing, and indeed often still perpetuated, discourses within Western culture. But Sandow harnessed them to a new mass audience for print and photographic media, to growing anxieties about racial degeneration, and to a specific physical training (and money-making) scheme. In opening the Crystal Palace School of Physical Culture, he grafted these ideas to a location where scrutiny of the body, and comparisons between people and sculpture, were a well-established form of entertainment and education.

The Crystal Palace had one unique facility which no other Sandow school could offer: its Fine Arts Courts provided access to an unparalleled collection of plaster casts of sculpture. Sandow emphasises the importance of museum visits for physical culturists, to familiarise themselves with the most superior (Greek) body type. Each edition of *Sandow's Magazine* opened with a photograph of a classical (or classicising) sculpture, or a nineteenth-century painting of Greek and Roman subject matter.[39] In 1904 it ran a year-long series on 'Physical Beauty in Art'; a matter of 'natural interest' to the physical culturist.[40] Adverts for the Physical Culture School from 1908 proudly boast that admission to the Palace was included in School membership; at Sydenham, men and women fresh from swinging Sandow's patented dumbbells in the gym could walk just a few paces from the north tower gardens into the Fine Arts Courts in the north nave of the Palace to come face to face with the plaster bodies that they were encouraged to emulate.[41] And if they strolled further down to the south nave, and into the Natural History Department, they might encounter bodies that deviated from Sandow's gleaming white marble ideals for white British bodies – the painted plaster models of colonised peoples.[42] Sandow valorised the physical prowess of several 'native races', casts of whom were also on show at Sydenham, including Maoris, Zulus and Arabs. But, like the responses to the 'Dahomey Amazons' on show at the Palace, these celebratory comments came from a position of assumed white superiority, and emphasised that, despite physical attributes, these 'natives' remained savage and lacking in self-restraint. The ultimate aim of physical culture was to improve the 'Anglo-Saxon' race.[43]

The presence of Sandow's School certainly reinforces an interest in the relationship between plaster sculpture and real human bodies at the Palace, and brings ideas about bodily difference, racial degeneration and eugenics into its glassy centre. For men and women who read *Sandow's Magazine*, and who attended the classes in the School, an umbilical connection was established between the bodies of Greek sculpture, and the

ideal British body. And visitors to the Palace who looked at Greek sculpture might likewise be encouraged by what they saw to take up physical culture. Art and eugenics can work together as 'mutually reinforcing mechanisms disciplining the body'; Greek art on show in the early twentieth century did not simply reflect the broader developments in eugenics, but contributed towards the vision of the ideal human body.[44] Eugenics breathed new life into the ancient sculpture on show at Sydenham, and the Palace as definitively modern education and entertainment venue made sculpture accessible and newly desirable.

Inter-Empire Games, 1911

On Saturday 1 July 1911, the 'antediluvian monsters' at Sydenham's lower lake, that solid concrete 'panorama of geological progress', watched over a transient, fleshy marker purporting to show imperial progress and friendship: the swimming events of the Inter-Empire Games ('Boating Lake' on figure 5.1).[45] The games are usually regarded as the first incarnation of the Commonwealth games, which formally began as the British Empire games in 1930. They took place as part of the 1911 Festival of Empire, bringing teams of amateur male athletes from Australasia (here referring to New Zealand and Australia), Canada and England to compete over three days in athletics, swimming, boxing and wrestling.[46] The games commenced with athletics on Saturday 24 June, held in the 'Empire Sports Arena' in the Palace grounds (see figure 1.7). On Wednesday 5 July, the central transept of the Palace housed the Inter-Empire boxing and wrestling.[47]

The idea of an Inter-Empire Games is usually dated back to the journalistic correspondence of John Astley Cooper in 1891. Cooper wrote a letter to *The Times* advocating a 'Pan-Britannic or Pan-Anglian contest and festival', 'a periodical gathering of representatives of the race in a festival and contest of industry, athletics and culture'.[48] Cooper proposed a festival as means of popularising the idea of a 'Greater Britain', a union of white people living in so-called settler colonies – concluding that 'though in many lands we are one people'.[49] Despite a flurry of attention in the 1890s, Cooper's suggestions for a sporting and cultural festival to be held every four years for young men of 'English speaking races' was overtaken (from 1892) by the Olympic movement, which held the first modern Olympic games at Athens in 1896. But the idea of fostering a pan-white settler identity through sport, industry and culture was revived in the 1911 Festival of Empire, where all three coalesced in the displays at the Crystal Palace and in its grounds.[50]

The sporting body constituted at the Palace during the 1911 Inter-Empire

Games was white, male and emphatically imperial. It appears that the organisers may have considered inviting an Indian team, although this idea was quashed at an early stage, despite the established participation in Palace sports of at least one Indian sporting champion, the wrestler Ahmud Bux, who competed at the Palace in May 1911.[51] The decision to exclude non-white colonial competitors, apparently negotiated between British and Australian sports administrators, provides further evidence of the role played by sport in the early twentieth-century 'drawing of the global colour line', the transnational construction of self-styled white men's countries.[52] Female athletes had competed in archery and lawn tennis at the 1908 London Olympics, but their role in the imperial future envisioned by the 1911 games was not acknowledged or even discussed as a possibility by the games organisers, again despite the long-standing array of sporting activities for women at the Palace.[53] It was not until the second British Empire games, held in London in 1934, that either women or Indian athletes were allowed to compete, and then only in select sports. Despite the illusions of social unity, as J. A. Mangan has pointed out, 'To a considerable extent imperial sport was a favoured means of creating, maintaining and ensuring the survival of dominant male elites.'[54] The imperial games and their administrators excluded those who had previously competed at Sydenham.

The press showed little interest in individual athletes and their bodily form. The focus was more on the cultural ties that emerged through physical competition (suggested by the emphasis on a shared language), than on the details of individual physical appearance and their correlation to the ideals of Greek sculpture as it had been at Sandow's School. Australian reportage emphasised the bonds formed among dominions by the undertaking, a demonstrable 'comradeship in Empire'.[55] It also stressed the 1911 games as the starting point for future collaboration that looked beyond – perhaps even dissolved – national boundaries. The games were officially closed on 1 August 1911, with the presentation of medals to athletes and of the Lonsdale Cup to the victorious Canada, followed by a dinner and speeches hosted at the Palace. The Sydney *Referee* and *Sydney Morning Herald* both featured extensive articles on the closing speech given by Lord Desborough, celebrated president of the 1908 Olympic games, who also chaired the organising committee for the Inter-Empire Games. Desborough suggested that, based on the 'friendships of Empire' cemented at Sydenham, future Olympic games might feature a single empire team competing together, rather than as individual nations. The *Referee* went on to note, 'This excellent idea had been so far accepted that next year the Canadian, Australian, New Zealand and South African teams will meet in

England a week or so before the Olympic games at Stockholm, and then proceed to Sweden *in one body as British Empire athletes*.'[56] As Robert J. C. Young has argued, the idea of a white imperial English ethnicity emerged in response to the global migrations of people from the British Isles. The singular imperial body growing out of the Inter-Empire Games might be seen as the ultimate consolidation and physical reunion of a globally scattered English 'race'.[57]

Despite Lord Desborough's backing and a handful of articles in specialist sporting journals, this singular imperial body was almost entirely ignored in the British press. The same went for the Inter-Empire Games themselves. Indeed, the 'antediluvian monsters', and the casts in the central transepts seem to have made up a significant portion of the audience for the games; one estimate in the Sydney *Referee* put the figures at 40 spectators for the swimming, and 30 for the boxing and wrestling – pitiful in comparison with the more than 300,000 people who attended the 1908 Olympics at White City, and the estimated 80,000 who watched the FA cup final in 1910 at the Palace.[58] The *Referee*, and especially Australian sports administrator Richard Coombes, lamented that the English sporting establishment and media had not sufficiently promoted the events.[59] And those who did attend and write about the games (as their desultory appearance in *The Times* suggests) did not acknowledge their imperial significance, a marked contrast with the enthusiastic and lengthy discussions of the games' specifically imperial importance in the Australian press.[60] Lord Desborough apparently spoke of 'the want of interest shown by the Londoner in anything imperial. The Londoner did not seem to understand that there was something beyond mere athletics in these Empire gatherings.'[61]

This apparent failure to recognise the imperial dimensions of the Inter-Empire Games is particularly noteworthy given that they took place in the midst of the Festival of Empire at the Palace. But as Deborah Sugg Ryan has suggested in her analysis of the diaries of one participant in the Pageant of Empire, the explicitly imperial messages intended by official exhibitions, pageants and sports events are not always conveyed, engaged with, or even noticed.[62] The bodies of the men and women pageanteers daily enacting the 'living history of London city' through the summer of 1911 might be seen as a counterpart to those of the Inter-Empire athletes, whose sporting activities performed a living, breathing and healthy imperial present.[63] The Londoners performing in the pageant of the city hailed mostly from its suburbs, a similar demographic to the majority of the English Inter-Empire athletes. The English athletes' clothing also suggests that even these Inter-Empire sportsmen may have treated the 1911 games

more like a suburban club meet; in contrast with the uniform T-shirts of the Australasian and Canadian teams, the English athletes competed in their own individual running club vests (figure 5.4). To further confuse the relationship between the Inter-Empire Games and suburban sporting life, several other local sports meets took place at the Palace while the Festival of Empire was still in full swing.[64] The Inter-Empire Games might only have stood out if spectators noticed the maple leaves on the Canadian team's T-shirts (figure 5.4).

For contemporaries, the Palace's suburban location rendered it a particularly appropriate place for the Festival of Empire, offering 'all the charm of rural England … sufficiently near the Empire City for the throb of the great heart of London to be audible.'[65] It was also an apposite location for the new form of sporting activity constituted by the Inter-Empire Games. David Gilbert has argued that Edwardian suburbia was not just a passive setting for sports events, but 'an active agent in the making of new sporting practices and cultures'.[66] The imperial suburbs and the sporting suburbs came together in Crystal Palace park, where attempts were made to forge an imperial sporting community as a marker of imperial progress and friendship, and to consolidate a modern transnational white imperial body – aims which seem, however, to have been almost entirely ignored by Londoners.

HMS *Crystal Palace*, 1915–19

The much-touted imperial credentials of the Palace, as a place where imperial family ties might be forged through physical exercise, were brought into a stark and violent realisation during the First World War. Some 125,000 men were housed and trained for fighting at sea and on land on board 'HMS *Crystal Palace*', requisitioned by the Royal Naval division, and closed to the public on 10 February 1915.[67] All the sculpture that could be moved was relocated out of the Fine Arts Courts, and hammocks slung across many of them; 'the men live exactly as if on board ship'.[68] The Egyptian and Greek Courts became letter-writing rooms hosting 700 men at a sitting, with over 5,400 letters dispatched per day; the Byzantine Court was stocked with billiard tables. The terraces, previously home to promenading couples, were now referred to as 'decks', and were used for marching, while the sports facilities became military training grounds.[69] On rainy days this activity moved inside the Palace, the central transept 'swarming with sailor-men and sailor-boys drilling, flag-waving, doing Swedish physical drill'.[70] The press praised the adaptability of the capacious Palace and park, and enjoyed elaborating on the contrasts between

5.4 'The Inter-Empire Athletic Championship', *Lotinga's Weekly* (1 July 1911),
p. 531. The 'very smart' Canadian team sport matching maple leaf T-shirts.
Australia are clad in black, while the British team wear their own suburban
running club vests; the distinctive red hoops of the Queens Park Harriers are
visible here; the other British competitors, from the Broughton Harriers and
Cambridge University are clad in white shirts. © The British Library Board
(LOU.LON 761).

its previous associations with leisure, and current role as training ground
for war.[71]

The Palace continued to host a broad social demographic; men from
the Clyde, Tyneside and mill towns of Lancashire apparently rubbed
shoulders there with the Public Schools Division.[72] And despite their total
omission in articles on HMS *Crystal Palace* in official publications and
the press, women from the Women's Royal Naval Service (WRNS) also
trained at Sydenham. The WRNS was created in November 1917 to
fulfil many of the roles previously undertaken by men stationed on shore.
Official Royal Navy photographs document the range of new physical
activities undertaken by the WRNS at Sydenham. They show women
undergoing physical training, marching, practising semaphore, playing
cricket, cooking, shooting, issuing kit and learning about battleships.[73]

Photographs capture these women amidst the statuary in the Palace
park, and the contrasts set up between the two are striking. Figure 5.5
shows a team of women in long-coated uniform 'learning to break rank

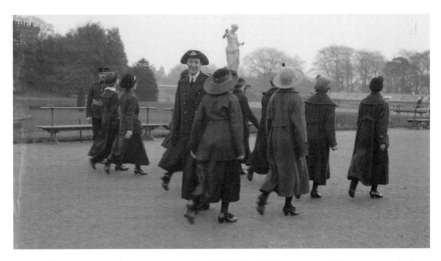

5.5 Photograph of women from the WRNS drilling in the Palace grounds in front of a copy of the Roman sculpture known as the Venus of Arles (1918). Dame Katharine Furse, first director of the WRNS, faces the camera. Published under Imperial War Museum's non-commercial licence © IWM (Q 18714) www. iwm.org.uk/collections/item/object/205253172.

correctly during squad drill', actively marching past the solitary, passive Venus of Arles, a park decoration with drapery slinking off her hips.[74] The purposeful, soberly dressed women portrayed in this photograph are a marked departure from the winsome watercolour lady cyclists of 1899 in figure 5.3. The image represents a brief wartime moment when British women escaped – even surpassed – comparison with classical norms of 'female grace and loveliness'. At the turn of the century, Venus of Arles' close relative, the Venus de Milo, was the 'dominant beauty ideal' for women, celebrated in physical culture circles for her healthy corset-free body.[75] After the war, as Ana Carden-Coyne traces, a 'New Venus' was mass marketed across the anglophone world. Classical sculpture figured in cosmetics adverts as a marker of female modernity and self-knowledge, but 'this apparent bodily freedom was, however, only *symbolic* of personal and sexual liberation.'[76] Champions of physical exercise for women, and celebrants of Venus as a model, were primarily concerned with improving contemporary women's fitness as future 'race mothers', maintaining traditional gendered expectations. The women striding across Crystal Palace park in figure 5.5 needed healthy bodies in order to serve their country – not through biological reproduction, but through physical and mental labour.[77]

Official Royal Naval publications and comment in the press observed

a 'new vitality' in the combination of sailors and glass building; 'there is something about it, there is some spirit in the air, which seems to differentiate it from any other drilling one ever saw'. The official publications used the novelty of the Palace as a means to demonstrate the 'gladness of heart' of the men stationed there. But even if these comments were intended as propaganda, it is noteworthy that they identify one particular source of this unusual ambience; the presence of 1915's modern militia before the various pasts embodied in the Palace, in particular Egyptian and ancient Greek. Photographs documenting the Navy's stay at the Palace show some outdoor activities such as parades on the terrace. But most are keen to show men at work and play among the Palace's exhibits; in group photographs, sailors clamber over the sphinxes on the Palace stairwell; others show them playing chess, writing letters and reading the newspapers among the architectural sculpture in the Egyptian Court.[78] In journalistic comment on HMS *Crystal Palace*, Egyptian sculpture is characterised by established ideas about monumental permanence, combined with well-worn orientalist clichés about the 'curious' nature of Egypt's gods.[79] Greek sculpture figures rather differently, however.

The respectability of the large numbers of unclothed classical sculptures had been a pressure point throughout the Palace's life, not always safely subsumed into the artistic category of the nude. Under naval occupation, the sculptures initially left on show came back to life as titillating sexual objects; 'It was not an easy matter to drill raw recruits in the vicinity of statues of immodest gladiators and nude women, which were poised high up on pedestals before the advancing squads.'[80] Sailors apparently knocked off plaster genitalia, and daubed them with red paint.[81] According to the editor of *With the Royal Naval Division on Board HMS Crystal Palace* 'the Sphinxes and the Statesmen, the Egyptian Gods and the naked Grecian men seem a little shamefaced at being so shoddy, their many chips showing them to be but copies, in the presence of the real thing – the Bluejacket'.[82]

Of course, these sculptures were indeed copies, plaster casts of Greek and Egyptian sculpture made in 1850s Britain. Here, however, the article prioritises their lack of originality not as plaster replicas in the face of ancient marble, but of modern British manhood. The use of the particular sartorial metonym 'Bluejacket' further emphasises the contrast between the once again embarrassingly naked statuary and the finely turned out naval men. The unclothed classical sculpture on show at Sydenham was no longer an ideal to which men might aspire, bodies for emulation as they had been in Sandow's School; the bodies of sculpture have been surpassed by British sailors. The 'Bluejacket' was now 'the real thing'. Here sculpture loses its connection with any sort of living human body,

becoming frozen in place again as a mere (chipped) copy of the British bodies invigorated by training to fight for their nation. This vision of the Palace perpetuating 'healthful, vigorous manhood' stands in stark contrast with the reality.[83] By November 1918, 117 men had died at the 'Crystal Palace Death Trap', having contracted the influenza that swept the globe in that year.[84] Contemporaries regarded the Crystal Palace to be a particularly dangerous place for the spread of disease: a fateful combination of large numbers of people cooped up together in a humid greenhouse environment. Previous claims for the Palace venue seemed grossly inappropriate – so much for the healthful properties of its hill-top location in the 'fresh air suburb' and the celebratory reports that it provided an all-weather exercise yard; 1,000 of the 5,000 men housed there at any one time were affected.[85]

The peculiar atmosphere identified at the Palace was not only associated with the ancient Egyptian and Greek pasts that it contained. It was also part of wartime nostalgia for a more recent lost era (and more poignant for its proximity). The 'good ship Crystal Palace' was 'so intimately linked with the far-away Victorian era of progress and international peace that called into being the glitter glass pile on Sydenham Hill – a fit symbol of the age preceding the universal cataclysm.'[86] The Palace had become a place of war – but in the eyes of the British press at least, the site was still understood as embodying Victorian Britain.

Conclusion

In figure 5.6, men, women and children visiting the Palace ignore the screen of sculpted kings and queens from Westminster Abbey that look over them, and instead contemplate the 'latest type British aircraft'. Other images of the first incarnation of the Imperial War Museum, housed in the Palace from 1920 to 1923, show battery guns and tanks among sculpture in the nave.[87] The focus of these images is no longer, as in figure 5.2, the interaction between people and sculpture, but people and machinery. Perhaps it was difficult to look at the ideal bodies of sculpture after the unprecedented and brutal destruction of human bodies during the First World War – or perhaps machinery seemed more relevant, more important.

Sandow's School, run by the Crystal Palace Company since (at least) 1908, was, from 1920, home to administrative offices for the Imperial War Museum; the Palace was no longer a place to reform the body, but to observe machines that destroyed it.[88] But in the years that followed, as Carden-Coyne argues, classical sculpture in particular had a key role to

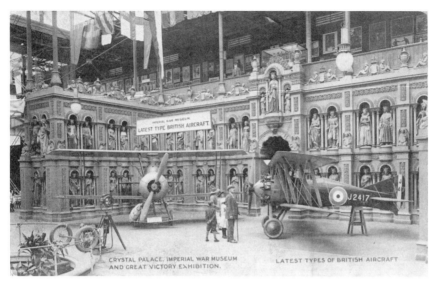

5.6 Postcard depicting a family looking at the 'latest type of British aircraft' in the Imperial War Museum at the Crystal Palace. The planes are parked in front of the screen of British kings and queens in the south nave, constructed especially for the Palace in 1854 to house the 1840s sculptures made by John Thomas for the new Houses of Parliament. Author's collection.

play in recovering and reconstructing both the human and social body. From the Palace's opening in 1854 to its reopening after the First World War, the plaster bodies housed in its Fine Arts Courts were continuously points of (varying) comparison with its moving breathing audience, contributing to gender and racial identities. In wartime propaganda, they were inferior to the bodies of British warriors, and bypassed by marching women, while in in *fin-de-siècle* physical culture they stood as markers of an ideal body for the 'Anglo-Saxon' race. Yet sculptural bodies were never mentioned in the mooted construction of a transnational white imperial sporting identity at the 1911 games; here the geography of the Palace, as a suburban but imperial setting, was more important than its artistic connections for the growing class of professional colonial sports administrators that wrote about it. Scholarship on the Palace, and indeed until very recently on the history of sport in general, has perpetuated this distinction. The Sydenham Palace was a unique site of mass engagement with both art and sport, as spectator and participant. It is an ideal location from which to begin to examine the changing relations among art, sport and consumer culture in nineteenth- and early twentieth-century Britain.

Notes

1 On the 'scramble for sport' in British society, see J. Lowerson, *Sport and the English middle classes 1870–1914* (Manchester: Manchester University Press, 1993). The *Illustrated London News* is packed with photographs and sketches of sport at the Palace. See, for example, 'The International Badminton Tournament at the Crystal Palace, March 19–20', *Illustrated London News* (29 March 1902), p. 455; 'A New Winter Game: Pushball at the Crystal Palace', *Illustrated London News* (11 October 1902), p. 540; 'The "All Blacks" Against England: the New Zealanders' Victory at the Crystal Palace December 2', *Illustrated London News* (9 December 1905), pp. 862–3.

2 'Crystal Palace National Sports Centre', www.better.org.uk/leisure/crystal-palace-national-sports-centre# (accessed 17 September 2014).

3 E. McDermott, *Routledge's guide to the Crystal Palace and park at Sydenham* (London: Routledge, 1854), p. 47.

4 On Blondin, see J. R. Piggott, *Palace of the People. The Crystal Palace at Sydenham 1854–1936* (London: Hurst & Co., 2004), pp. 188–91; on netball, 'Bank Holiday', *The Times* (7 August 1900), p. 10; 'Roller Skating at the Crystal Palace', *The Times* (November 1905), p. 12.

5 For a survey see M. Huggins and M. O'Mahony, 'Prologue: Extending the Study of the Visual in the History of Sport', *International Journal of the History of Sport*, 28:8–9 (2011), 1089–104; F. Brauer and A. Callen (eds), *Art, Sex and Eugenics: Corpus Delecti* (Aldershot: Ashgate, 2008).

6 On the complex social negotiations that go into the construction and acceptance of the nude as an art form, see L. Nead, *The Female Nude. Art, Obscenity and Sexuality* (London: Routledge, 1992).

7 Parl. Debs. (series 3) vol. 147, col. 1483 (12 August 1857); col. 1864 (19 August 1857).

8 'The Decline of Art: Royal Academy and Grosvenor Gallery', *Blackwood's Edinburgh Magazine* (July 1885), 11; A. Smith, 'The "British Matron" and the Body Beautiful: the Nude Debate of 1885', in E. Prettejohn (ed.), *After the Pre-Raphaelites: Art and Aestheticism in Victorian England* (Manchester: Manchester University Press, 1999), pp. 217–39.

9 For more detailed examination of this debate see K. Nichols, *Greece and Rome at the Crystal Palace. Classical Sculpture and Modern Britain, 1854–1936* (Oxford: Oxford University Press, 2015), chapter 5.

10 R. G. Latham and E. Forbes, *Handbook to the Courts of Natural History* (London: Bradbury & Evans, 1854), p. 54.

11 For a detailed discussion of the Natural History Department in its ethnological context, see S. Qureshi, *Peoples on Parade. Exhibitions, Empire and Anthropology in Nineteenth-century Britain* (Chicago: University of Chicago Press, 2011), pp. 193–218.

12 See D. Challis, '"The Ablest Race". The Ancient Greeks in Victorian Racial Theory', in M. Bradley (ed.), *Classics, Imperialism and the British Empire* (Oxford: Oxford University Press, 2010), pp. 94–120.

13 See Nichols, *Greece and Rome at the Crystal Palace*, pp. 217–18.

14 *Ibid.*, pp. 224–8.

15 *Ibid.*, chapter 1, provides detailed discussion of the Palace's audience and critical responses to it.

16 E. Eastlake, 'The Crystal Palace', *Quarterly Review*, 96:92 (1855), 306.

17 Robin Law provides a useful survey of the 'Amazons', and also suggests that the people exhibited in Europe in the 1890s were unlikely to have actually been warriors. 'The "Amazons" of Dahomey', *Paideuma*, 39 (1993), 245–60.

18 S. Mathur, *India by Design: Colonial History and Cultural Display* (Berkeley: University of California Press, 2007), p. 23.

19 'Amazons of Dahomey at the Crystal Palace', *Penny Illustrated Paper* (10 June 1893), p. 361; 'Amazons at Home', *Sketch* (15 October 1893), p. 629. See also 'Crystal Palace', *Morning Post* (19 May 1893), p. 2; 'Crystal Palace', *Standard* (12 June 1893), p. 6.

20 See Challis, 'The Ablest Race'; A. S. Leoussi, *Nationalism and Classicism: The Classical Body as National Symbol in Nineteenth-century England and France* (Basingstoke: Macmillan, 1998).

21 'Crystal Palace', *Daily News* (23 May 1893), p. 3.

22 'The Crystal Palace', *Standard* (3 April 1894), p. 3; 'Mrs Murray-Cookesley's Tableaux at the Crystal Palace: "The Vestal"', *Sketch* (18 April 1894), p. 621.

23 'A Novel Bicycle Display by Ladies at the Crystal Palace', *Graphic* (12 August 1899), p. 214.

24 'Easter Entertainments, the Crystal Palace', *The Times* (19 April 1870), p. 10.

25 A. B. Maddock, MD, *Sydenham. Its Climate and Palace; with observations on the efficacy of pure air, especially when combined with intellectual and physical recreation, in the prevention and treatment of disease* (London: Simpkin, Marshall & Co., 1860), pp. vii–viii.

26 The Shorthand Writer, *The Crystal Palace in adversity: the duty, importance, and facility of raising it to prosperity, popularity, and national usefulness, with special reminiscence of the Great Exhibition of 1851* (London: Wilson, 1876), p. 40.

27 I. Zweiniger-Bargielowska, *Managing the Body: Beauty, Health, and Fitness in Britain, 1880–1939* (Oxford: Oxford University Press, 2010), pp. 62–104.

28 D. Waller, *The Perfect Man: The Muscular Life and Times of Eugen Sandow, Victorian Strongman* (Brighton: Victorian Secrets, 2011), pp. 117–20.

29 Physicist, 'Around the Schools', *Sandow's Magazine of Physical Culture*, 5 (1900), 116–18.

30 'Crystal Palace School – by a Lady Pupil', *Sandow's Magazine of Physical Culture*, 6 (1901), 151–2; 'Physical Culture at the Crystal Palace', *Sandow's Magazine of Physical Culture and British Sport*, 10 (1903), 276.

31 E. Sandow, 'Physical Culture: What is it?', *Sandow's Magazine of Physical Culture*, 1 (1898), 4.

32 'Sandow Interviewed in America', *Sandow's Magazine of Physical Culture and British Sport*, 7 (1901), 56.

33 Sandow, 'Physical Culture: What is it?', 7.

34 Zweiniger-Bargielowska, *Managing the Body*, pp. 112–18, 126–7.

35 Classical statuary of course includes a wide range of potential models. In physical culture *c.*1900, for men these included the 'Hercules/carthorse' type and the 'Apollo/racehorse' type; for women, Venus de Milo was usually cited. See Henry E. Brown, 'Some Modern Specimens of Physical Perfection', *Vim Illustrated Magazine*, 5:1 (1906), 97. On classical sculpture and bodybuilding more generally, see M. Wyke, 'Herculean Muscle!: the Classicizing Rhetoric of Bodybuilding', in J. I. Porter (ed.), *Constructions of the Classical Body* (Ann Arbor: University of Michigan Press, 1999), pp. 355–79.

36 'Sandow Interviewed in America', 56.

37 On Sandow and physical culture across media, from postcards to early cinema, see M. Budd, *The Sculpture Machine: Physical Culture and Body Politics in the Age of Empire* (Basingstoke: Macmillan, 1997), pp. 42–57.

38 Sandow, 'Physical Culture: What is it?', 5. See also 'Plato, the Philosopher and First Physical Culturist', *Vim Illustrated Magazine*, 4:9 (1906), 6.

39 For an exploration of the relationship between physical culture and the new sculpture movement in the 1890s, see M. Hatt, 'Physical Culture: the Male Nude and Sculpture in late Victorian Britain', in Prettejohn (ed.), *After the Pre-Raphaelites*, pp. 240–56.

40 Sandow, 'Physical Culture: What is it?', 6.

41 *Crystal Palace Programme Supplement* (26 September 1908), not paginated.

42 There was one very famous – and much derided – painted Greek sculpture at the Sydenham Palace: Owen Jones's 'polychrome' restoration of the Parthenon frieze, a source of outrage in the 1850s. Several critics held that only 'barbaric' peoples (and Catholics) painted sculpture, and that it was an abomination to suggest that the Greeks had done so. For further discussion of the relations between paint on Greek sculpture and on the ethnological models at Sydenham, see Nichols, *Greece and Rome at the Crystal Palace*, pp. 229–31. On white marble as 'privileged racial signifier' in the nineteenth century, see C. Nelson, *The Color of Stone: Sculpting the Black Female Subject in Nineteenth-century America* (Minneapolis: University of Minnesota Press, 2007), pp. 57–72.

43 See further Zweiniger-Bargielowska, *Managing the Body*, pp. 97–101.

44 F. Brauer, 'Making Eugenic Bodies Delectable: Art, "Biopower" and "Scientia Sexualis"', in Brauer and Callen (eds) *Art, Sex and Eugenics*, p. 31.

45 J. A. Secord, 'Monsters at the Crystal Palace', in S. de Chadarevian and N. Hopwood (eds), *Models: The Third Dimension of Science* (Stanford: Stanford University Press, 2004), p. 142.

46 South Africa was invited to compete but declined. For a detailed analysis of the organisation of the games, see K. Moore, 'The 1911 Festival of the Empire: a Final Fling?', in J. A. Mangan and R. B. Small (eds), *Sport, Culture, Society. International Historical and Sociological Perspectives* (London: Spon, 1986), pp. 84–90.

47 'How Harold Hardwick won', *Referee* (9 August 1911), p. 7.

48 J. Astley Cooper, 'The Proposed Pan-Britannic or Pan-Anglian Contest and Festival', *The Times* (30 October 1891), p. 3.

49 *Ibid.*

50 On Cooper's ideas and their reception in Australia, see K. Moore, '"One Voice in the Wilderness": Richard Coombes and the Promotion of the Pan-Britannic Festival Concept in Australia, 1891–1911', *Sporting Traditions*, 5:2 (1989), 188–203. Nielsen further explores the role played by the games in fostering 'notions of Britishness' in Australian sport. See E. Nielsen, *Sport and the British World, 1900–1930: Amateurism and National Identity in Australasia and Beyond* (Basingstoke: Palgrave Macmillan, 2014), pp. 114–19.

51 I am grateful to Sarah Turner for pointing this out. On wrestling and visual culture in the early twentieth century, see further S. Turner (ed.), *In Focus: 'Wrestlers' 1914, Cast 1965, by Henri Gaudier-Brzeska* (2013), www.tate.org.uk/art/research-publications/gaudier-brzeska-wrestlers (accessed 1 December 2014).

52 M. Lake and H. Reynolds, *Drawing the Global Colour Line. White Men's Countries and the International Challenge of Racial Equality* (Cambridge: Cambridge University Press, 2008). On Australian 'white race patriotism' and the decision to exclude India, see Nielsen, *Sport and the British World*, p. 115.

53 D. Gilbert, 'The Edwardian Olympics: Suburban Modernity and the White City Games', in M. O'Neill and M. Hatt (eds), *The Edwardian Sense. Art, Design and Performance in Britain, 1901–1910* (New Haven. CT: Yale University Press, 2010), pp. 85–9.

54 J. A. Mangan, 'Prologue: Britain's Chief Spiritual Export: Imperial Sport as Moral Metaphor, Political Symbol and Cultural Bond', in J. A. Mangan (ed.) *The Cultural Bond: Sport, Empire, Society* (London, 1992), p. 6.

55 'The Inter-Empire Games', *Referee* (6 September 1911), p. 9.

56 *Ibid.*, emphasis mine. See also 'Empire Athletes. Dinner at Crystal Palace', *Sydney Morning Herald* (2 August 1911), p. 15.

57 R. J. C. Young, *The Idea of English Ethnicity* (Oxford: Blackwell, 2008).

58 'Swimming: Champion Home Again', *Referee* (20 September 1911), p. 8; Gilbert, 'Edwardian Olympics'; 'Football Association Cup. Final Tie', *The Times* (25 April 1910), p. 19.

59 R. Coombes, 'Empire Festival Championships', *Referee* (2 August 1911), p. 1; 'Why is England so Apathetic in Reciprocating in the Matter of Inter-Empire Visits?', *Referee* (9 August 1911), p. 1.

60 'Athletics. Festival of Empire Sports', *The Times* (26 June 1911), p. 14. The sports journal *Lotinga's Weekly* features several pages of photographs, but presents the games as simply one of many sporting events, with no emphasis on its imperial dimensions, for example, 'Canada's Brilliant Athletic Team', *Lotinga's Weekly* (1 July 1911), p. 529; 'The Inter-Empire Athletic Championship', *Lotinga's Weekly* (1 July 1911), p. 531.

61 'The Inter-Empire Games', *Referee* (6 September 1911), p. 9.

62 D. S. Ryan, 'Staging the Imperial City: the Pageant of London, 1911', in F.

Driver and D. Gilbert, *Imperial Cities. Landscape Display and Identity* (Manchester: Manchester University Press, 1999), pp. 117–35.

63 'Citizens of London as the Living History of London City: The Pageant at the Festival of Empire', *Illustrated London News* (10 June 1911), pp. 902–3.

64 For example, 'The Police Athletic Sports', *Lotinga's Weekly* (22 July 1911), p. 590, and 'The Finchley Harriers' Athletic Carnival', *Lotinga's Weekly* (5 August 1911), p. 629.

65 *Festival of Empire and Imperial Exhibition 1911. Under the Patronage of His Majesty's Government* (London: Bemrose & Sons, 1911), p. 22; *Crystal Palace Sydenham. To be Sold by Auction* (London: Hudson & Kearns, 1911), p. 3.

66 Gilbert, 'Edwardian Olympics', p. 88.

67 'Crystal Palace to be Closed Tomorrow', *The Times* (9 February 1915), p. 5; 'Crystal Palace Freed', *The Times* (11 November 1919), p. 11. For a detailed description of life on board HMS *Crystal Palace*, see Griff, *Surrendered. Some Naval War Secrets* (Twickenham: the author, n.d. [*c*.1926]), pp. 14–27.

68 L. Yexley, 'HMS Crystal Palace. The Story of the Royal Naval Division', *Navy and Army* (1 May 1915), p. 57.

69 *With the Royal Naval Division on Board HMS 'Crystal Palace' and Elsewhere. A Souvenir* (1915), pp. 73–8.

70 *With the Royal Naval Division on Board HMS 'Crystal Palace' and Elsewhere. Second Souvenir* (1915), p. 73.

71 W. P., 'HMS Crystal Palace. Sons of the Sea at Sydenham', *Graphic* (29 September 1917), p. 404.

72 'HMS Crystal Palace', *The Times* (29 January 1915), p. 11.

73 These are from 'Ministry of Information First World War Official Collection', fully searchable with images at www.iwm.org.uk/collections (accessed 2 December 2014).

74 On the connection between the two Venuses, see B. S. Ridgway, 'The Aphrodite of Arles', *American Journal of Archaeology*, 80 (1976), 147–54.

75 Zweiniger-Bargielowska, *Managing the Body*, pp. 121–3.

76 A. Carden-Coyne, *Reconstructing the Body. Classicism, Modernism and the First World War* (Oxford: Oxford University Press, 2009), p. 247 (emphasis mine).

77 As Zweiniger-Bargielowska explores, however, physical culture, and the idea of women as race mothers, was also connected to political liberation for women. See *Managing the Body*, pp. 124–36. On the opportunities for women provided by the WRNS, see K. Robert, 'Gender, Class and Patriotism: Women's Paramilitary Units in First World War Britain', *International History Review*, 19:1 (1997), 52–65.

78 See Piggott, *Palace of the People*, p. 179; 'His Majesty's Ship Crystal Palace', *Graphic* (6 February 1915), p. 171.

79 'Progress of the Naval Division', *The Times* (17 April 1915), p. 6; *With the Royal Naval Division on Board HMS 'Crystal Palace' and Elsewhere. A Souvenir* (London, 1915), pp. 18–19.

80 Griff, *Surrendered*, p. 16. See also D. Barker, 'Crystal Palace Memories', *Evening Standard* (21 December 1936), p. 22.

81 Described by Mr T. Dysart, stationed at the Crystal Palace during the First World War. Norwood Local Studies Library, 'Crystal Palace Memories', 2, p. 38.

82 *With the Royal Naval Division on Board HMS 'Crystal Palace' and Elsewhere. Second Souvenir* (London, 1915), p. 73.

83 *With the Royal Naval Division on Board HMS 'Crystal Palace' and Elsewhere. A Souvenir* (London, 1915), p. 69.

84 'The Crystal Palace Death Trap' is discussed in 'The Real Remedy for Influenza', *Vegetarian* (16 April 1919), p. 49. For a first-person account of the Palace and its sick bay, see Imperial War Museum Archives, G. Pitcairn Knowles, 06/57/1. These comprise the letters of George Pitcairn Knowles, a serviceman called up to the Crystal Palace in August 1918 who caught influenza and was nursed back to health at the Palace.

85 'House of Commons. Influenza Epidemic', *Manchester Guardian* (31 October 1918), p. 6.

86 W. P., 'HMS Crystal Palace. Sons of the Sea at Sydenham', graphic (29 September 1917), p. 404. See also '"Jenny Wren," the handywoman of the "WRNS"', *Illustrated London News* (16 February 1918), p. 214.

87 These are from the 'Imperial War Museum Photograph Archive Collection', fully searchable with images at www.iwm.org.uk/collections (accessed 2 December 2014).

88 The physical culture building had been out of use for some time when it was handed over to the Imperial War Museum, and was, according to correspondence, in a deplorable state, crowded with old furniture, overrun by mice, and with burst heating pipes. Imperial War Museum Archives, Physical Culture Building (Crystal Palace) EN1/1/CPL/25.

6

From Ajanta to Sydenham: 'Indian' art at the Sydenham Palace

Sarah Victoria Turner

Histories of the display of Indian art and material culture in Victorian Britain have, for very good reason, largely focused on the dazzling spectacles of the Great Exhibition of 1851, its progeny, the South Kensington Museum (now the Victoria and Albert Museum), and subsequent temporary international exhibitions at South Kensington, such as the Colonial and Indian Exhibition of 1886.[1] By the second part of the nineteenth century, India occupied a significant amount of exhibition floor space at many of the major international exhibitions. These displays communicated to the public at home the territorial control and riches of British imperial expansion in the subcontinent, through an array of exquisite and practical objects, towering creations made from bountiful resources often referred to in international exhibition lingo as 'trophies', and images of a subservient and peaceful indigenous population; an image that exhibitions helped to carefully reconstruct after the violence of the Indian Uprising in 1857.[2]

It is quite surprising, then, given the sheer amount of physical space and critical attention devoted to, as well as public appetite for, India at the Great Exhibition of 1851 in the Crystal Palace in Hyde Park that there was no significant standalone 'Indian Court' at the Sydenham site among the imposing series of Fine Art Courts devoted to Egyptian, Assyrian, Greek, Roman, Pompeian, Italian, Byzantine, Medieval and Renaissance 'styles'. This deficiency was noted and commented on from the opening of the Sydenham Palace in 1854. Wares from Birmingham and Sheffield had a court at Sydenham, but India did not. That is, not until a part of the building was appropriated around 1855 to form a small, but distinct, 'Indian Court'. Making their way through to the back of the Assyrian court, the

visitor to the Sydenham Palace would have encountered the entrance to the Indian Court, a rather inauspicious passageway in comparison to the grand avenue of lions, or the winged bulls, that flanked the entrances to other courts in the Palace. Nevertheless, once inside, the visitor could not have failed to notice a large series of oil paintings – a very large and near complete set of reproductions of the ancient paintings from rock-hewn temples of the Buddhist monastery complex at Ajanta in Western India, which had been constructed in two phases from the first or second century BCE to the first century CE, and copied in the mid-nineteenth century by Major Robert Gill of the Madras army (figure 6.1).

Overseen by the directorship of the formidable duo of Owen Jones and Matthew Digby Wyatt, the Fine Art Department presented 'courts' of reconstructions of architectural details and sculptural objects – and in the case of the Ajanta copies, as well as Pompeii, of a select number of paintings too. Copying and reproduction was central to the programme conceived by the Crystal Palace Company's directors to represent examples of what they considered as the finest examples of the world's artistic achievements. Some faithful and some fictitious, copies were integral

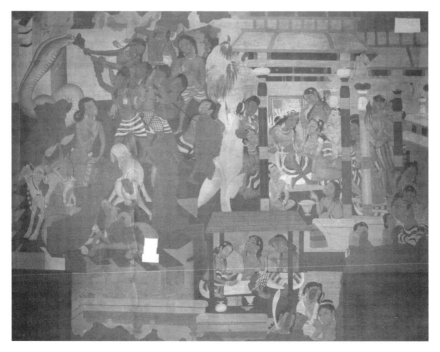

6.1 Robert Gill, 'Copy of Painting inside the Caves of Ajanta', 1856. Oil on canvas. © Victoria and Albert Museum, London.

to the system of education, instruction and pleasure at the Palace. Reproductions of the Ajanta paintings made appearances in two different episodes in Sydenham's somewhat patchy history of displaying Indian art and architecture.

As well as Major Gill's copies on display in the nineteenth century, a different set of copies was available to view in 1911 at the Festival of Empire, made by the artist and campaigner, Christiana Herringham, and a team of Indian artists from government art schools in India. More prominently exhibited in a dedicated Indian Pavilion in the grounds of the Palace and discussed in the national press, these copies were (for a time) some of the most high-profile examples of Indian art in Britain. The displays of the Ajanta copies, and the responses to them, reveals much about Sydenham as an imperialised site of display. The Palace, and its grounds, offered an alternative kind of encounter with Indian art in the imperial metropolis, one that was very different from the aesthetic experience of the more formal museological displays at South Kensington and the British Museum, and it is significant that these reproductions of the Ajanta paintings went, in both 1855 and 1911, to Sydenham, not to South Kensington or to Bloomsbury. Yet, somewhat curiously, Sydenham has often been overlooked in the scholarship on art and empire in Victorian and Edwardian Britain. Through looking in detail at the case of the colonial copies from Ajanta in the mid-nineteenth century, and then again at the beginning of the twentieth century, this chapter seeks to re-evaluate Sydenham as a space in which the relationships between nation and empire were frequently shaped and tested through its exhibitions and displays.[3]

Ajanta in Sydenham, via Assyria

at the back of the Assyrian Court, we enter a department appropriated as an Indian Court.[4]

The first Indian Court at Sydenham, as the description of the revised official guide book of 1860 made clear, was not exactly prominent. Visitors had to wrest themselves from the 'wonders of Assyrian art' – a hybrid amalgamation of casts organised by James Fergusson from ancient Mesopotamian sites, which included casts of impressive winged bulls from objects that had been moved from Khorsabad, in present-day Iraq, to the Louvre – and enter the unprepossessing entrance to the Indian Court.[5] The 'first object which we notice', reported the revised guidebook, 'is a stand covered on both sides with a fine collection of Indian arms and armour arranged with other objects of interest'.[6] At the front of the book

in a section entitled 'The Handbook Advertiser', these objects were offered for sale via a notice that described them as a 'Great Collection of Indian Arms, Armour, and Curiosities'. This 'splendid collection' comprised, the advert effused, of a 'large number of the most valuable examples – many of high historic interest', and those interested in making a purchase were directed to the Superintendent of the Literary Department. This was obviously not envisioned as a permanent display, but a commercial one that would result in sales and presumably the removal of the objects from the Palace into private hands.

There were also some paintings lent by the East India Company, 'several Burmese idols and other curious objects', examples of 'magnificently embroidered garments, saddle-cloths etc., which display that craving after splendour which appears to be part of Oriental nature', jewellery, ivory objects and precious metalwork, as well as objects from Japan, Persia and China. It other words, it was an ad hoc collection which grouped an array of objects from vastly diverse regions under the rubric of the 'Oriental'. 'Curious' is a description used frequently in the guidebook for the items of display in this court. How different and ad hoc this small medley must have seemed in contrast to the Indian material at the Great Exhibition described in *The Times* as 'one of the most complete, splendid, and interesting collections'.[7]

The contemporary press was quick to observe the various gaps and omissions in the new Crystal Palace scheme. In 1854, the *Art Journal*, the most prominent and widely circulated art periodical in mid-Victorian Britain, carried a number of articles on the progress of the Palace prior to, and after, its opening. The unevenness of representation of artistic cultures was discussed at length.[8] The author of an article entitled 'The value of the "courts" of architecture and sculpture at the Crystal Palace', lamented the omission of some 'styles' altogether, such as Louis XIV, and the profusion of other examples, although the author was prepared to recognise that 'such deficiencies, many of which we are content to think were unavoidable under the extraordinary difficulties that there were' would not prevent observers from reaping 'great benefit from the collection'.[9]

The following month, the September issue of the *Art Journal* addressed the issue of sculpture at Sydenham remarking on the 'poetical and inspiring objects in the Art-halls, ancient and modern, Egyptian, Greek, Roman, Assyrian, Byzantine, Italian, etc. through which our duty and pleasure lead us'.[10] It was noted, however, that the 'present collection at Sydenham affords us no section applied to Indian or Chinese art', although this was due to, the author suggested, the lack of 'remains extant there which appear to have historical claims to equal antiquity … afforded

us by Egypt.'[11] *The Sydenham Crystal Palace Expositor* put its complaint at the absence of an Indian court much more forthrightly:

> With an oriental empire extending from Cape Comorin to the Himalayas hundreds of thousands of our countrymen are intimately associated, and that empire possesses a remote antiquity as well as Assyria and Egypt; nor are its monuments less interesting. Every facility exists for ornamenting such a court … surely then the architecture and sculpture of India are entitled to a court, where some of its monuments might be restored.[12]

India was, it would seem, more fulsomely represented in the Palace's Natural History Department than in the Fine Arts courts. The India display here included a group of models of Hindus birds, an Indian hog, and a spectacular taxidermic tour de force of a tiger hunt including an elephant. This provided a dramatic scene, described by Phillips with great excitement noting how the 'elephant is in the act of uttering a roar of fear, and starting off with the speed of terror from the scene of the action', suggesting that the visitor might be in imminent danger should these stuffed animals suddenly be animated; a palpable excitement that was nowhere present in the description of the collection of Indian artworks and curios.[13] So popular, the tiger-hunting scene made it on to the cover of George Measom's *Crystal Palace Alphabet* (figure 6.2).[14] Another journalist wrote that a 'better subject than this could scarcely be selected for India', perhaps with another infamous tiger-mauling scene on display in London in mind in the form of the mechanical pipe organ owned by the East India Company popularly known as 'Tipu's Tiger'.[15] On maps of the Palace, the Tiger Hunt was singled out for special significance, indicating its popularity as a destination in its own right that the visitor would want to locate easily. Taxidermy and the spectacle of the hunt undoubtedly trumped what was on offer from India in the Fine Arts Courts.

Given the triumph of the Indian Court at the Great Exhibition, it is remarkable that it was left out of the original Sydenham scheme and then given such cramped quarters, ostensibly tacked on to another court as something of an afterthought. One reason, as Nicky Levell has suggested in her work on the 'Oriental visions' of Victorian collectors and collections, is that the arrangement of the courts was 'an arbitrary, Eurocentric classification, which served to position and fix the Orient in distant antiquity, in contrast to Europe's successive advancement through historical time'.[16] The displays of Indian art at the Great Exhibition had been very enthusiastically received, casting an unfavourable light on modern British manufacture. This unflattering comparison was one that the directors of the Crystal Palace Company perhaps wanted to avoid. The emphasis at

6.2 George Measom, *The Crystal Palace Alphabet. A Guide for Good Children* (London: Dean and Son, 1855). Reproduced by kind permission of the Syndics of Cambridge University Library.

Sydenham was very much on a teleological sequence of courts that represented 'progress' – a contentious concept with which to associate countries and regions under British imperial rule.

The violent events of the Indian Uprising – or 'mutiny' as it was called at the time – in 1857 threw an even sharper light on such issues and made the display of India's culture deeply and pressingly political. Perhaps it was decided by Jones and Digby Wyatt that it would be safer to ignore India altogether and focus on more comfortably distant civilisations such as ancient Assyria and Egypt, and the Byzantine Empire, as well as make progressive links between Greece, Rome and modern Europe. Where to place India within this chronology of styles was a challenging question that the organisers obviously did not feel sufficiently well equipped to face in 1854. Working within the parameters of the extent of loaned collection from the India Museum, managed by the Directors of the East India Company, limited what the curators of the Crystal Palace could create in terms of an Indian Court. Interestingly, in 1855 there was a petition to transfer the entire collection of Indian material sent to the Paris International Exhibition to the Crystal Palace instead of it being dispersed to different collections as had happened after the Great Exhibition.

However, this did not come to pass and the curators at Sydenham had to work with what they were offered.[17]

The initial marginalisation of India at Sydenham is all the more surprising given the involvement of the architectural historian James Fergusson in the Sydenham project. Fergusson oversaw the creation and construction of the Assyrian Court, and was General Manager of the Crystal Palace Company from 1856 to 1858.[18] By the time he joined the team at Sydenham, Fergusson had lived in India for many years and published *The Rock-Cut Temples of India* in 1845 (one of the earliest studies in English on India architecture). To great acclaim, Fergusson had also published *The Illustrated Handbook of Architecture* in two volumes in 1855. The large amount of material on Indian architecture was removed from this book and eventually published separately as *The History of Indian and Eastern Architecture* in 1876, the first survey work on this subject. Yet, in the 1850s, the kind of archaeological survey work that had been carried out by Henry Layard in the Middle East, which was heavily celebrated at the Sydenham Palace, had not taken place in India and it was frequently cast as a land of architectural ruin and material decline yet to be properly surveyed, measured and classified by the British authorities.[19] The Archaeological Survey of India was not officially founded until 1861 and imperial record and archive of India's architecture was, in the mid-1850s, nascent yet patchy to say the least. If Fergusson, and presumably others, felt that India's architecture could not be easily situated in Sydenham's Fine Arts Courts, he did endorse the inclusion of a major series of copies from India in the form of Major Robert Gill's reproductions of the Ajanta frescos.[20]

A culture of making and displaying copies was ingrained in the Sydenham Palace mission to create a visual encyclopaedia of the world's monuments and manufacture. However, copies usually took the form of three-dimensional reproductions made from plaster of Paris, and sculptural and architectural casts predominated in the collections. Gill's copies were executed in oil paint, not plaster, and thus occupied an ambiguous position, not only in terms of their placement in the Indian Court, but also in terms of their materiality. The official guidebook described these as 'copies of some frescoes found on the walls of a series of caverns at Adjunta (*sic*), in Western India, and were made at the instance of the Indian Government by Captain Gill of the Madras army'.

Robert Gill's talents as a draughtsman were highly regarded by the East India Company and he was an obvious choice when the Company was approached by the Royal Asiatic Society for a recommendation of a copyist.[21] Between 1844 and 1863, he painted thirty large copies in oil taking nearly twenty years to complete, working and living in the remote dramatic

location near Aurangabad, then in the territory of Nizam of Hyderabad. The Ajanta 'frescoes' were to be found inside the halls of monasteries (*caityas*) which had been hewn into a rock between in two phases, starting around the second century BCE with a second group dating from *c.*460–77 CE (figure 6.3).[22] Most of the series was put on display at the Sydenham Palace. Using pigments, such as lapis lazuli, the paint of the originals was applied using a technique known as 'dry fresco' (painted on top of dry plaster). The subject matter was described as scenes from the 'life of Buddha and of Buddhist saints, and various historical events connected with the rise and progress of the Buddhist religion in India'. Neither the surroundings of the cramped Indian Court, nor the brief guidebook entries, did much to evoke the wild drama of the setting of the rock temples at Ajanta, or the spiritual and ritual significance of the originals. In the Palace's official guidebook, Phillips then went on to make some interesting cross-cultural comparisons noting that 'in style they closely resemble the contemporary works of painters in Europe possessing nearly the same amount of artistic merit' – 'nearly', but not quite, is the implication here, swiftly putting some distance between the skills of Asian and European painters, and not qualifying which European painters he had in mind. However, Phillips rounded off his short assessment of Gill's copies by stating that the 'collection is valuable as affording the means of comparing the state of art in the East with that in the West during the same period'.

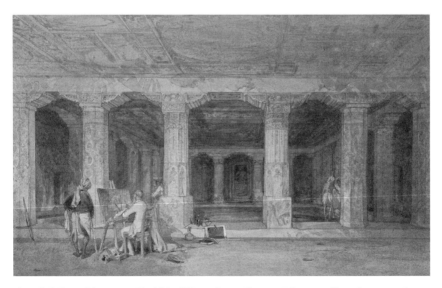

6.3 William Simpson, *Buddhist Vihara Cave, Ajunta*, 1862, pencil and watercolour. © Victoria and Albert Museum, London.

Such period-based comparisons were possible if the visitor also made a visit to the brightly painted Pompeian Court which contained 'reconstructions' of Roman wall paintings executed by the Neapolitan draughtsman Giuseppe Abbate, based on designs made in collaboration with Digby Wyatt based on recent excavations at Pompeii.[23] The results of such a comparison are not hinted at, although presumably the hierarchies of art, so carefully managed in the Sydenham courts, would not be completely overturned as to allow the painting of the ancient East to triumphantly cast a complete shadow over the early painting of the West. However, the open-ended nature of Phillips' invitation to make such a comparison via the displays at the Palace does allow at least for the potential of the arts of the East, even in spite of their small showing, to be appreciated and even to be compared favourably with European painting of a similar period. This was the ultimately the potential of the Palace, and as Kate Nichols has noted in her work on the Palace, its displays were always open to various interpretations and multiple readings.[24]

I can find no visual documentation recording how the copies were displayed, and such an absence is certainly significant. However, Owen Jones made one of the most conspicuous, and immediate, responses to Gill's Ajanta copies in his landmark publication *The Grammar of Ornament* which was published in 1856 (figure 6.4). In the section on 'Hindoo Ornament' (remember that the paintings were from Buddhist monasteries), Jones remarked:

> On Plate LVII, we have gathered together all the examples of decorative ornament that we would find on the copies of the paintings from the Caves of Ajunta (*sic*), exhibited by the East India Company at the Crystal Palace.

As copies of this 'Hindoo' art, Jones was however suspicious of their authenticity. Quick not to cast aspersions on Gill's abilities, he clarified that he was sure that they had been faithfully copied, but 'are yet by a European hand', and as a result, he summed up, 'it is difficult to say how far they may be relied upon'. That the plaster copies of the Egyptian and Assyrian sculpture had been made by European workmen did not seem to cast doubt on their usefulness, and Abatte, the artist responsible for the Pompeian Court paintings was described as having the 'authority of one risen from the dead', but for Jones, it would seem that painted copies taken from India were somehow more subjective and not 'facsimile' reproductions in the way that plaster copies or copies of ancient European art were seen to be. They were, Jones suggested, also quite unspecific. Writing about the 'ornamental' section of the frescoes, he observed that 'there is so little marked character, that they might belong to any style

6.4 Owen Jones, *The Grammar of Ornament* (London: Day and Son, 1856), Plate
57, British Library HS.74/376. Author's photograph.

… There is a remarkable absence of ornament even in the dresses of the figures.'[25]

Jones struggled to place the paintings from Ajanta, to know what to do with these remarkable and very early ancient paintings. The implication here is that they were also not 'ornamental' enough to be useful for European designers, whom the Crystal Palace directors envisaged coming in droves to the Palace to study in the Fine Arts Courts. With their detailed scenes from the *jatakas* – the tales of the lives of the Buddha – depicted in great detail the natural world, courtly life and the spiritual realm, the Ajanta paintings undoubtedly challenged prevalent assumptions about the slower development of naturalist representation in Eastern aesthetics in comparison with the art of the West. Employing foreshortening, perspective and complex compositions to great effect, the Ajanta series of paintings remain one of the most complete cycles of ancient art that survives.

It would seem that Gill also questioned the usefulness of painted copies and, as an enthusiastic amateur photographer, began to think about the potential of photography for making more accurate copies. In 1850s, the Madras Government supplied Gill with a camera and in 1862 he sent nearly two hundred stereo views of scenes of Indian life from around Ajanta back to England. A selection of these was published in 1864 in *One Hundred Stereoscopic Illustrations of Architectural and Natural History in Western India* and in *Rockcut Temples of India*, both with texts by James Fergusson (figure 6.5).[26] When the East India Company asked him to take photographs of the Ajanta and Ellora caves, Gill realised that he would have

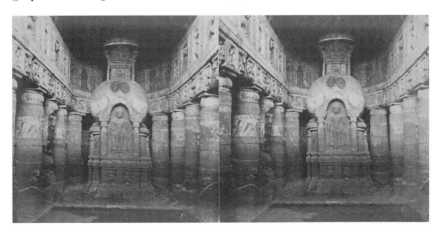

6.5 Robert Gill, '*Interior of Cave 19, Ajanta*', 1864. *One Hundred Stereoscopic Illustrations of Architectural and Natural History in Western India* and in *Rockcut Temples of India* (London: Cundall & Downes, 1864), British Library. Author's photograph.

to work in cramped spaces and requested a 10 × 8 in. camera, specify-
ing a Dallmeyer Newpatent Rectilinear (wide-angle) lens.[27] He was a
member of the Bombay Photographic Society and presumably such tech-
nical knowledge came from correspondence with other members.[28] While
longevity for his photographs was safely secured through publication, the
painted copies were not so lucky and were destroyed in the calamitous
fire of 1866 which ravaged much of the building at Sydenham. The few
Gill copies not sent to the Crystal Palace belonged to the collection of the
India Museum, owned by the East India Company, and were displayed
in 1873 at the South Kensington annual exhibition.[29] However, the rest of
the collection of Indian material at Sydenham and all of Gill's copies were
nothing but ashes.

Ajanta and the Festival of Empire

Ajanta did come again to Sydenham. The next time was in 1911 in the
Indian Court of the Festival of Empire, making the journey only very
shortly after the paint had dried on a set of copies, also made in situ in
India, between 1909 and 1911 by Christiana Herringham and her team,
which included students Nandalal Bose, Samarendranath Gupta and Asit
Kumar Haldar from Calcutta Art School. All were students of the Vice-
Principal and key figure in the Bengal cultural revival, Abanindranath
Tagore, and would play an important role in the nationalist art movement
in India. They were joined by Syad Ahmed and Muhammad Fazl ud Din,
both from the Government Art School at Hyderabad, and one British
artist, Dorothy Larcher, was recruited from Hornsey Art School to join
Herringham's team.

Christiana Herringham (1854–1929) was an active artist, campaigner
and organiser who, as her biographer Mary Lago writes, 'played an
important part in the cultivation of new attitudes towards the fine arts in
Britain and in Britain's Indian Empire'.[30] Travelling between Britain and
India from 1906 and 1911, she was a prominent voice in the promotion of
Indian art in Britain and she fostered important connections with artists
in India. Yet despite all her incessant cultural activity, both in Britain and
India, Herringham's career has been largely forgotten.[31] Translator of
Cennino Cennini's fifteenth-century manual on painting, *Il Libro dell'arte
o trattato della pittura* (1899), a founder member of the movement to revive
tempera painting, and a significant financial backer of both the National
Art Collections Fund (now known as The Art Fund) and *The Burlington
Magazine*, Herringham is only known to a small circle of Edwardian art
aficionados.

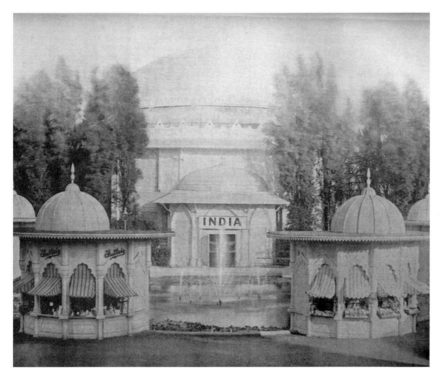

6.6 'Exterior of the Indian Court at the Festival of Empire, 1911', *Journal of Indian Art and Industry*, vol. XV, no. 117 (London: W. Griggs and Sons, 1913). Author's photograph.

The Indian Court (figure 6.6) was a much grander affair than its predecessor, situated in a separate pavilion in the grounds of the Palace and was reached by travelling on a miniature railway called the 'All Red Route'. On the hot summer days of 1911, visitors to the Festival of Empire could take a mile-and-a-half trip on this electric railway 'travelling' through the British Empire, constructed at a cost of £40,000 (see figure 1.7).[32] On the journey the train passed three-quarter replicas of parliament buildings in the colonies and dominions, tableaux of colonial life populated by 'natives' and live animals, and scenes of imperial landscapes and industries, such as an Indian tea plantation, connecting what Sir Melville Beachcroft, the Vice-Chairman of the Executive Council· called the 'Red World', a reference to the colouring of British colonies in red on maps. The visitor could alight from the train at different countries, then re-board and zip off to another region of the British Empire.

In connecting the colonies and dominions of the British Empire by the All Red Route railway and miniaturising Parliament and other buildings,

the Festival offered the visitor a manageable, ordered, consumable and connected image of the British Empire: *The Illustrated London News*'s tagline, a 'world in a suburb', expressed it succinctly. The miniature according to Susan Stewart, 'offers a world clearly limited in space but frozen and thereby both particularized and generalized in time – particularized in that the miniature concentrates upon the single instance and not the abstract rule, but generalized in that that instance comes to transcend, to stand for, a spectrum of other instances'.[33] This play between the 'particular' and the 'general' was certainly in operation at the Festival of Empire through the miniaturised buildings which stood in for the different regions of the Empire. The site offered a world view 'limited in space', which could evoke a 'spectrum of other instances' beyond the perimeter fence of the Sydenham Palace site, encouraging the visitor to indulge in an 'imaginative geography' of empire.[34]

Taking place exactly sixty years after the Great Exhibition, the Festival of Empire was inaugurated with a 'Grand Opening Concert' on 12 May 1911.[35] Originally planned for 1910, but postponed owing to the death of King Edward VII, the 1911 version of the festival 'took a far wider and more Imperial shape', according to Beachcroft.[36] It was certainly an Edwardian event, bumped into the next monarch's reign by unforeseen circumstances. Music was provided by the Queen's Hall Orchestra, the London Symphony Orchestra and the Festival of Empire Military Band, conducted by such Edwardian musical luminaries as Sir Hubert Parry, Sir Alexander Campbell Mackenzie and Sir Henry Wood. The concert included Elgar's arrangement of 'God Save the King' and his 'Land of Hope and Glory', as well as a 'Patriotic Chorus: For Empire and for King' by Percy E. Fletcher creating an unparalleled imperial soundscape.[37] The Sydenham Palace and 'especially the grounds', said Beachcroft, became in 1911 the 'temporary home, so to speak, of the Empire of which London is the Metropolis'.[38] This temporary homing of the Ajanta copies by Herringham and her team within the imperial space of the Festival of Empire serves to remind us of the entanglements of the display and writing on Indian art with the popular spectacle of international exhibitions well into the twentieth century.

On 16 April 1911 Herringham gifted her copies of the Ajanta cave paintings to the India Society, a body that campaigned for better knowledge of Indian art, and it was the society that arranged for their display (figure 6.7).[39] Made transportable to the colonial exhibition in London, Ajanta was quite literally framed, translated from the walls of the dark cave-temple to the canvas-backed cartridge paper and placed under the strong, and much celebrated, electric lighting of the Empire exhibition,

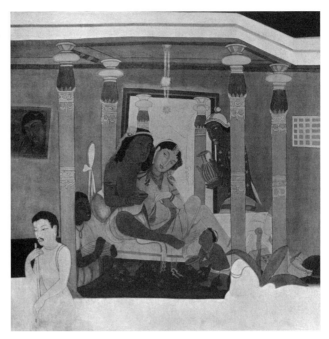

6.7 'Royal Love Scene, Cave XVII', Plate 3, *Ajanta Frescoes, 42 plates in colour and monochrome, with explanatory and critical texts by Lady Herringham, Laurence Binyon, William Rothenstein and others* (London: India Society, 1915).
© British Library Board.

alongside the wide array of other Indian art and manufacture on display. Aware of the deficiencies of such a setting in conjuring the atmosphere of the original location in India, Herringham observed in the catalogue to the Indian section: 'Copies of detached portions of these wall paintings deprived of their surroundings and framed, can give very little notion of the real effect of the whole.' The paintings she and her team had made were, she quite freely admitted, not exact 'copies', but interpretations by artists whose skills, she stressed, were inferior to those of the original artists. She did not worry too much about the inscriptions or the chronology of the caves. She gave her reasoning thus: 'A copy of a damaged picture must necessarily look like the copying of a badly painted or unfinished one. In reality, the technique of the original work is so sure and swift and perfect, that we, none of us, were good enough executants to repeat it.'[40]

She frequently stressed that her relationship with India was as an artist, not as an historian or archaeologist. She did, however, contribute writing on the paintings at Ajanta to *The Burlington Magazine*, *The Times* and for an essay in the India Society publication. Herringham's encounter with

Indian art was relatively brief, but her role in bringing the art of Ajanta to the attention of artists, writers and a larger audience in Britain through the display of her copies of the site at the 1911 Festival of Empire came at an important juncture for interpretations of Indian art in the imperial metropolis.[41] 'Copyist' perhaps does not adequately describe her position. As Herringham herself had pointed out, these were not exact copies, but translations produced by intermediaries – Herringham and her team – resulting in visual interpretations of this ancient Buddhist cycle for a modern audience.

In their status as copies, the Ajanta paintings displayed at Sydenham belong within the networks of what Saloni Mathur has described as the 'mimetic imperative' of the colonial cultural system. Copies of European sculpture and painting were regularly shipped in to feed 'gaps' in colonial collections in art schools and museums and, in return, important colonial monuments and archaeological sites were transported out of the colonies to be displayed at the international exhibition and in the museums of European capital cities.[42] In the context of the Festival of Empire, the copies were interpreted as a material manifestation of the Festival's message about the bonds of union of the 'imperial family' that the pageant had also conveyed. One reviewer noted that the 'co-operation of these young painters and the disinterested devotion, courage and skill by which an English lady has carried so arduous an enterprise' was one of the 'durable impressions carried away from this Festival of Empire with all its show of material activities'.[43] In this interpretation, the Ajanta project was seen as a conduit of imperial cooperation between Britain and India, and more specifically, Herringham was cast in the role of imperial matriarch.

However, the Ajanta copies, their display in 1911, and subsequent publication by the India Society in 1915 also elicited other responses from artists and art writers in both Britain and India, conjuring new articulations about the aesthetic significance of Indian art to the world's art history, ancient and modern.[44] In 1911, the Ajanta copies shared an exhibition space with paintings and drawings by contemporary Indian artists connected to the cultural revival led by artists such as Abanindranath Tagore and Nandalal Bose. In his essay for the Indian Court's guidebook, Ananda Coomaraswamy, an art historian and prominent member of the India Society, who was closely associated with the nationalist cultural revival in India, described the works on display as visually embodying a phase of 'national reawakening', a sentiment that was undoubtedly at odds with the official message of imperial union and a deeply political one too given the contemporary unrest in parts of India associated with nationalist campaigns.[45]

The involvement of the India Society and some of its most promi-
nent members in the organisation of its Indian Section highlights that the
Festival, and to a larger extent the Sydenham Palace, was a complex space
in which different messages about Britain's relationship with the colonies
could be articulated alongside, or in competition with, one another. It
should also be emphasised that the participation of various members of
the India Society in the Festival was by no means uniform. T. W. Arnold,
E. B. Havell and Walter Crane sat on the Indian Committee of the
Festival, headed by Colonel Thomas Holbein Hendley, a former officer
in the Indian Medical Service and writer on Indian art. Private exhibi-
tors and India Society members in the Indian Court included Crane,
Havell, Herringham, William Rothenstein and Abanindranath Tagore.[46]
Herringham and Rothenstein both resigned from the Festival's Indian
Committee, although this decision did not affect Herringham's copies
of the Ajanta paintings which were displayed under the auspices of the
India Society. Herringham wrote to Rothenstein saying, 'I hate the name
Imperial Festival.'[47] Havell had written to Rothenstein at the beginning of
1910 saying that the Secretary of the Festival had approached him some
time ago with the idea of an Indian section with an exhibition of Indian
pictures 'old and new'. Havell was worried that it was not a suitable place
for such a show, but reasoned that 'the exhibition may serve to create
interest in the subject and lead to better things afterwards', by which
he presumably meant better knowledge of Indian art among the British
public.[48] It was also Herringham's expressed wish that her copies find
a permanent home in Britain so that students could learn about Indian
aesthetics. This interest in Ajanta in 1911 was not simply an antiquarian
one, but was also linked to the simmering politics of Indian artistic and
cultural revival.

As this chapter has demonstrated, the display and encounter with
Indian art at Sydenham in the Palace's first years was somewhat compro-
mised by the physical conditions of its display, and the directors' somewhat
ambivalent attitude towards South Asian art, seeming to prefer its natural
history rather than the ancient and venerable art historical traditions of
South Asia. The differences between the tacked-on 1855 Indian Court
and the 1911 Indian display housed in its own pavilion is telling about
the changing relationship between Britain and India and its increasingly
important place in the British Empire from the second half of the nine-
teenth century onwards. However, both in 1855 and 1911, the position of
Ajanta at Sydenham was delicate and the reception of the copies by both
Gill and Herringham and her team was impinged upon by the conditions
of their display. As painted copies, their status was in many ways a fragile

one; always interpretations, or translations, rather than direct impressions from the originals. Their authority could always be questioned, as had been the case with Owen Jones's assessment in *The Grammar of Ornament* in 1856. In 1911, just below the painted copies were hung over one hundred photographs of the caves and their paintings by Victor Goloubew, who had worked in the caves at the same time as Christiana Herringham, and it was these photographs that won the Gold Prize at the exhibition.[49] The painted copies, significantly, were not awarded anything. After a spell at the Victoria and Albert Museum after the Festival of Empire, the copies were returned at the request of the State of Hyderabad in 1931.[50] From Ajanta, then to Sydenham, and then back to India again, like many copies, these examples travelled back and forth through the restless circuits of empire.

Notes

I would like to acknowledge the advice, inspiration and friendship of Kate Nichols.

1 The literature on India at nineteenth-century international exhibitions has been the subject of some excellent research on the impact of 'empire at home'. C. Breckenridge, 'The Aesthetics and Politics of Colonial Collecting: India at World Fairs', *Comparative Studies on Society & History*, 31:2 (1989), 195–216 was path-breaking. Other important and rich studies on this topic include: P. Hoffenberg, *An Empire on Display: English, Indian and Australian Exhibitions from the Crystal Palace to the Great War* (Berkeley and London: University of California Press, 2001); L. Kriegel, 'Narrating the Subcontinent in 1851: India at the Crystal Palace', in L. Purbrick (ed.), *The Great Exhibition of 1851: New Interdisciplinary Essays* (Manchester: Manchester University Press, 2001), pp. 146–78; S. Mathur, *India by Design: Colonial History and Cultural Display* (Berkeley and London: University of California Press, 2007). For South Kensington and India, see in particular T. Barringer, 'The South Kensington Museum and the Colonial Project', in T. Barringer and T. Flynn (eds), *Colonialism and the Object: Empire, Material Culture and the Museum* (London: Routledge, 1998), pp. 11–27. See also my other essays on sculpture and empire: 'The "Essential Quality of Things": E. B. Havell, Ananda Coomaraswamy and Indian Sculpture in Britain', *Journal of Visual Culture in Britain* (2010), 239–64, and 'Victorian Sculpture, International Exhibitions and Empire', in M. Droth, J. Edwards and M. Hatt (eds), *Sculpture Victorious: Art in an Age of Invention 1837–1901* (New Haven, CT: Yale University Press, 2014), pp. 298–305.

2 Such images were often signified by the exhibition of indigenous labourers and artisans who would perform their 'native skills' for a metropolitan audience, or by dioramas and models supposedly representing life and work in the colonies. See Sadiah Qureshi's important book on human displays

of indigenous people, *Peoples on Parade: Exhibitions, Empire, and Anthropology in Nineteenth-Century Britain* (Chicago: University of Chicago Press, 2011).

3 Presenting this research on Ajanta and Sydenham at Birkbeck, the Paul Mellon Centre for Studies in British Art and Yale University, and the extremely helpful responses to my papers, has helped me to develop this work and the arguments put forward here. I am very grateful to the organisers who invited me to speak on this subject and the audience members who responded to my ideas. Lynda Nead's question about the relation between nation and empire in the case of Sydenham has been particularly useful.

4 S. Phillips, *Guide to the Crystal Palace and its Park and Gardens* (London: Crystal Palace Library, rev. edn, 1858), p. 141.

5 M. D. Wyatt, *Views of the Crystal Palace and Park* (London: Day & Son, 1854), p. 20.

6 Phillips, *Guide to Crystal Palace*, p. 141.

7 *The Times* (2 October, 1851), quoted in Mathur, *India by Design*, p. 16.

8 K. Haskins, *The Art-Journal and Fine Art Publishing in Victorian England, 1850–1880* (Farnham: Ashgate, 2012).

9 'The Value of the "Courts" of Architecture and Sculpture at the Crystal Palace', *Art Journal*, 6:68 (1854), 233.

10 'School of Sculpture at Sydenham', *Art Journal*, 6:69 (1854), 257.

11 *Ibid.*

12 *Sydenham Crystal Palace Expositor* (1854), 5.

13 S. Phillips, *Guide to the Crystal Palace and its Park and Gardens* (London: Bradbury & Evans, 1854), p. 137. The animals were not sourced from India, but had been denizens of a landscape closer to home, the zoo in Regent's Park.

14 G. Measom, *The Crystal Palace Alphabet. A Guide for Good Children* (London: Dean & Son, 1855).

15 'Tiger Hunt', *Illustrated Crystal Palace Gazette* (1 July 1854), 168–9, quoted in Qureshi, *Peoples on Parade*, p. 206.

16 N. Levell, *Oriental Visions: Exhibitions, Travel, and Collecting in the Victorian Age* (London: Horniman Museum and the Museu Antropológico de Coimbra, 2000), p. 30.

17 See India Office Records, British Library IOR L/F/2/192, Finance & Home Committee, 27 September 1855.

18 Levell, *Oriental Visions*, p. 38.

19 See T. Guha-Thakurta, *Monuments, Objects, Histories: Institutions of Art in Colonial and Post-Colonial India* (New York: University of Columbia Press, 2004).

20 Robert Gill was part of the 44th Madras Native Infantry. He was born in London on 26 October 1804 and elected to go to India when he signed up in 1835.

21 R. Desmond, *The India Museum 1801–1879* (London: Her Majesty's Stationery Office, 1982), p. 104.

22 *Ajanta Frescoes Being Reproductions in Colour and Monochrome of Frescoes in Some of the Caves at Ajanta after Copies Taken in the Years 1909–1911 by Lady Herringham and her*

Assistants, with essays by various members of the India Society (London, Edinburgh, Glasgow, New York, Toronto, Melbourne, Bombay: Humphrey Milford and Oxford University Press, 1915).

23 J. R. Piggott, *Palace of the People: The Crystal Palace at Sydenham* (London: Hurst & Co., 2004), p. 98.

24 K. Nichols, *Greece and Rome at the Crystal Palace: Classical Sculpture and Modern Britain 1854–1936* (Oxford: Oxford University Press, 2015).

25 O. Jones, *The Grammar of Ornament* (London: Day & Son, 1856), p. 83.

26 G. Thomas, 'Major Robert Gill in the Nizam's Dominion of Berar', *History of Photography*, 7:4 (1983), 327.

27 See R. Desmond, *Photography in India during the 19th Century* (London: India Office Library, 1974), p. 26.

28 Later, in his correspondence with the Bombay Photographic Society, he is said to have suggested that one way of solving the problem of taking photographs might be to work from a balloon, suspended in front of the cave. Thomas, 'Major Robert Gill in the Nizam's Dominion', 327.

29 Desmond, *The India Museum*, p. 105. Following the destruction of Gill's work in the Crystal Palace fire, the Government of Bombay sent the Principal of J. J. School of Art in Bombay, John Griffiths, on a twelve-year campaign to make new copies at Ajanta in 1872. Three hundred paintings were shipped to London only to be victims of the cruel fate of history when the majority, save some fragments, were also destroyed in a fire at the Imperial Institute.

30 M. Lago, *Christiana Herringham and the Edwardian Art Scene* (London: Lund Humphries, 1996), p. 1.

31 Mary Lago's biography of Herringham is certainly an exception and is the result of painstaking research into an artist deemed 'minor'. More recently, Rupert Richard Arrowsmith has discussed Herringham's work in relation to that of William Rothenstein and the Bengal School. See R. R. Arrowsmith, '"An Indian Renascence" and the Rise of Global Modernism: William Rothenstein in India, 1910–11', *The Burlington Magazine*, 152 (2010), 228–35.

32 Sir Melville Beachcroft, 'Note on the History, Objects, and Ideals of the Festival', *Journal of Indian Art and Industry*, 15:117 (1912), 2.

33 S. Stewart, *On Longing: Narratives of the Miniature, the Gigantic, the Souvenir, the Collection* (Durham, NC: Duke University Press, 1993), p. 48.

34 F. Driver, *Geography Militant: Cultures of Exploration and Empire* (Oxford: Blackwell, 2000), p. 148.

35 *Festival of Empire: The Pageant of London, May to October, 1911* (London: Bemrose, 1911). For an excellent discussion of the Festival of Empire and the Pageant of London see D. S. Ryan, 'Staging the Imperial City: the Pageant of London, 1911', in F. Driver and D. Gilbert (eds), *Imperial Cities. Landscape, Display and Identity* (Manchester: Manchester University Press, 1999), pp. 117–35.

36 Beachcroft, 'Note on the History, Objects, and Ideals of the Festival', 3.

37 'Festival of Empire: Grand Opening Concert' booklet, contained in Miss

Noel's scrapbook, National Art Library, Victoria and Albert Museum, MSL/1971/4510.

38 Beachcroft, 'Note on the History, Objects, and Ideals of the Festival', 2.

39 *The India Society Report for the Year Ending December 31, 1911* (London: printed at The Chiswick Press, 1912), p. 5.

40 Herringham, 'The Paintings (Frescoes) of the Ajanta Caves', in *Ajanta Frescoes Being Reproductions in Colour and Monochrome*, p. x.

41 See S. V. Turner, 'Crafting Connections: The India Society and Inter-imperial Artistic Networks in Edwardian Britain', in S. Nasta (ed.), *India in Britain: South Asian Networks and Connections, 1858–1950* (Palgrave Macmillan, 2012), pp. 96–114. The ground-breaking book on the European reception of India art is Partha Mitter's *Much Maligned Monsters: A History of European Reactions to Indian Art* (Oxford: Clarendon Press, 1977). See also R. R. Arrowsmith, *Modernism and the Museum: Asian, African, and Pacific Art and the London Avant-Garde* (Oxford: Oxford University Press, 2010).

42 Mathur, *India by Design*, p. 85.

43 'Buddhist Paintings at the Festival of Empire', *The Times* (7 September 1911), p. 7.

44 Arrowsmith, '"An Indian Renascence"', 228–35.

45 A. K. Coomaraswamy, 'The Modern School of Indian Painting in 1910', *Festival of Empire 1911: The Indian Court Guidebook and Catalogue* (London: Bemrose & Sons, 1911), p. 109.

46 A detailed list of the Indian Committee can be found in the *Journal of Indian Art and Industry*, 15:117 (1912).

47 Houghton Library, Harvard University, Papers of William Rothenstein, MS ENG 1148/694/16, Letter from Christiana Herringham to William Rothenstein, 31 May 1911.

48 Houghton Library, Harvard University, Papers of William Rothenstein, MS ENG 1148/680/2, Letter from E. B. Havell to William Rothenstein, 15 February 1910.

49 For more on the disastrous relationship and rivalry between Herringham and Golobew, see Lago, *Christiana Herringham*.

50 *Ibid.*, p. 246.

7

Peculiar pleasure in the ruined Crystal Palace

James Boaden

In ruined palaces there lies a peculiar pleasure.[1]

A lump of molten glass studded with grit and charred with smoke. It's not quite a crystal ball – more of a milky lump marbled with soot – but for some it acts as a way of seeing into the past. London is littered with these lumps. There is one on loan to the Victoria and Albert Museum, where it sits at the base of a case of memorabilia relating to the Crystal Palace, it acts there as a peculiar souvenir of sorts. Others were used as outdoor ornaments to pick out the pathways of gardens in Sydenham. These rocks of glass were found following the great fire of 1936 that saw the major part of the Palace building collapse in an enormous blaze that sent rivers of molten glass seeping into its foundations. *The Guardian* reported: 'The flames shooting from the blazing structure made a dazzling red glare in the sky which could be seen for many miles. The crashing of glass and woodwork was heard at places far distant, and sparks fell at Beckenham, two miles away. The glare was seen from Devil's Dyke, Brighton, nearly fifty miles away, and from Hogs Back, the belt of hills in Surrey.'[2]

The reports make clear that many came out of their homes to see the blaze, and that spectators reminisced about the times they had spent there in better days. Most, though, seemed to come simply for the spectacle, for the pleasure. The site had long been used for crowd-pleasing firework displays and observers at the time saw the fire as its final hurrah. What a strange, almost alchemical, transformation occurred that evening as a skyward vision of crystalline brilliance fell to become mere matter lodged into the ground on which it was built.

The suburban gardeners who took these globs of glass and planted

them among their herbaceous borders were also involved in an act of transformation – taking a sign of grand-scale ruination and transforming it into a domestic pleasure. This chapter considers the ruination of the Crystal Palace site and how it might be understood as an allegory for the state of the nation in the mid-twentieth century. In particular it examines James Broughton's film *The Pleasure Garden*, shot in the ruins of the Palace, in terms of transforming the ruins into a site of eccentric pleasure.

The ruins of Sydenham

The palace was run down at the time of the fire; in the mid-1970s C. F. Bell-Knight recalled visiting just before the blaze: 'It presented a most woe-begone picture, peeling and sun blistered paintwork, the glass grimy, ironwork encrusted with rust and stonework suffering from erosion … The grottoes were literally refuse bins and fouled by urine and excreta … It was a sad and sorry sight – as if the old palace was about to give up the ghost.'[3] Ghosts seemed to be also on the mind of Christopher Hobhouse, who wrote a history of the Palace published the year after its destruction:

> You arrived at the Crystal Palace to find it towering above you like a glass cliff … You entered by a dingy passage beneath the organ. On most occasions the place was as empty as the tomb. On your left lay the historical courts. One after another you passed through these tawdry reproductions of the hundred and one styles that all came alike to the Victorians. In some of them, masses of aspidistra had been introduced to give the Latin effect, and seemed positively welcome by the mere fact of being, albeit furtively, alive … There were refreshment rooms so long deserted as to impose upon the hungry customer the sensation that he was committing an act of awful impiety, as though he were eating food dedicated to the use of a dead Pharaoh, somewhere in King Solomon's Mines.[4]

Despite the valiant – and indeed somewhat successful – efforts of the Palace's general manager Sir Henry Buckland to repair and rejuvenate the fortunes of the Palace in the inter-war years, it is clear that it would forever be associated with the previous century.[5] These memories suggest that by the mid-1930s the Palace had become a monument to a different mindset. It may well have begun to acquire the kind of appeal that both Walter Benjamin and the Surrealist group were beginning to find in the glazed arcades of Paris that were threatened with demolition at this time.[6] Those passages sheltered shops selling clothes that nobody wanted, housed cafes that were barely frequented, and offered dingy premises for eccentric businesses. But these spaces captured the imagination; they had once been at the height of fashion and drew attention to the transitory nature

of modern life and the peculiarity of that which was left behind when fashions moved on. While Louis Aragon in his novel *Le Paysan de Paris* took pleasure in the arcades for the way in which they showed a dream world of the commodity now devoid of the appeal of the new, Sydenham seemed to contain an outmoded vision of the past.[7] The collection of casts and courts inside the building, and the disjointed collage of history they narrated, were a mirror to the idea of colonial adventure and a belief in the timeless beauty of a classical style. The palace was clearly intended as both a didactic, patrician space that would better the tastes of its visitors as well as a populist spectacle.

Douglas Murphy has described the way in which the Sydenham site could be thought of as already ruined from the outset. Murphy understands its presentation of a plaster cast and paperboard history as, 'riven between two simultaneous yet opposing logics, that of permanence and that of transience', a dialectical space that was, 'fragmented in the manner of what Walter Benjamin calls "the Ruin"'.[8] For Murphy the building – from the time of its opening in Sydenham – was caught between the transitory quality of festival architecture and the seeming rootedness of its historical displays linking it to romantic ideas of the ruin taken up by Benjamin. Hobhouse's and Bell-Knight's memories of the Palace suggest that by the time of its destruction it was already a space of deep melancholy – with enough of a sense of death to bring it into a ghostly life.

By the time of the Depression the building also stood as an allegory to the decay of imperial capitalism. The site had been used repeatedly throughout the early twentieth century as a space to stage the imperial ambitions of the nation. In 1911 the Festival of Empire had been held there, the lawns filled with a village of temporary buildings dedicated to each of the countries within the Empire at that time. From 1920 to 1924 the Palace itself housed the Imperial War Museum, showing the long reach of British military involvement across the globe. During the Depression it stood as testimony to a time of greater prosperity built on an empire that was beginning to become fractious. While the courts contained fragmented representations of toppled empires of the past – that of the Ancient Egyptians and Greeks, Romans and Moors – they were contained within an edifice that seemed to assert the ruin of the British Empire itself. The remains of the fire, then, were a ruin of a ruin. Although photographers caught images of fallen statuary prostrate among the iron girders in the days following the fire it was not long before Buckland had cleared much of the site and all that remained were those carbonated boulders of glass.

During the Second World War the remains of the building and the

park around it lay mostly abandoned, the two flanking water towers designed by Isambard Kingdom Brunel were taken down and the metal used for munitions. In 1950 the final remaining section of the building burnt down. Between the fire of 1936 and that of 1950 the face of the rest of London had been repeatedly scarred by bombing, leading the city to an ambivalent relationship with the past. On the one hand, with so much destruction all around, it became difficult to really think through what had been lost. On the other there was a heightened awareness of the historical importance of the built environment through organisations such as the National Buildings Record that had been set up to photograph architecture threatened with destruction. It would have been easy for the Crystal Palace to have simply drifted out of memory by mid-century, lost just like so much of the pre-war world. However, the 1951 centenary of the Great Exhibition in Hyde Park, for which the Palace had originally been built, meant that the site returned to the public consciousness at this time.

As early as 1943 the Royal Society of Arts had proposed to the government a festival to celebrate the centenary of the Great Exhibition. For a while it was expected that this would take the form of an international exhibition, a 'Worlds' Fair'. A number of obstacles led to the development of a very different festival, one that would support the process of post-war reconstruction and a re-evaluation of national identity.[9] The Festival of Britain, held on the bomb-damaged South Bank of the Thames near Waterloo, would be a celebration of the British character with a positive look towards both the past – in its promotion of traditional crafts, such as corn dollies – and the future – in the audaciously modern design of structures such as the Skylon and Dome of Discovery.

As the plans developed, the Festival moved away from its focus on commemorating the Great Exhibition. Both Hyde Park and the Sydenham site were briefly considered as a space for holding the Festival, spaces which would have linked it clearly to the Great Exhibition. In the 1950s, as Becky Conekin has explained in her history of the Festival of Britain, the Labour Government's struggle to manage the problems in the Middle East, Africa, and South East Asia coupled with the tragically bloody partition of the Indian sub-continent made the lost British Empire a taboo topic for a morale-boosting festival.[10] The Crystal Palace did eventually feature within the designs for the festival buildings but in a marginal form; a very small pavilion that echoed the shape of Paxton's design was erected on the South Bank site – filled with ostrich feathers, while the Festival Gardens in Battersea incorporated a screen shaped as the Palace, made from cane, as part of the Grand Vista, designed by the artist John Piper and the illustrator Osbert Lancaster. In his work as an official war artist Piper had

created a number of works depicting ruined buildings and after the war was employed on the rebuilding of Coventry Cathedral.

James Gardner, who was in overall charge of the Battersea Gardens design, described the Grand Vista as, 'a lacy screen like the Crystal Palace with a great bank of trees behind it, then a lake with fountains … and shallow steps leading down in the Venetian manner, flanked by two colonnades'.[11] Both representations of the Palace were romantic evocations of a lost time, which played on the idea that the past was a pastoral realm. This way of understanding the recent past seemed to neatly sidestep the problem of the legacy of Empire that Conekin has registered as a pressing one for the Festival organisers. Turning the Palace into a filmy whimsical mirage or a vitreous jewel box left very little opportunity for thinking about what it had meant historically, and what its architecture, its message, and its site meant for contemporary Britain.

The Pleasure Garden

At the time of the Festival of Britain James Broughton began making a film at Sydenham that provides a different way of thinking about ruination and the shadow of the Palace in the early 1950s. Broughton was a poet and filmmaker who lived and worked in San Francisco. He made his first foray into filmmaking in 1946 and published his first book of poetry the following year; he continued to make films and write poetry until his death in 1999. In 1951 he moved to the UK and made *The Pleasure Garden* (1953), his only film intended for commercial release. The film, which runs for only 38 minutes, took two years to complete. The experience of making the film and its subsequent reception caused a hiatus in Broughton's filmmaking that lasted more than a decade. Although Jean Cocteau awarded it a special prize at Cannes in 1954, the film is widely regarded as a low point in Broughton's career. The experimental filmmaker Stan Brakhage wrote, 'It is too strange, too weird a work to become popular. It is filled with anxious wit – it is ratchety. The viewer finds himself laughing, but at the same time is disturbed.'[12]

The Pleasure Garden draws on Broughton's previous experimental work, such as *Mother's Day* (1948) and *Four in the Afternoon* (1951), which are short exaggerated character studies set in the ruins of buildings or public parks that act out the verse he was writing at the time. *The Pleasure Garden* follows a more conventional narrative and has been criticised for selling out the avant-garde to the culture industry.[13] However, examining the film's site of manufacture may hold a key for unlocking a more subversive reading of *The Pleasure Garden*, explaining its 'ratchety humour'.

In his 1993 autobiography Broughton recalls some of the reasons for moving to Britain: 'We were seeking a more sympathetic country. Not only had the war in Korea increased military censorship, but the excesses of Senator McCarthy and his gross sidekick Roy Cohn had made liberal thought perilous.'[14] This comment refers not only to the general state of the arts in America, but the very particularly 'perilous' situation in which a queer artist like Broughton was placed at the time. The planned trip was an escape from authority, a chance to play the rebellious child/man that had featured so prominently within his earlier films.

The four films Broughton had made since the late 1940s were accepted for inclusion in the Edinburgh film festival of 1951. In August of that year Broughton persuaded his lover Kermit Sheets to travel to Europe with him and they left the Centaur Press, the business they had run for the previous five years, in the hands of the poet Robert Duncan and signed over their apartment to Duncan and his lover Jess. In New York they boarded a ship for London. Broughton had an idealised vision of England that he found confirmed on arrival, staying with the illustrator and musician Gerard Hoffnung, 'in a pseudo-Tudor cottage in Golders Green that could have been the model for the witch's house in Hansel and Gretel'.[15] Broughton writes in a postcard to Jess from Cambridge, 'England, England. The weight of the past comes down upon one, visually […] for the eye things are conditioned by medieval architecture and neat landscapes. Quaintness and charm, of course. But no shapes for anarchy.'[16]

One of the first things Broughton did in London during the wet summer of 1951 was visit the Festival of Britain. As Broughton's films were seen by various influential figures in the film world, he began to acquire a reputation. By the time he got to Edinburgh (where his film *Loony Tom* (1951) was honoured with an award) Broughton had garnered the attention of Denis Forman, the head of the British Film Institute (BFI), who agreed to try and find funding for a new project that could be made in the UK. A small committee was set up calling itself 'Flights of Fancy'. The group consisted of Denis Forman, the poet and critic Paul Dehn, Gavin Lambert, the head of BFI publications, and the documentary filmmaker Basil Wright. Broughton described his situation to Duncan: 'This is a little like falling into a fairy tale full of good fairy godfathers; it will be nice if it is not just a dream. I cross fingers daily.'[17]

The film was made with the assistance of two of the future voices of the British 'free cinema' movement, Lindsay Anderson and Gavin Lambert. In a number of articles written for the BFI's mouthpiece *Sight and Sound* and the film journal *Sequence*, Anderson offered a severe critique of the British documentary movement as it was represented by the followers of

John Grierson, instead reserving praise for Humphrey Jennings, the Mass Observationist and British Surrealist who completed more lyrical works such as *Britain Can Take It* (1940) and *Fires Were Started* (1943) during the war years.[18] Jennings had also made the film *Family Portrait* (1951) for the Festival of Britain, which attempted to show the nation brought together as a single family. Anderson's dismay at the state of the British independent film was shared by Kermit Sheets, who wrote to Jess and Duncan from Edinburgh: 'It is so grim, so cold, so deadly. I am sure that the Scots invented the word SERIOUS, I am tired of tea, and of having to eat-at-the-scheduled-hour-or-go-hungry, and oh so tired of documentary film … And no wonder they love *Loony Tom* because it's one of the three or four films out of this long, long list that has a laugh in it!'[19] In many ways this letter is the beginning of *The Pleasure Garden* as it lays out the anarchic disturbance that Broughton's films could make on the dour horizon of British film.

Shortly after the death of King George VI, Sheets and Broughton left England for Cyprus where they prepared the script for the film. The film's story was simple, but told through a complex web of characters. The thread that bound together the protagonists and provided the thrust to the story is the setting of Crystal Palace Park, which was portrayed as a decrepit public garden. Fifteen characters are introduced to the camera including: a young female dreamer, a frustrated artist, an old maiden aunt and her spritely charge, a carefree American and a fanatical cyclist. These figures go about their business each one isolated from the next in short vignettes. As two young wrestlers tussle in swimming trunks, they are reprimanded by a grim park-keeper (John Le Mesurier) who pulls them apart – he wishes those in the park to be 'dignified swans' like the ballet dancers who pirouette in the park's bandstand (somewhat ironic given that the Crystal Palace had once been a major venue for competition wrestling). This begins an ardent campaign against pleasure as the park keeper censors statues and displays prohibitive notices 'Cycling is Prohibited', 'Dogs Must be Led', 'Suspension of Play'.

As the park keeper slips home early he is spotted by Mrs Albion (Hattie Jacques), described in the script as,

> agelessly dainty, necessarily deft at verses, dancing and fancy dress, with the cozy imperial manner of one who has presided over innumerable Christmas parties. Even so you might easily mistake her identity, for nowadays she has to go about disguised as an ordinary citizen today she resembles a middle-class fortuneteller escaped from high tea at a Ladies Club.[20]

Albion proceeds to unite the lonely denizens of the park in suitable couplings: the dreaming girl and the frustrated artist; the fanatical cyclist and

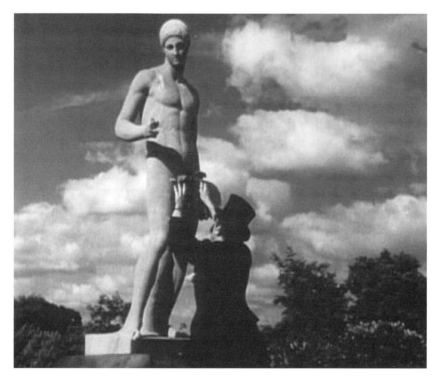

7.1 Still from *The Pleasure Garden*, dir. James Broughton, 1953. Author's
collection.

an undernourished bodybuilder; and the wandering cowboy Sam with
the spritely raven-haired Bess – who has escaped the sights of her mean-
spirited aunt. When Aunt Minerva finds her niece with such an unsuitable
suitor she marches to the Ministry of Public Behaviour to find the park
keeper and put an end to Albion's reign of pleasure. Returning with a
hearse filled with undertakers, the park keeper declares that the area is to
be made into a cemetery and sends the people he has brought with him
into the undergrowth to rake out the couples in the bushes. Matters come
to a head as the pleasure seekers and the killjoys line up for a game of tug
of war – pulling on Albion's magic stole – the pleasure seekers win and
the undertakers become statuary while the couples caper around the park.

Broughton makes full use of the abandoned state of the park itself,
which had been out of use throughout the war. The remaining masonry
on the site comprised of the steps that led from the lawns to the Palace
itself and the arches that supported it, as well as the classical balustrades
that bordered several paved terraces. All of this stonework was eroded
and covered by weeds. The grass surrounding the area had grown to

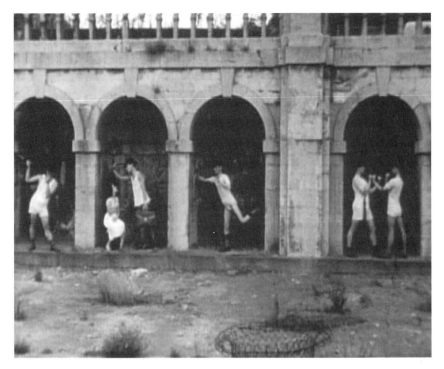

7.2 Still from *The Pleasure Garden*, dir. James Broughton, 1953.
Author's collection.

almost knee height, while all of the shrubbery had sprouted into new and unruly shapes. However, it is the abandoned statuary of the park that is most heavily emphasised in the images Broughton frames throughout the film. The statues that Broughton films for the most part are classical nude or semi-nude idealised bodies, some of these sculptures remained on their plinths at the time; others had fallen to the ground (figure 7.3). All of the sculpture had taken on a strange quality, as they had been originally placed in relation to an architectural setting that had now disappeared leaving behind very little evidence of its previous scale. Almost all of the film's characters are introduced in a shot that frames them in the foreground of the screen, with a piece of classical statuary positioned behind them in the near distance.

The juxtaposition is rarely random, the statues can often be read as idealised alter egos for the characters in the film – what they aspire to be, for others they are what they desire. In the opening shots of the film the dreaming girl stands next to a statue that is inscribed on the plinth as an allegory of love. When Bess enters the park for the first time, set free from

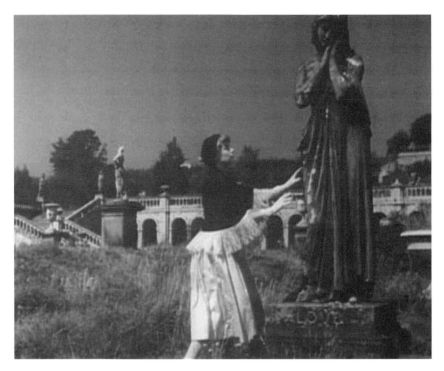

7.3 Still from *The Pleasure Garden*, dir. James Broughton, 1953.
Author's collection.

the watchful gaze of her aunt, she wanders into a space in which sculptures become almost indistinguishable from human bodies. Topless men and women in diaphanous dress stand on top of abandoned pedestals stretching and posing – inviting the gaze. This is contrasted with Bess herself who carries a very heavy Bible close to her chest in crossed arms and wears a thick long overcoat. Most of the sculptures in the film are in good condition and they are clearly legible to the viewer. There are shots in the film, however, of fallen statuary and sculptures covered with ivy and bindweed. This kind of neglect immediately gives the park the look of a cemetery – the kind of space in which sculpture is allowed to be taken over by nature in this way. This image is, of course, a romantic cliché of the ruin, which sees all that is man-made returning to dust beneath the power of uncontrollable nature. This version of ruination is the foil to Broughton's vision, which refuses the melancholic message it brings.

Eccentric pleasures

The persistence of the Sydenham site as a space of eccentric pleasure inspired the script. 'Eccentricity' began as a spatial term, meaning to diverge from a centre, later coming to be applied to unusual personal character traits. The idea of eccentricity is useful to discuss the themes of sexuality, provincialism and ruination that are central to the vision of Britain in Broughton's film. In 1951, the year of Broughton's arrival, the park had been passed over to the London County Council and plans were afoot to turn it into playing fields, thus setting the film there was an act of preservation. *The Pleasure Garden* might be seen as a way of reincorporating the decaying corpse of the Empire into the fantastic image of Britain as a garden Arcadia. In his autobiography Broughton describes the park at Sydenham as suggesting 'nothing less than the destruction of Western Civilization'.[21] The razed space of the Palace that is seen in the film can be read as a direct symbol for the Empire's decline in the immediate post-war years and the call for a future-orientated pleasure: a clarion call against the suggestion that the space become a cemetery, a site of mourning and melancholia.

Many of the exhibits in the Festival of Britain emphasised compromise – the way in which Britain could embrace science and craft, learning and entertainment, the past and the future. Through these juxtapositions, the Festival seemed to challenge its audience to ask what they thought it meant to be British today. Jennings' official Festival film *Family Portrait* for example presents a very wide range of society, and takes the viewer through a whole cavalcade of famous British people in order to establish a sense of the character of the nation. Jennings sees Britain as a great nation established not only through engineering and scientific progress but also through knowledge of traditional skills and a respect for the land.

Broughton was also interested in defining the characteristics of the nation. He wrote in his notebook in 1951, 'This film now, my own "festival of Britain": can it be made a pleasure garden? Microcosm of a society both sensible and absurd. A real "dance of life". No less. A revue of human oddities. Touching too.'[22] Broughton uses a cast of 'human oddities' to show the way in which the 'British' character can be seen to resist and subvert any call for conformity: either from the globalising forces of American capital or the drab Soviet alternative. Eccentricity was long associated with the English in the cultural imagination, especially since the publication in 1933 of Edith Sitwell's book *The English Eccentrics*.[23] Jennings underlines this in *Family Portrait* with footage of a man building nursery-rhyme whirligigs in the garden of his cottage as the voiceover relates the genius of Edward Lear and Lewis Carroll.

Within the Festival of Britain, the committee chose to represent the
nation through the figure of the White Knight from Carroll's *Alice Through
the Looking Glass*. A large-scale plaster model, based on Sir John Tenniel's
frontispiece from 1871, was described as symbolising 'the fantastical genius
of the English character' and headed up a display of 'British eccentrics.'[24]
Other characters from the Alice books appeared across the Festival site:
the Mad Hatter emerging from the chimneystack of the Guinness clock
in Battersea Garden and Alice herself (doubled in the looking glass) in the
Lion and the Unicorn Pavilion.[25] Broughton writes in his notebook, 'they
do not realize how peculiar they are. When they do they approve their
own peculiarity … it is all true. Alice in Wonderland. Their country is on
the other side of the looking glass.'[26]

Broughton was particularly fascinated by the representation of English
eccentricity in the novels of Ronald Firbank. Firbank was an aesthete and
a homosexual who worked in the outmoded style of the 1890s through
the First World War and into the Jazz Age. Firbank's short novels are
filled with spinsters, clerics and dowagers whiling away their days in idle
prattle and pursuing vainglorious dreams. In the early 1950s he enjoyed a
brief resurgence in popularity as Osbert Sitwell dedicated a chapter of his
book *Noble Essences* to him in 1950, and a biography by Jocelyn Brooke was
published in 1951.[27] The title page of Broughton's unpublished script of
The Pleasure Garden is inscribed with a quote from Firbank's novel *Vainglory*
while in his notebook he jotted down, 'I want them to be much more
florid, giddier, more eccentric: where is the outrageous individuality? This
one wants from England: more Firbanky, Elizabethan, Restoration.'[28]
The vast historical scale conjured in this note points towards the strange
temporality of many of Firbank's novels, in particular *Valmouth*. That book
is set in an English coastal resort where the waters allow the residents to
live for centuries, with memories that stretch well into the eighteenth cen-
tury.[29] Time without ageing is made possible in a demarcated space cut off
from the rest of the world.

This play with temporality, and its spatialisation, is clearly evidenced
in *The Pleasure Garden* with its allusions to a lost world of the past found
decayed in a walled garden. Broughton asks the viewer to recognise in
the past not a melancholic sentiment but rather to find and celebrate
eccentric pleasure wherever it may lie. This strange temporality was a
major factor in the pleasure gardens built by the festival commission at
Battersea. Those gardens were the festival's playground – conceived as
a respite from the edifying educational aims of the festival proper they
included such luxuries as high-end dining, ladies' powder rooms stuffed
with cosmetics, and American fairground rides, at a time when rationing

was still in place.[30] Broughton, whose eye was always alert to the whimsi-
cal, was clearly struck by these gardens; an early script of *The Pleasure
Garden* ends with the park at Sydenham transformed into the glittering
expanse of Battersea.[31] The garden's printed guide recounts the history of
the famous parks that girded central London from the eighteenth century
onwards, parks whose names provided those for the bars in the Battersea
complex: Vauxhall, Cremorne, Ranelagh.[32] Those pleasure gardens were
long associated with erotic encounters, both romantic and illicit. Vauxhall
closed in the mid-nineteenth century largely due to its popularity with
prostitutes. This aspect is developed in Broughton's film; its closing theme,
'It's a pleasure if you please, to come as you are and go as you please, it's
twice the pleasure to come together and make a pleasure for two', is far
from ambiguous.

Michel Foucault in 1967 examined areas which he described as 'coun-
ter-sites, a kind of effectively enacted utopia in which real sites, all the
other real sites that can be found within the culture, are simultaneously
represented, contested and inverted'. He called these spaces 'heteroto-
pias' in contrast to the fantasy of 'utopia'.[33] Foucault goes on to say, 'The
garden is the smallest parcel of the world and then it is the totality of the
world. The garden has been a sort of happy, universalizing heterotopia
since the beginnings of antiquity.'[34] It is no surprise to find that often
the spaces Foucault chooses as heterotopic are those that have a powerful
place in the lexicon of homosexual desire in the mid-twentieth century; the
naval ship, the prison, the cemetery.

Crystal Palace Park was somewhat notorious in the early part of the
twentieth century as a kind of vast lovers' lane, with its various nooks
and arbours providing shelter for all manner of activities.[35] According to
the historian Matt Houlbrook, after the Second World War sexual activ-
ity in London parks – which had been fairly common among both the
straight and queer working class in the earlier years of the century – began
to disappear as police surveillance increased and the growing affluence
of the working class began to make the cramped shared domestic spaces
of the slums a thing of the past.[36] Houlbrook argues that this shift within
heterosexual mores had a direct affect on the way in which homosexual
cruising in parks, public toilets and the cinema were viewed by the public
as this activity seemed 'increasingly distant from the spatial organisation of
respectable "heterosexuality"'.[37] Broughton could not have been unaware
of the crepuscular culture of cruising, a major factor in the sexual lives of
queer men in both London and San Francisco throughout the 1940s and
1950s. A strange, silent community of walkers alerted to one another's
intentions by almost invisible signs. A peculiar dance of desire, which

could at once signify the isolation of these men from society – both a queer community and the broader society at large – as well as representing a glimpse of a potential world of warm brotherly solidarity.

Conclusion

For Broughton the 'shapes for anarchy', which he had bemoaned the lack of in England in his postcard from Cambridge, could be found in the heterotopic space of the abandoned park. The illusion of sexual freedom played out in *The Pleasure Garden* was a way of escaping the discipline of society, both at the micro-geographic level of the park and also at the global scale referenced in the ruined form of the Crystal Palace. In a note written on the film shortly after its completion Broughton writes, 'I wanted to sketch a small fable of the wars that are always and everywhere with us: creation against destruction, pleasure against puritanism, love against death. What in the end concerned me was to put out a few flags for the total triumph of love.'[38] The Festival of Britain may have offered England a vision of itself as a green and pleasant realm, but Broughton's pageant is a vision that offers a way out of pastoral melancholia to embrace a joyous future.

At the time Broughton's film appeared in the cinema Rose Macaulay published her well-known book *Pleasure of Ruins*. She wrote there 'the pleasure felt by most of us in good ruins is great', but as Brian Dillon has pointed out, her pleasure is somewhat perverse given that her own home had been destroyed by the Blitz.[39] Macaulay takes her reader on an armchair journey to Italy, Guatemala, India and beyond in search of picturesque ruins, yet it is only in the conclusion that she turns her eye to bomb-damaged Britain. She suggests that modern ruins have not yet found the patina of age and writes that 'ruin pleasure must be at one remove, softened by art'.[40] It is Broughton's art to bring pleasure to the tumbledown gardens of Sydenham; it allowed them to be understood metaphorically – to transform molten glass back into an edifice full of meaning.

Notes

1 Rose Macaulay, *Pleasure of Ruins* (London: Thames & Hudson, 1953), p. 398.
2 'Crystal Palace Burned Down', *Guardian* (1 December 1936).
3 C. F. Bell-Knight, *The Rise and Fall of the Biggest Ever Glass Container* (Bath: The Author, 1977), p. 49, quoted in D. Murphy, *The Architecture of Failure* (London: Zero Books, 2012), pp. 41–2.

4 C. Hobhouse, *1851 and the Crystal Palace* (London: John Murray, 1937), pp. 162–3.

5 J. R. Piggott, *Palace of the People: The Crystal Palace at Sydenham 1854–1936* (London: Hurst & Co., 2004), pp. 180–205.

6 See H. Foster, *Compulsive Beauty* (Cambridge: Massachusetts Institute of Technology Press, 1993), pp. 157–91.

7 Louis Aragon, *Le Paysan de Paris* (Paris: Gallimard, 1926).

8 Murphy, *Architecture of Failure*, p. 34.

9 B. Conekin, *The Autobiography of a Nation: The 1951 Festival of Britain* (Manchester: Manchester University Press, 2003), pp. 4, 84–90.

10 *Ibid.*, pp. 4, 84–90.

11 B. Turner, *Beacon for Change: How the 1951 Festival of Britain Shaped the Modern Age* (London: Aurum Press, 2011), p. 99.

12 S. Brakhage, *Film at Wits End* (Edinburgh: Edinburgh University Press, 1990), p. 78.

13 P. Adams Sitney, *Visionary Film: The American Avant-Garde* (New York: Oxford University Press, 2002), p. 76.

14 J. Broughton, *Coming Unbuttoned* (San Francisco: City Lights, 1993), p. 101.

15 *Ibid.*, p. 102.

16 State University of New York, Poetry Collection, Robert Duncan Papers, 17 August 1951, James Broughton to Jess.

17 Poetry Collection, State University of New York, Robert Duncan Papers, 6 August 1951, James Broughton to Robert Duncan and Jess.

18 L. Anderson, 'A Possible Solution', *Sequence*, 3 (Spring 1948); 'British Cinema: The Descending Spiral', *Sequence*, 7 (Spring 1949); and 'Only Connect: Some Aspects of the Work of Humphrey Jenninngs', *Sight and Sound* (April–June 1953), reprinted in P. Ryan (ed.), *Never Apologise: Lyndsay Anderson, The Collected Writings* (London: Plexus, 2004), pp. 336–9, 340–7, 358–64.

19 State University of New York, Poetry Collection, Robert Duncan Papers, 3 September 1951, Kermit Sheets to Robert Duncan and Jess.

20 Kent State University, Ohio, James Broughton Papers, collection 2, box 4, James Broughton, unpublished script 'The Pleasure Garden a film masque by James Broughton'.

21 Broughton, *Coming Unbuttoned*, p. 106.

22 Kent State University, Ohio, James Broughton Papers, collection 1, box 32, folio 11, James Broughton, Notebook 1951.

23 E. Sitwell, *The English Eccentrics* (London: Faber & Faber, 1933).

24 R. D. Russell and R. Gooden, 'The Lion and the Unicorn Pavilion', in M. Banham and B. Hillier (eds), *A Tonic to the Nation, The Festival of Britain 1951* (London: Thames & Hudson, 1976), pp. 96–101, esp. p. 99.

25 Banham and Hillier, *A Tonic to the Nation*, p. 99; B. Conekin, 'Fun and Fantasy, Escape and Edification: The Battersea Pleasure Grounds', *Twentieth Century Architecture*, 5 (2001), 128–38, esp. 129.

26 Kent State University, Ohio, James Broughton Papers, collection 1, box 32, folio 12, James Broughton, Undated Notebook.

27 O. Sitwell, *Noble Essences: A Book of Characters* (Boston: Little Brown & Co., 1950), pp. 77–100; J. Brooke, *Ronald Firbank* (London: Barker, 1951).

28 Kent State University, Ohio, James Broughton Papers, collection 1, box 32, folio 11, James Broughton, Notebook 1951–52.

29 R. Firbank, *Valmouth: A Romantic Novel* (1919) in *The Complete Firbank* (London: Picador, 1988), pp. 387–477.

30 Conekin, 'Fun and Fantasy', 129.

31 Kent State University, Ohio, James Broughton Papers, collection 1, box 26, folio 7, James Broughton, The Pleasure Garden, early treatment.

32 A. H. Coxe, 'It Sprang from the Spring Gardens', in Festival of Britain Commission, *Pleasure Gardens, Battersea Park Guide* (London: Festival of Britain, 1951), pp. 44–8.

33 M. Foucault, 'Of Other Spaces', trans. J. Miskowiec, *Diacritics*, 16 (Spring 1986), 22–7.

34 *Ibid.*, 25.

35 See P. Beaver, *The Crystal Palace: A Portrait of Victorian Enterprise* (Chichester: Phillimore, 1986), p. 136.

36 M. Houlbrook, *Queer London: Pleasures and Perils in the Sexual Metropolis, 1918–1957* (Chicago: University of Chicago Press, 2005), pp. 66–7.

37 *Ibid.*, p. 67.

38 Kent State University, Ohio, James Broughton Papers, collection 1, box 26, folio 6, James Broughton, 'A Note on The Pleasure Garden,' undated type-written screening note.

39 Macaulay, *Pleasure of Ruins*, p. ii; B. Dillon, 'Decline and Fall', *Frieze*, 130 (April 2010).

40 Macaulay, *Pleasure of Ruins*, p. 454.

8

Dinosaurs Don't Die: the Crystal Palace monsters in children's literature, 1854–2001

Melanie Keene

In October 1869, Uppingham School Magazine reported on a troubling event which had regrettably delayed the kick-off for their old boys' football match. Players attempting to find their way to the pitch in south-east London had been 'transfixed with terror', 'frightened by' 'icthyosauri, crocodiles, armadillos, and other amphibious animals'.[1] Of course, that day the footballers had not encountered revivified prehistoric beasts themselves, but rather the 'terrible figures' of antediluvian creatures that resided on a series of geological islands at the Crystal Palace, Sydenham, where the Rovers were to play their alumni match. Yet the overtly terrifying presentation of the sculpted monsters as demonstrably 'alive' reveals just one way in which they have impacted on juvenile pastimes over the past 160 years. In this chapter I survey how shifting uses of the Crystal Palace monsters – in children's alphabets, annuals, newspapers, picture books, primers and more – maps onto their evolution from part of an innovative pedagogic scheme, to once more the sole surviving remains of a past age.

Visual education

Much excellent historical scholarship exists on the creation and original reception of the model 'antediluvian animals' of Benjamin Waterhouse Hawkins and Richard Owen, which were resurrected with great fanfare in south-east London in 1854.[2] The model rock strata and large iron-and-brick sculptures of creatures including ichthyosaurs, plesiosaurs, hylaeosaurus, megalosaurus, megatherium and iguanodons, formed just one part of a grand visual pageant that took its visitors from the depths of time, through a succession of historical courts, to the glass marvel of Victoria's

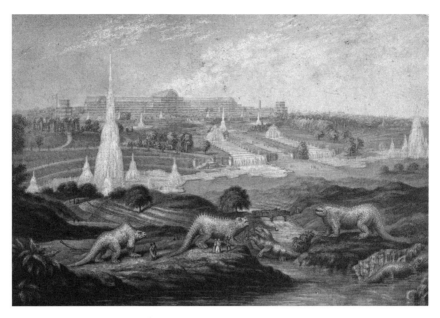

8.1 George Baxter, 'The Crystal Palace and Gardens' [1854?], coloured
photomechanical print, 10.9 × 16 cm, courtesy of the Wellcome Library,
London (CC-BY 4.0).

Britain.[3] Lying on islands in the lake at some distance from the Palace, the
monsters were visible from the train line as part of the landscaped grounds
of walkways and fountains, as depicted in contemporary illustrations (see
figure 8.1). In these imagined perspectives the sculptures took a prominent
position in the foreground as a necessary precursor and counterpoint
to the Crystal Palace itself, and like the glass building they were works
both old and new, recreated as well as novel objects. That novelty was
lauded in the press: Hawkins' sculptures were the first three-dimensional
reconstruction of such creatures. Periodical articles breathlessly reported
from his mud-filled workshop of the contribution the project would make
to 'Fairyland in "Fifty Four"', and he even arranged an extravagant New
Year's Eve dinner on 31 December 1853 inside the mould of the iguanodon
model, Owen taking the prestigious seat literally at the head of the table.[4]

The Crystal Palace was easily accessible by suburban train, and received
something like a million visitors a year for the rest of the nineteenth
century; it came to occupy a particular niche in the south-east London
leisured landscape, as various additional amusements, events – and even a
liquor licence – were added to its more educational elements in an attempt
to attract audiences back to the site, and to prolong the excitement and
momentum of the no-longer-ephemeral display.[5] Lurking on their increas-

ingly overgrown islands, the monsters continued to be popular throughout the nineteenth century, appearing in the press to comment on anything from the reappearance of their old friend a comet, to being a suitably uncivilised tent pitch for a trial colonial trip.[6] When Joseph Paxton's building and its contents caught fire in 1936, the monsters became Sydenham's only extant (extinct) display, and are now Grade I listed monuments.[7] A beloved local attraction and reassuringly static nostalgic touchstone for generations of children, they have been name-checked extensively, from the fictional detective Peter Wimsey to characters from Buffy the Vampire Slayer, and reproduced on postcards, murals, and even tea-towels.[8]

From the outset, Sydenham guidebooks emphasised the novelty and the impact of the 'geological islands' as 'one of the most original features of the Crystal Palace Company's grand plan of visual education':

> There, all the leading features of Geology are found displayed, in so practical and popular a manner, that a child may discern the characteristic points of that truly useful branch of the history of nature. The spectator standing on the upper terrace of the Plateau, has before him the largest educational model ever attempted in any part of the world.[9]

Even 'a child', the official text asserted, was capable of comprehending the significance and details of geological science. As architect Matthew Digby Wyatt wrote, a combination of 'the simple uses of the organs of sight' and 'little more than the natural instincts of a child' were all that were required to appreciate the exhibits.[10] Moreover, the solid reality of the models promised to be more striking, and more pedagogically effective, than mere pictures.[11] In an address to the Society of Arts, Hawkins had emphasised how, unlike previous attempts to teach with 'only the names' of prehistoric life-forms, he wished to present his audience with 'the things themselves', quoting the influential educational philosopher Johann Heinrich Pestalozzi.[12] The entire Sydenham site, in fact, was 'one vast and combined experiment of visual education': its middle-class developers conceived of the displays in the Fine Arts Courts as providing working-class historical and aesthetic education for and, crucially, '*by* the eye'; the 'scientific art' in the grounds would also provide a new type of technical education.[13] As Hawkins noted in his speech, this 'direct teaching through the eye has been recognised as a principle and a facility of education for some years past, even in the limited sphere of schools', and could be put to potent work in the particularly visually impressive exhibitionary context.[14]

However, some visitors were upset at the removal of their own imaginative work from the creation of prehistoric scenes: for Margaret Oliphant, for instance, 'Professor Owen's "restorations," however true they may be, are

rather a damp upon the fervour of geological visions'.[15] She recommended
that the 'young geologist' should 'close his eyes very hard' as he approached
the lake.[16] Textual descriptions, including the many verbal accompani-
ments to the visual display, could be conceived of as more reliable means of
creating such prehistoric scenes, ones that led the reader to an accurately
imagined picture, with knowledge of the scientific basis on which it was
built, rather than an immediate spectacle that collapsed not only past and
present into one, but also the successive geological epochs themselves.[17]

In her 1979 book, *Fanny and the Monsters*, Penelope Lively went back to
this early history of the models, and to the context of rational education
in which they had been conceived and displayed. Setting the story in
1866, she made her eponymous protagonist a 10-year-old Victorian girl
who decided she was 'going to be a palaeontologist'.[18] Playing with her
readers' expectations of the social place of young women over a hundred
years previously, the book opened with Fanny's disappointment that she
had received rather conventional birthday presents ('a doll, a needle-case
and embroidery frame, a story-book and a seed-pearl necklace') rather
that what she had 'been hoping for' ('a microscope, a geological hammer,
a book about fossils and a butterfly net').[19] Fanny's interest in the natural
sciences was heavily foregrounded in the story, for instance through her
facility with Latin binomials ('because it was fun' as well as because having
such a secret language would annoy her brother).[20] The narrative detailed
Fanny's move from studying familiar natural objects such as daisies and
caddis flies to her encounter and eventual discovery of unfamiliar palae-
ontological remains; at its heart was her process of visual education, from
seeing model monsters to spotting fossilised remains.

Sneaking away from her overbearing godmother on a trip to the
Crystal Palace (rather, Fanny noted, 'like an enormous light and airy
railway station'), the story's heroine followed the path down to the 'prehis-
toric monsters', to be amazed by the model creatures. Striking up a rather
anachronistic conversation with a tame palaeontologist (for instance, there
is mention of a Tyrannosaurus Rex, which was not named until the early
twentieth century) she learns all about the scientific basis on which the
models have been constructed, and even the Darwinian theory of evolu-
tion. Back home, when she later encounters part of a fossilised specimen
in her local quarry, she is able to work out what it is, get in touch with the
man of science at the British Museum, and ensure that it is not destroyed.
As one scholar of children's literature puts it, Fanny 'is enabled to "see"
the iguanodon fossil before her only because her cognitive repertoire has
been expanded' by the process of visual education undertaken at the
Crystal Palace.[21]

Lively's attempt to recreate a visual education process in her narrative was just one way in which the experience of visiting Sydenham has been mimicked in print. Following the example of the many paper artefacts, prints and books for children published in association with the 1851 Great Exhibition, including poems and perspective views, printers and authors also tried to recreate the unique visual experience of Sydenham on the page in stories and in games.[22] For instance, the 1855 *Crystal Palace Alphabet* by George Measom used the 'queer-looking statues' to solve the often tricky problem of what to set for letter 'X'.[23] There were also educational wall-charts produced by Hawkins, as well as miniature models of the creatures themselves. For the rest of the century, introductory textbooks and periodical articles seemingly inspired by the particular sequence of strata and sculptures, such as Charles Baker's 1866 *Plants, the Earth and Minerals*, fixed this particular set and style of specimens as a common entry-point to geological knowledge.[24]

The images even circulated as clippings in informal scrapbooks, for instance a picture book put together by Hans Christian Andersen and Mathilde Oersted, daughter of the physicist, in 1869 included a megatherium illustration derived from Hawkins' drawings.[25] By the twenty-first century, Hawkins' Pestalozzian project of visual education was the explicit inspiration for Barbara Kerley and Brian Selznick's 2001 picture book, *The Dinosaurs of Waterhouse Hawkins*, recasting nineteenth-century modes of visual education for modern readers used to decoding colourful double-page spreads.[26]

Terrible lizards

From their first appearance, commentators noted that this project of visual education, whereby prehistoric sites were restored directly to the eye, also had a potentially dangerous side: the creatures would live up to the literal translation of Owen's name for them as 'terrible lizards'. By removing the mediating work of text and sketch, the three-dimensional models appeared as if they had actually been resurrected, momentarily frozen but poised to spring back into bloodthirsty life. The sculptures' emphasis on dental details, with jaws ajar and molars bared, served a similarly double-edged purpose, both teaching about the particular type of fossil remains (teeth) from which specimens had often been reconstructed, but heightening this sense of threat.[27] As ever, *Punch* provided an early commentary in its depiction of 'Master Tom', who had been taken to see the prehistoric spectacle, but who, the caption claimed, 'strongly objects to having his mind improved' (figure 8.2). Actual visitors also reminisced about how they had

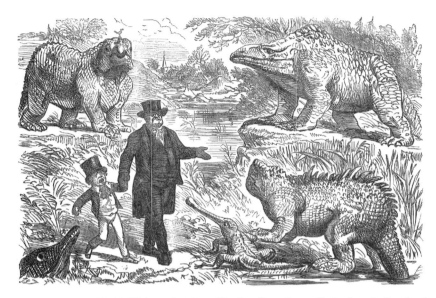

8.2 [John Leech], 'A Visit to the Antediluvian Reptiles at Sydenham', *Punch*, 28 (1855), viii. Author's collection.

been scarred by early exposure to the creatures, one remembering: 'I was petrified by the prehistoric monsters which I came upon suddenly one day. I think my very real fear of water goes back to that day. The great lake, so calm and still, and those great monsters rising up, as it seemed, out of the water!' Another reminisced: 'I felt some concern about being near them. I was sure they moved. The harder I looked the more sure I became that they moved. I was absolutely certain their eyes followed me as I passed.'[28] It was only so long before the monsters would actually come alive, even if only in children's dreams.

By the turn of the twentieth century, *Punch*'s wailing *Master* Tom had become responsible *Uncle* Tom, whose nephew Cyril starred in the Crystal Palace Annual for 1899–1900. Published by the Crystal Palace Company itself, the beautifully illustrated magazine featured one central story, 'Cyril's Christmas dream' by Cunningham Bridgeman, flanked by advertisements. With a frontispiece of Santa riding a sleigh marked 'Crystal Palace only', the publication was a thinly veiled marketing exercise promoting the 'thousand attractive side-shows of the Palace'.[29] As the story concluded, 'the little boys and girls who visit the Crystal Palace during the holidays … will be delighted to see in real life the many wonderful things that my little Cyril saw in his Christmas Dream'.[30] Once again, the importance of first-hand observation of 'the things themselves' was stressed. Cyril's

governess, named Miss Girton in homage to the Cambridge women's college, had recommended that her young charge visit what he termed 'the ante- ante-what-you-may-call'ems'.[31] Having amused themselves with a fortune-teller, they wandered down the footpath to the lake, where 'the mammoth forms of the antediluvian animals ... hush ... Cyril's shouts of merriment':

> loathsome looking beasts appear to be staring Cyril in the face. He clings to his Uncle's side, trembling with fear.
> "Don't be frightened, my boy – why they are nothing but blocks of stone; see, the little birds are not afraid; watch the sparrows perched upon that ugly old fellow's nose, and, look there, I do declare there's an old duck roosting in that big one's mouth."
> Cyril's courage was promptly restored, and he laughed at his own fear.[32]

The model nature of the creatures – that they were 'nothing but blocks of stone' – here helped attenuate childish fears, even though it could be argued that this went against the purpose of showing 'the things themselves'. Uncle Tom's explanation even seemed to refer directly back to the earlier *Punch* cartoon, in which a small bird can be seen on top of the iguanodon model. Nonetheless, Cyril's 'rest that night was disturbed by a very strange dream', possibly, the narrator points out, a result of a rather indulgent afternoon tea and dinner:

> I saw the lake below overflow its bank, and now the water came creeping, creeping slowly up – up the hill, driving before it all those nasty ante-what-you-may-call-'ems. Then it grew dark, so dark that I lost sight of you, and so I began to feel frightened ... as I looked behind I saw the water still creeping slowly after me, and before it wobbling and creeping and rushing and roaring all the ugly ante-what-you-may-call-'ems.

Fleeing these monstrous creatures, Cyril, with the aid of a fairy, took refuge in the Crystal Palace, which had been converted into a latter-day Noah's Ark (to which the monsters were refused entry, reinforcing the earlier identification of the fossil creatures as those animals that perished in the flood, quite literally antediluvian. Giving 'a great howl of despair', they 'crawled back, back into the flood').[33]

Similar discussions of fear and also of the Flood had been included in George H. Robinson's *Peter's Paradise* (1890), another dream vision and series of adventures set in and around the Crystal Palace. As the story's rhyming couplets revealed:

> Then the antediluvians loomed into sight,
> Peter knew them quite well, so he did not take fright;

But when all around him these huge monsters stood,
He felt *rather* thankful there HAD been a Flood.[34]

Though here Peter, unlike Cyril, had already been acquainted with the
creatures and was therefore less disturbed by their original state, it was
the liveliness of the resurrected creatures that made him glad that this
could only occur in a somnial state. Even though his uncle's rational
explanation had quelled Cyril's fears, they were still there in his dreams
(or, perhaps more accurately, nightmares), where they took on fantastical
properties, however educated he had been about the factual basis of the
sculptures and their natural historical existence. Something of the same
argument was made by George Du Maurier in his 'A Little Christmas
Dream' cartoon. Riffing on French author Louis Figuier's assertion that
children should replace their traditional fairy-tales with natural history
books, Du Maurier reported on the results of this literary experiment on
his 6-year-old, replacing Cinderella and Puss-in-Boots with 'some of the
more peaceful fauna of the pre-Adamite world ... he has not had a decent
night's sleep since'.[35]

The motif of geology as a resurrectionary process was common
throughout the nineteenth century, often drawn in comparison to the
biblical tale of Ezekiel, breathing life into the valley of dry bones.[36] For
authors such as John Mill in his *The Fossil Spirit: A Boy's Dream of Geology*
(1854), bringing specimens to life and – going one further – giving them a
voice, could be used to evoke and explore complex relationships among
the past, the empire, religion, fossils and spirits.[37] The continued presenta-
tion of revivified creatures in these children's writings reveals something
more, then, than the common use of appealing and enlivened animal
characters, something that reflects the particular magic of palaeontology,
and the particular magic of these sculpted forms.[38] In *The Enchanted Castle*
(1907), the children's author Edith Nesbit depicted an eponymous building
that resembled the Crystal Palace, especially in the statues which inhab-
ited its grounds.[39] Classical figures, such as Pan, but also more ancient
antediluvian beasts were to be found sculpted in stone, and placed 'in the
middle of last century' at strategic points around the estate just as they
were in Sydenham, set 'in a beech-wood on a slope at least half a mile
across the park from the castle'.[40] Direct comparisons were also made in
the text between this fictional enterprise and 'the Exhibition of 1851, Sir
Joseph Paxton, and the Crystal Palace'.[41]

From the point of view of the children, the sculptures were presented as
unfamiliar objects, with 'wide, ungainly wings' and 'lozenged crocodile-like
backs' which 'show grey through the trees': undermining Hawkins' visual

education project, in this story the children's eyes and tongues needed to be guided and compared with living creatures such as crocodiles.[42] There was no unmediated comprehension: they were simply 'enormous shapes of grey stone, like nothing that the children had ever seen before'; their names were also tricky to master, the children calling the creatures 'the anteddy-something animals it means before Noah's Ark; there are lots besides the dinosaurus'.[43] Nesbit's favoured term for the beasts, 'dinosaurus', reflects changing nomenclature by the early twentieth century that would soon result in the widespread adoption of Owen's word 'dinosaur' to refer to new palaeontological discoveries from the United States, and the replacement of the more biblically allusive 'antediluvian'.[44] In Nesbit's book we can see both past and future scientific terminology side by side, as well as the trouble children had with the polysyllabic and increasingly unfamiliar word.

However, the series of stone monsters inspired by the Sydenham display were not just scientific objects: they were simultaneously part of a magical world revealed under the cloak of darkness. The promise inherent in Cyril's turn-of-the-century nightmare was here presented as just one of the preternatural occurrences at this supposedly fairy-tale location, where all of the statues came alive at night. This fitted into the wider story Nesbit told, which echoed other themes of her fiction, most famously *Five Children and It* and its sequels (1902–6), in which childish characters become unwitting owners of magical objects, or friends to magical creatures. In the *Enchanted Castle* a magical ring disrupts its protagonists' usual holiday occupations, as it is gradually revealed that otherworldly powers possess the children and also the particular place itself. From encountering sleeping beauties to golden treasures, to adventures in invisibility and magically enhanced architecture, at the *Enchanted Castle* the palaeontological process of bringing stone forms to life was just another kind of fairy-tale trope. Nesbit used evocative language to describe the enlivened creature, describing the 'crunching' of the gravel under its foot, its bearing 'enormously long and darkly grey', 'of the same awful size' as it was 'millions of years ago'. It was explicitly 'alive in its stone', rather than having 'come alive'. Touching its flank, Gerald, one of the story's boyish protagonists, sees his initial bravado melt away: it turns towards him and he runs with all his speed towards the house. Just as in Cyril's dream, the story featured a flight from the revivified creature, and an anxiety personified by Nesbit as 'Fear': 'at that stony touch Fear had come into the garden and almost caught him. It was Fear that he ran from, and not the moving stone beast'.[45] In the children's other interactions with the creatures a more friendly aspect was traced: after a picnic, the children reflect on how 'peaceful and happy' the 'vast stone dinosaurus' seems:

"I dare say he liked a good meal in his day," said Gerald, stretching luxuriously.

"Who did?"

"The dino what s-his-name," said Gerald.

"He had a meal today," said Kathleen, and giggled … "we fed the dinosaurus through the hole in his stomach with the clothes the Ugly-Wuglies were made of!"[46]

The children had taken up residence inside the model 'dinosaurus' to hide clothes that they had accidently also brought to life: they also hid themselves, with Nesbit perhaps consciously referencing Owen's monstrous meal, and the lyrics to the song chorused on New Year's Eve, 1853:

> Beneath his hide he's got inside
> The souls of living men,
> Who dare our Saurian now deride
> With life in him again?
> The jolly old beast
> Is not deceased
> There's life in him again!
> ROAR.[47]

Just as in Nesbit's books the creatures moved from being 'fearsome' foes to 'jolly old' friends, so too did more generalised representations shift from terrifying ogres to companionable creatures. By the time Ann Coates wrote *Dinosaurs Don't Die* in 1970, her version of the stone beast brought to life by moonlight could be given a name, Rock, and could be quite explicitly described as its protagonist Daniel's pet.[48]

Pets among the monsters

By the twentieth century, the monsters had become familiar local landmarks, well-known characters that often appeared in juvenile periodicals. For the *Girl's Own Paper*, 'gazing at the antediluvian monsters on the lake' was 'just the place to spend a happy day'.[49] The monsters also made a series of appearances in Arthur Mee's *Children's Newspaper*: in 1953, for example, the *Children's Newspaper* reported on the Pets' Corner 'due to be opened shortly in the grounds of London's Crystal Palace', which would 'be on the island in the lake, close to the statues of prehistoric reptiles, which have been restored and redecorated'.[50] Notable not just for the new vocabulary of 'reptiles', which was now being used to categorise the display, the article also made it seem as though the monsters themselves were the pets of local children, or akin to tamed and caged creatures in

the zoo. In contrast to the Victorian presentation of the monsters as enormous creatures about to burst back into ferocious life, photographs in the later publication emphasised their placidity: rather than an exaggerated sense of scale being used to emphasise their size (as in figure 8.1), they were shown harnessed and controlled, with children climbing all over them.

The monsters were also shown on cinema newsreels; 'In Those Good Old Days – Filmed at the Crystal Palace (1922)', focused explicitly on children's interactions with the antediluvian creatures. Rather than bringing the sculptures themselves to life, it took children back in time to imagine when these had been real, live creatures. The audience was asked to imagine 'meeting a gentle Iguanodon … about a million years ago', before being shown footage of the Crystal Palace display, with a man walking around the grounds. Just as in the newspaper pictures, children were next filmed climbing all over the models, sitting on top of them, and even putting their heads between those jaws. The scientific names for several of the statues were introduced, including megalosaurus, plesiosaurus and teleosaurus; but the statues were presented as familiar inhabitants of an ancient world that was not so different from our own: for instance, the teleosaurus 'used to roam around Whitby (how they must miss him)'. Even the scientific monikers were translated into fewer syllables, easier for young tongues to handle: the megalosaurus became 'Mr Meg'. Contemporary slang was also used to rework potentially difficult language and concepts into something suitable for a younger audience: the different models were described as being 'pals' with each other; and it was imagined that 'our ancestors must have had a pretty rapid time of it'. Rather than being the products of a specific geological or historical time period, the monsters were identified merely as part of the 'good old days'.

The presentation of the monsters as overtly benign and 'friendly' was also found in Jean and Gareth Adamson's 1978 children's book, *Topsy and Tim Meet the Monsters*.[51] Part of a long-running and beloved series, this story took its twin protagonists on a trip with their mother: though the text did not explicitly state the location they were visiting, the accompanying illustrations made it clear that their destination was the Crystal Palace, to meet these particular monsters.[52] By emphasising the length of time it took first to drive to the 'Park', then to walk 'along a path between dark bushes', and then to row in a boat onto the island where the monsters lived, a sense of adventure and distance was created for young readers.[53] A foreboding atmosphere was also built up in the early pages of the book: on the journey the day 'turned cold and gloomy', so cold that the 'ice-cream man was packing up his van'; and Tim became increasingly 'FED UP'.[54] The cosy domestic space in which the work had opened, with Topsy and

Tim 'playing "monsters"' by dressing up in old clothes, seemed very far away.[55] Yet the implicit suggestion that the 'lake full of stone monsters' was somehow 'frightening' – with, for instance, the 'sharp teeth' pointed out by the narrator – was undermined by the children's encounter with two adults.[56] Reassuring the children that the monsters 'knew them', and that they were 'friendly monsters anyway', the young man and woman took Topsy and Tim across to the island in the lake, where – in an echo of the *Children's Newspaper* article – Topsy clambered on top of the 'biggest monster of all', the iguanodon.[57] Depicted with a smile on her face and her hair ribbons streaming out behind her in the breeze, Topsy seemed to have made friends with the monsters.[58]

It turned out that these two adults, Paul and Anna, were artists, employed to paint the sculptures: donning 'real painters' aprons', Topsy and Tim helped them splash green paint on to a blue iguanodon model.[59] Back home, the twins then made their own 'big monster in the garden' 'out of bits and pieces' including cardboard boxes and tubes, surprising their father on his return from work.[60] The illustrations for both of these images showed Topsy and Tim at work as artists, mimicking Hawkins' construction and decoration of the original sculptures in more rough-hewn and childish fashion. In *Topsy and Tim Meet the Monsters*, therefore, the sculptures were portrayed explicitly as works of art (as fantastical 'monsters' not 'dinosaurs'), and moreover as works of art that needed continued attention and upkeep. This chimed with contemporary recognition of the historical significance of the creatures, for instance through their listing as Grade II buildings by the government in 1973. Though the historical significance of the creatures was not foregrounded in the prose, as it would be in *Fanny and the Monsters*, it instead highlighted their status as precious and as artistically created objects that required conservation. *The Children's Newspaper* had similarly shown the work entailed in the statues' maintenance, photographing the cleaning of their monstrous teeth (though it was pointed out that a file rather than a toothbrush was being used).[61] Another photograph had compared the creatures to a similarly monstrous ocean liner, printing side-by-side images of the 'cleaning' of the two beasts.[62] These were now pet objects, but objects that needed to be cared for.

The most explicit presentation of the monsters as 'pets' occurred in Coates's *Dinosaurs Don't Die*, with the introduction of 'Rock' the iguanodon (a very appropriate name, since he retained his stony substance when revivified, as in previous stories such as 'Cyril's Christmas Dream' and Nesbit's *Enchanted Castle*). Unlike its previous incarnations, the revivified creature was neither terrifying nor was it content to remain on site at Sydenham: this time Rock and Daniel broke out of the Palace grounds.

Traversing first the geological islands' lake, and then the capital city itself, illustrator John Vernon Lord made the most of this opportunity for incongruous juxtaposition in his accompanying linocuts of contemporary London landmarks. However, Rock's original date of birth was in fact subconsciously highlighted for readers: on the journey it was the surviving monuments of Victoria's Britain that were given prominence, from the underground to policemen, to the Natural History Museum. The sculptures, Coates seemed to show, could be the pets of modern children, but they had an inescapable Victorian past as well.

Comparative anatomy

Even by the end of the nineteenth century, the distance (and difference) between current understandings of how the extinct creatures looked and acted was being commented upon. For instance, a preface by Henry Woodward, keeper of geology at the Natural History Museum, to Revd H. N. Hutchinson's *Extinct Monsters* (1892), made mention of Hawkins' project and how expert opinion on the dicynodon, labyrinthodon, megalosaurus and iguanodon had been changed by successive fossil discoveries, including many from the United States.[63] The new generation of both practising geologists and audiences were working with different models of these animals; as well as with discoveries that had been made since 1854, skeletons such as the Carnegie diplodocus casts that were to become new exhibition favourites as assemblages of bones, not fully embodied specimens.[64]

Coates brought this notion of lineages out well in *Dinosaurs Don't Die*, as Rock's journey across the capital was spurred by his wanting to meet his 'ancestor', an iguanodon displayed according to the most up-to-date scientific knowledge. After the exciting trek down the railway line, the river and the underground tunnels to the Natural History Museum, Rock was shown in John Vernon Lord's striking illustration as coming face to face with a current posing of a complete iguanodon specimen, as if looking into some sort of flesh-stripping, time-travelling mirror. The contrast between Rock's enlivened presentation and the museum specimen's dry persona inverted their roles: the modern interpretation, its supporting structures clearly in view, and sequestered behind ropes and barriers, was ironically much further away from an idea of a living creature. Earlier in the story, Coates had taken the opportunity to demonstrate the dated appearance of Rock, introducing her young readers to the well-known palaeontological faux pas that had placed the iguanodon's thumb on the end of its nose. Even Richard Owen had apparently been unwilling to approve this, and other aspects of the creatures that Hawkins had assumed or inferred. Part

of the bonding experience for Daniel and Rock, this also served as commentary on the now elderly status of the specimen, making him slightly old-fashioned and ridiculous. Moreover, it permitted an opportunity to address the issue of the model's stance: just as expert geological opinion on the iguanodon's nose-thumb had shifted over the centuries, so by the 1970s had current thinking on what type of creature the iguanodon was. Rather than being a hefty four-footed beast, the latest scientific discoveries and models depicted the iguanodon (and also the megalosaurus) as lither, two-footed creatures.[65]

Kerley and Selznick's *The Dinosaurs of Waterhouse Hawkins* (2001) focused even more explicitly on the nineteenth-century construction of the creatures, identifying the models with their sculptor, and using a more biographical approach to recreate canonical Victorian images from the *Illustrated London News* of Hawkins' workshop and the famous meal, as part of a prize-winning modern picture book.[66] Hawkins is the hero of the story, the model creatures his legacy. Again, the comparison between then and now was most effectively brought out through images, and through comparative anatomy: the book ended by overlaying how Hawkins and Owen had envisioned and incarnated the prehistoric creatures, with early twenty-first century depictions: the Victorian models are a ghostly but constant presence behind full-colour modern versions. The comparison between the anatomical presentations past and present brings out how the monsters have evolved from being a way to teach geological knowledge through visual education, to a way to teach the history and heritage of geological knowledge.

Conclusion

In their geologists'-eye view, Doyle and Robinson claimed that by the late twentieth century the Crystal Palace's monster models were 'mostly viewed as oversized Victoriana'.[67] Yet the sculptures have adapted well to life in the twenty-first century, even tweeting as @cpdinosaurs. This survival to some degree could be said to render the antediluvian animal sculptures apparently timeless: they have outlasted and transcended not only their original lives in prehistoric times, but also their second life as part of Sydenham's display. However, such an appeal to timelessness is not only historically unsatisfactory, but also denies how these artefacts have increasingly become precisely 'timed' objects, the emphasis no longer on the terrible spectre of primitive survivors, but instead on their historical significance as the first of these now ubiquitous types of palaeontological display, and of a particular stage in geological understanding. In

more recent publications, comparisons are frequently made between the nineteenth-century and current scientific decisions that have been taken in how to reconstruct the look, heft and stance of these vanished beings – decisions that demonstrate the precariousness of scientific knowledge, and its existence as a human activity. Appropriately, a renewed emphasis on palaeontologists as the creators of these reconstructed specimens, and attention to Hawkins and Owen in particular, has accompanied this more historical perspective on the Crystal Palace exhibits in children's literature. Nostalgia for the novelty of viewing such embodied beasts, revealed in three dimensions to the human eye for the first time, and a heroic celebration of the scientific feat behind this resurrection, is particularly appropriate for children's media, as these audiences, too, are experiencing such sights for the first time, and being taught to appreciate the results of scientific enquiry.

The children's stories and images discussed in this chapter bring out these issues through their highlighting and sophisticated use of time. For example, the very specific hours after dark, so freighted with folkloric significance, are highlighted by Cyril's dream (1899), by Nesbit's *Enchanted Castle* (1907), and by Coates's cross-city adventure (1970), as a time in which the usual laws of nature are suspended, and the promise of the three-dimensional existence of the creatures can be realised in their conversion into enlivened creatures. That the monsters could come back to life was at the heart of their potential terror for young audiences, but also the source of Hawkins' and Owen's palaeontological triumph. Furthermore, the particular location of the geological islands seems to be one that exists on the borderlands of life and death: all three of these authors present the creatures as suspended in time, waiting patiently in the light of day, but certainly not dead. For Nesbit, the monster models play a key role in *The Enchanted Castle*'s closing pageant at 'moon-rise', which occupies a peculiarly suspended moment for the children: 'None of the six human beings who saw that moon-rising were ever able to think about it as having anything to do with time. ... And yet there was time for many happenings.'[68] In fact, the procession was led by the monsters themselves, 'the great beasts, ... strange forms that were when the world was new'; joined by the rest of the statues ('the stone gods of Egypt and Assyria', angels, sphinxes, gods and goddesses), they communed in silence: 'All the faces, bird, beast, Greek statue, Babylonian monster, human child and human lover, turned upward, the radiant light illumined them and one word broke from all ... "The light!" they cried'[69]

As Measom's 1855 alphabet had indicated in its discussion of the letter 'C', the particular significance of the 'Building of iron and glass' was that

it was a 'light Crystal Palace': that, not only beginning with the letter 'C', both structure and contents were things that one could 'see'. In Nesbit's finale, the metaphors of vision and of understanding that underpinned the revamped exhibition's educational aspirations were particularly overt, and particularly embodied in the assemblage of varied sculptural forms.

Casting such disparate historical forms in stone, and casting aside the usual rules of space and time, permitted such an enlightening experience: a parody, perhaps, of the educational hopes of the original incarnation of the Crystal Palace, but one which again emphasised the crucial role of the monstrous models as the oldest of the Palace's reconstructed historical artefacts; the most difficult to resurrect, but also the most important, particularly for childish audiences. For Lively, as in so much of her other writings for children, a consciousness of the overlayering of the past and present is demonstrated through a geological and archaeological awareness. Elsewhere, such as in her renowned children's book *A Stitch in Time* (1976), slippages between centuries occur within the stories themselves; but for *Fanny and the Monsters* time travel occurs upon reading the book's opening lines.[70] Geohistory is accessed through history: a more familiar, more recent past the means by which both Lively's childish protagonist and her childish readers can learn about the former inhabitants of the globe, and also how to read their traces in the contemporary world. For Fanny, those traces take the form of fossil remnants in a quarry. For her readers, those traces are the Crystal Palace monsters themselves.

As the sole survivors of the original display, the Sydenham sculptures have a particularly nostalgic visual and material appeal, referencing past eras, prehistoric, Victorian, and also personal, that echo the historical purposes at the heart of the original enterprise. The continued physical presence of the monsters on the island, frozen and waiting to be brought back to life with the writer's keyboard and illustrator's pencil, has been a particularly tempting cue for children's authors. But this nostalgia and this resurrectionary process can take different forms: by tracing the monsters' tale from innovative, and potentially terrifying, project of visual education, to familiar – if slightly funny-looking – friends, I have explored just some of the ways in which the models have appeared in children's literature over the past 160 years. The models were the source of multiple and shifting meanings from their first inception, a way of bringing together the past, present, and – with juvenile audiences – the future, but always for particular purposes. Now, as themselves the fossilised remains of a past geological age, a visit to the Crystal Palace monsters arguably provides a re-enactment of the palaeontological process itself, Victorian Britain a pit-stop on the way to prehistory.



Notes

1 'Uppingham *vs* Incognito', *Uppingham School Magazine*, 8 (March–December 1869), 267.

2 P. Doyle and E. Robinson, 'The Victorian "geological illustrations" of Crystal Palace Park', *Proceedings of the Geologists' Association*, 104 (1993), 181–94; S. McCarthy, *The Crystal Palace Dinosaurs: The Story of the World's First Prehistoric Sculptures* (London: Crystal Palace Foundation, 1994); W. J. T. Mitchell, *The Last Dinosaur Book: The Life and Times of a Cultural Icon* (Chicago: University of Chicago Press, 1998); M. J. S. Rudwick, *Scenes from Deep Time: Early Pictorial Representations of the Prehistoric World* (Chicago: University of Chicago Press, 1992); J. A. Secord, 'Monsters at the Crystal Palace', in N. Hopwood and S. de Chadarevian (eds), *Models: The Third Dimension of Science* (Stanford: Stanford University Press, 2004), pp. 138–69.

3 J. R. Piggott, *Palace of the People: The Crystal Palace at Sydenham, 1854–1936* (London: Hurst & Co., 2004), pp. 158–64; A. Chase-Levenson, 'Annihilating Time and Space: Eclecticism and Virtual Tourism at the Sydenham Crystal Palace', *Nineteenth-Century Contexts*, 34 (2012), 461–75.

4 G. A. Sala and H. W. Wills, 'Fairyland in 'Fifty-four', *Household Words*, 8:193 (3 December 1853), 313–17; see McCarthy, *Crystal Palace Dinosaurs* for details of the dinner.

5 See Piggott, *Palace of the People*; Secord, 'Monsters at the Crystal Palace', p. 138; H. Atmore, 'Utopia Limited: The Crystal Palace Company and Joint-Stock Politics, 1854–1856', *Journal of Victorian Culture*, 9:2 (2004), 189–215.

6 'The Age of the Comet ascertained to a Nicety. The Antediluvians Recognise an Old Acquaintance of A.M. 1372', *Punch* (27 July 1861), 34; 'Education for Colonial Life at the Crystal Palace', *Graphic* (9 November 1876).

7 See http://news.bbc.co.uk/1/hi/england/london/6934908.stm (accessed 4 March 2014).

8 D. L. Sayers, *Have His Carcase* (London: Hodder & Stoughton, 2003), p. 56; A. Todd *et al.*, *Buffy the Vampire Slayer: Tales of the Slayer*, 2 (London: Pocket Books, 2003), p. 229.

9 *Crystal Palace Guide to the Palace and Park* (London: Robert K. Burt, 1871–72), p. 27.

10 Matthew Digby Wyatt, 1854, quoted in Secord, 'Monsters at the Crystal Palace', p. 141.

11 R. O'Connor, *The Earth on Show: Fossils and the Poetics of Popular Science, 1802–1856* (Chicago: University of Chicago Press, 2007), pp. 264–323 (esp. pp. 287–8); Secord, 'Monsters at the Crystal Palace'. N. R. Marshall, '"A Dim World, Where Monsters Dwell": The Spatial Time of the Sydenham Crystal Palace Dinosaur Park', *Victorian Studies*, 49 (2007), 286–301.

12 B. Waterhouse Hawkins, 'On Visual Education as Applied to Geology', *Journal of the Society of Arts*, 2 (1854), 444; Secord, 'Monsters at the Crystal Palace'.

13 Chase-Levenson, 'Annihilating Time and Space', 467.

14 Hawkins, 'Visual Education', 1.

15 M. Oliphant, 'Modern Light Literature – Science', *Blackwood's Edinburgh Magazine*, 78 (1855), 225.

16 *Ibid.*, 226.

17 O'Connor, *Earth on Show*, p. 287.

18 P. Lively, *Fanny and the Monsters* (London: Heinemann, 1979), p. 8.

19 *Ibid.*, p. 7.

20 *Ibid.*, p. 10.

21 C. Butler, *Four British Fantasists: Place and Culture in the Children's Fantasies of Penelope Lively, Alan Garner, Diana Wynne Jones, and Susan Cooper* (Lanham, MD: Scarecrow Press, 2006), p. 55.

22 V. Hunt, 'Narrativizing "The World's Show": The Great Exhibition, Panoramic Views and Print Supplements', in J. Kember, J. Plunkett and J. A. Sullivan (eds), *Popular Exhibitions, Science and Showmanship, 1840–1910* (London: Pickering & Chatto, 2012), pp. 115–32. See for instance, H. S. Evans, *The Crystal Palace Game. Voyage round the World; an entertaining excursion in search of knowledge, whereby geography is made easy* (London: Alfred Davis & Co., *c.*1855).

23 G. Measom, *The Crystal Palace Alphabet: A Guide for Good Children* (London: Dean & Son, 1855), p. 26. The monsters can also be seen in the background to letter 'L', for 'Lakes', p. 14.

24 C. Baker, *Plants, the Earth and Minerals. Third Series of Consecutive Lessons* (London: William Macintosh, 1866).

25 See www.kb.dk/permalink/2006/manus/4/eng/17+verso/?var (accessed 1 May 2014).

26 R. Veder, 'Pestalozzi and the Picturebook: Visual Pedagogy in *The Dinosaurs of Waterhouse Hawkins*', *Visual Resources*, 24 (2008), 369–90.

27 Doyle and Robinson, 'Victorian "Geological Illustrations"', 190; Marshall, 'A Dim World', 292.

28 Both quoted in McCarthy, *Crystal Palace Dinosaurs*, p. 28.

29 C. Bridgman, *Crystal Palace Children's Annual, Christmas, 1899. Cyril's Christmas Dream* (Sydenham: Crystal Palace Co., 1899), p. 16.

30 *Ibid.*, p. 32.

31 *Ibid.*, p. 15.

32 *Ibid.*

33 *Ibid.*, p. 21.

34 G. H. Robinson, *Peter's Paradise: a Child's Dream of the Crystal Palace. Illustrated by James Denholm* (London: Simpkin, Marshall, Hamilton, Kent & Co., *c.*1890), p. 14.

35 G. Du Maurier, 'A Little Christmas Dream', *Punch*, 55 (1868), 272.

36 Ezekiel 37:7–8, 10.

37 J. Mill, *The Fossil Spirit: A Boy's Dream of Geology* (London: Darton & Harvey, 1854).

38 T. Cosslett, *Talking Animals in British Children's Fiction* (Aldershot: Ashgate, 2005).

39 E. Nesbit, *The Enchanted Castle* (London: T. Fisher Unwin, 1907). Mention of the Crystal Palace display is made in M. I. West, *A Children's Literature Tour of Great Britain* (Oxford: Scarecrow Press, 2003), pp. 86–8, in the section on Nesbit.

40 Nesbit, *Enchanted Castle*, p. 312.

41 *Ibid.*, pp. 312–13.

42 *Ibid.*

43 *Ibid.*, p. 310.

44 R. O'Connor, '"Victorian Saurians": The Linguistic Prehistory of the Modern Dinosaur', *Journal of Victorian Culture*, 17 (2012), 492–504.

45 Nesbit, *Enchanted Castle*, pp. 114–16. An illustration of 'The moving stone beast' by H. R. Millar was included in the middle of this passage, on p. 115.

46 Nesbit, *Enchanted Castle*, pp. 259–60.

47 Mitchell, *Last Dinosaur Book*, p. 97.

48 A. Coates, illustrated by J. Vernon Lord, *Dinosaurs Don't Die* (London: Longman Young, 1970).

49 'Bob Briefless', 'Letters from a Lawyer', *Girl's Own Paper*, 980 (8 October 1898), p. 30.

50 'Pets Among the Monsters', *Children's Newspaper* (13 June 1953), p. 3.

51 J. and G. Adamson, *Topsy and Tim Meet the Monsters* (Glasgow and London: Blackie, 1978).

52 The illustration on p. 5 of the book depicts an entrance to a car park, with a sign saying 'Crystal Palace Park' next to it. The monsters depicted in later illustrations are also clearly these sculptures: a later sign saying 'Hyaleosaurus' is included next to its image on p. 11, again more for the adult reader that for the child.

53 *Ibid.*, p. 10.

54 *Ibid.*, pp. 5, 7 and 8.

55 *Ibid.*, p. 3.

56 *Ibid.*, p. 12.

57 *Ibid.*, pp. 14, 15 and 20.

58 *Ibid.*, p. 21. The cover of the book also shows an image of Topsy climbing on the iguanodon.

59 *Ibid.*, pp. 22–3.

60 *Ibid.*, p. 24.

61 'Trouble with his Teeth', *Children's Newspaper* (6 June 1959), p. 2.

62 'Monsters Past and Present', *Children's Newspaper* (29 June 1935), p. 9.

63 Reverend H. N. Hutchinson, *Extinct Monsters: A Popular Account of Some of the Larger Forms of Animal Life*, 5th edn (London: Chapman & Hall, 1897), pp. v–vi.

64 I. Nieuwland, 'The Colossal Stranger. Andrew Carnegie and *Diplodocus* Intrude European Culture, 1904–1912', *Endeavour*, 34 (2010), 61–8.

65 D. Norman, *Dinosaurs: A Very Short Introduction* (Oxford: Oxford University

Press, 2005), pp. 55–84. In this chapter, 'New Light on *Iguanodon*', the iguano-
don is the chosen species through which wider changes in the history of
palaeontological thinking are approached.

66 Kerley and Selznick, *Dinosaurs of Waterhouse Hawkins*. The image of the meal
is on pp. 18–19. See Veder, 'Pestalozzi and the Picturebook', 380, for how
'Kerley's text describes the biographical arc of Hawkins' life'.

67 Doyle and Robinson, 'Victorian "Geological Illustrations"', 181.

68 Nesbit, *Enchanted Castle*, p. 347.

69 *Ibid.*, pp. 347–9.

70 P. Lively, *A Stitch in Time* (London: Heinemann, 1976); Lively, *Fanny and the
Monsters*.

9

'A copy – or rather a translation … with numerous sparkling emendations.' Re-rebuilding the Pompeian Court of the Crystal Palace

Shelley Hales and Nic Earle

In 1896, the posthumous final volume of the Niccolini brothers' *Case ed monumenti di Pompei* was published. The previous volumes had recorded the excavations at Pompeii, featuring coloured plates of wall paintings alongside exhaustive details of finds, but, capitalising on a growing trend in visualising Pompeii's ruins restored, this volume introduced the 'Saggi di Restauro' (Essays in Restoration), in which sixteen buildings were returned to pristine wholeness.[1] One of the restorations, credited to D. Capri, visualises a domestic interior (figure 9.1). The viewpoint from the left of the *atrium* takes in the *tablinum* and peristyle before ending in the further *ala* (wing). The house, populated by its seated *matrona*, is beautifully decorated: on the walls, painted *candelabrae* frame myth panels (Perseus and Andromeda appear in the far *ala*), water pours from the jug of the fountain figure into the mosaic-bordered *impluvium* and through the *compluvium* the Mediterranean sky complements the colours of the walls.

To our knowledge, Capri's vision has never been contested but the house from Regio VIII, Ins II it claims to restore is actually clearly the Pompeian Court of the Crystal Palace (figure 9.2).[2] It was one of the few Fine Arts Courts to take the form of a coherent restoration; an entire Pompeian house, designed by Matthew Digby Wyatt and decorated with paintings traced on site and translated to Sydenham by Giuseppe Abbate.[3] Although originally intended as a refreshment room and stranded among the industrial exhibits, its design, domestic appeal and the perennial fascination with Pompeii made it one of the most successful and popular courts.[4]

The ongoing failure to recognise the Court's interruption into the 'Saggi di Restauro' reflects its apparent occlusion from history, as it is

9.1 Restoration of a Pompeian atrium, 1896, lithograph by D. Capri. From *Le Case ed I monumenti di Pompei disegnati e descritti*, IV, 1896, Saggi di Restauro, plate V. The Bodleian Libraries, University of Oxford (20501.a.2d).

9.2 Pompeian Court, Crystal Palace, 1854, lithograph by Day & Son after photograph by P. Delamotte. From *Views of the Crystal Palace and Park, Sydenham. From drawings by eminent artists and photographs by P. Delamotte*, 1854, pl. IX.
© British Library Board.

absorbed back into the archaeological record. Paradoxically, this absorption was made possible by its very high profile in the nineteenth century and the high regard placed on its apparent authenticity. Wyatt's illustration of his own Court served as an exemplum of the Roman decorative arts in the Scottish Exhibition in Glasgow and Abbate, whose arrival from Naples sealed his personal authenticity, was characterised as having arisen from Pompeii's ashes.[5] Journalists describing Roman lifestyles might refer readers to the Court rather than to 'real' Pompeii.[6] One validates his sightseeing at Pompeii by matching the things he saw with the Court, while another unflatteringly likens entering the site to going through the Palace's turnstiles.[7] At home, Scharf was adamant that there was no better way to see a Pompeian house and responses made explicit his implication that a visit to the Court might be better than to Pompeii itself.[8] The Court thereby could be understood to provide adequate compensation for thwarted time-travellers and those who could not afford access to Pompeii either through conventional travel or acquisition of expensive volumes, such as the Niccolinis'.[9]

In framing people's vision of the ancient city, the Court inevitably became likewise embroiled in responses to, and expectations of, other contemporary resurrections of Pompeii: a correspondent from the Crimea described the neo-Pompeian court of the Tsarina's Palace at Oreanda as being 'got up like the Pompeian Court at the Crystal Palace', thus occluding both other neo-Pompeian interiors and their ultimate prototype Pompeii.[10] The success of the Court perhaps lay in the way in which its walls conformed to contemporary aesthetics, creating the 'authentic fake' verified precisely because it meets expectations.[11] Although its motifs were gathered from disparate ruins, and despite the designers' own belief in the eclectic borrowings of Pompeian art, they were reassembled seamlessly into a consistent scheme that reproduced a style that now looks typically nineteenth-century neo-Pompeian.[12]

Alma-Tadema's *Returning Home from Market* (1865) exemplifies some of the difficulties in disentangling the Court from Pompeii's ruins and other contemporary restorations. The painting shows an aristocratic Roman woman, young child in hand, followed by her slave, who is laden down with the morning's purchases. The group are captured as they arrive at their front door, the porter standing aside to gesture them in to the mosaic-decorated vestibule. One review describes the entrance, 'such as may be seen in the Pompeian Court of the Crystal Palace'.[13] The remark is not unreasonable since Alma-Tadema has used the mosaic Salve (Greetings) from the House of the Vestals that featured in both the Court's side entrances (4 and 14 on the floor plan [figure 9.3]) and an adaptation of the

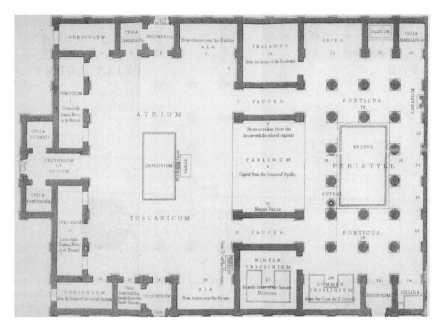

9.3 Floor Plan of the Pompeian Court, 1854, 7.5 × 2.4 cm, from G. Scharf, *Guide to the Pompeian Court* 1854, interleaf. University of Bristol Library Special Collections.

Cave Canem (Beware of the Dog) mosaic from the House of the Tragic Poet that decorated its *prothyrum*.[14] Meanwhile, his photograph archive includes a shot of the Court's atrium among images of 'actual' Pompeian houses and mistakenly labelled by the archivists as 'the real thing'.[15]

This complex interweaving of the Court with contemporary perceptions of Pompeii and other re-imaginings of the site was utterly ripped apart by its physical destruction in the Palace fire of 1936, and subsequent mental dismantling from nineteenth-century histories. For a good 70 years, the Court was reduced to near-invisibility and when its erstwhile existence was acknowledged it was generally misattributed to Hyde Park.[16] The result is that we have been able to remember neither the Court's mediating role in nineteenth-century consciousness nor its transformative effects on our own vision of 'real' Pompeii.

As the Crystal Palace has slowly hoved back into scholarly view under the steam of a wider re-evaluation of exposition culture, two factors in particular have been used to explain its long absence. First, Paul Greenhalgh suggests that precisely their associations with play, leisure and entertainment have led to the submersion of successive exhibitions under the 1851 Great Exhibition.[17] Second is the discreditation in museum practice of the

copy and fake, statuses with which the Sydenham Palace and its contents are ever bound.[18] In configuring the Pompeian Court as a 'simulacrum', Kate Nichols invokes Umberto Eco and Jean Baudrillard, whose essays created the discourse of the hyper-real, attacking primarily the physical heritage reconstructions of 1970s and 1980s America as controlling and alienating mechanisms of capitalism.[19] Similar charges appeared in work which implicitly or overtly condemned the commodification of history in Thatcherite Britain.[20] Critics suggested that visitors to reconstructions are reduced to spectatorship as their own history is screened from them by heritage 'imagineering'.[21] Distracted by the reconstruction's finesse and spectacle of 'reality', they are led from the rigours of history (detectable only by competent elites) to heritage's cosy verification of 'our past'.

Simultaneously, there was a tendency to trace back this malaise (and awareness of and anxiety about it) to the Victorians who, cast as hopelessly looking back, create nostalgia for any number of distant pasts even as they destroy them in the race for mechanised profit, replacing them with a series of exact reconstructions designed to enforce a hegemonic interpretation of those lost eras.[22] The application of such an interpretative model to the Sydenham Palace highlighted its association with an emergent rapacious capitalism. Its dismissal (and that of its educational and aesthetic aims) was largely assured. Academia's refusal to engage with the building has very real consequences. Its low profile perhaps contributed to the long-term disinterest in implementing a coherent conservation plan for the site. It is ironic that local communities' efforts to use the Palace site to foster a local feeling of a 'real' place, around which to attach memories and experiences, has been hampered by the very discourses which claimed to champion such parochial histories.[23]

This chapter offers an initial reflection on our attempt literally to remember a small part of the Crystal Palace, the Pompeian Court.[24] In looking for ways in which to approach the Court, we sought a format that would allow us to tackle the Palace's emphases on restoration and play head-on. We wanted to ensure, at least to a small extent, that increasing intellectual interest in the Palace did not simply equate to a re-sequestration of the Palace into the academy. Our first solution has been to create our own digital visualisation of the Court (figure 9.4), initially built in Second Life (SL), a popular multi-user online virtual world (VW) launched commercially in 2004 and accessed via avatars, users' virtual representations, which they control from their computer keyboards. In-world, the particular appeal of SL is its modelling affordances which mean that users can build anything from simple 3D objects to extensive resorts.

At the commencement of the project, Second Life was at its peak, with

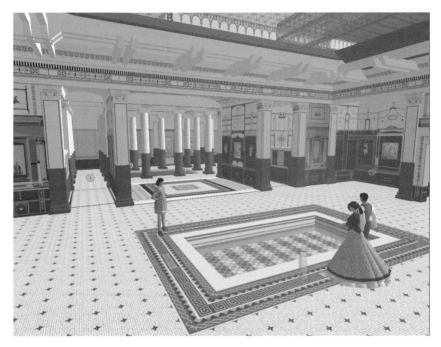

9.4 View of Atrium of the digital Pompeian Court, Second Life.
Author's screenshot.

a massive international user community, whose members were meeting
in-world, sharing ideas and building projects together, and a thriving
internal economy. It was attracting investment from major multinational
companies and higher education institutions alike, all wanting a share
of that community's attention. Anxiety and interest in its growth were
reflected in coverage in the media and academic monographs.[25] Our
model is presented as the product of our research but the process of crea-
tion and inhabitation itself offers a reflexive mode of engagement with the
wider themes of the Palace. Rather than attempting a mode of reception
by which we claim to read the Palace Company's reception of Pompeii
from a safe, unimplicated distance, our format forced us to effect some
kind of direct conversation between their – and our own – restoration
endeavours. That is not to say that we wished disingenuously simply to
collapse our sense of distance, rather we adopted the term 'productive
juxtaposition' to describe a process by which issues raised by one format
inevitably foregrounded certain aspects of the other.[26]

Experiencing the Court

In order to translate into written text a mode of presentation that was never meant to exist in linear narrative, we begin with a virtual visit to the digital Pompeian Court, taking the 'text-book' route (as recommended by George Scharf's guidebook and reflected in the numbering sequence in its floor plan), obedient to the organisational structures imposed by the Palace Company. However, since the Court had no ropes or barriers, you are free to progress in any order and if, at any moment you wish to rest, should proceed straight to the Summer Triclinium (numbered 25 on the floor plan, figure 9.3). The information presented here is also designed to mimic the mapping of information in the VW. The displayed text is the equivalent of experiencing our data, the main text plays the role of explanatory paradata, while the footnotes substitute for metadata. In the spirit of virtual mobility you may decide to read or ignore these layers in any order that you wish.

First sightings

> After 43 pages of preparatory information, presumably consumed in sedentary fashion, Scharf expects his readers to burst rapidly into action, viewing in quick succession the façade from the Palace nave and the rooftiles from the gallery.[27] In SL you can climb the Palace superstructure to gaze down on the house – or you can simply press the fly button and hover effortlessly above it. (figure 9.5)

Scharf's rapid shift of viewpoints reflects other guides and reviews in stressing the variety of views of the Court on offer to visitors, who are privileged to see not only the past restored but to inspect it from novel angles. Under the influence of recent studies into the scopic regimes of the nineteenth century, the visual experience and the extent to which the Palace reconstructions were understood by reference to the latest photographic technologies – as living stereographs and daguerreotypes – has been increasingly stressed.[28] Those photographic developments, alongside innovations such as aerial travel, are understood to have created the 'mobile self', freeing the Victorian eye to roam, in the middle rather than on the edge of the visual field, and to see the world from new angles – to peer into houses like toys from the air (an effect mimicked by the much written-about but ironically rarely illustrated view from the gallery).[29] Physically immersive views such as the panorama have been paralleled with developments in exhibition practice which likewise favoured three-dimensional immersion.[30] The views valued here are not those of the ancient inhabitants of the Court but

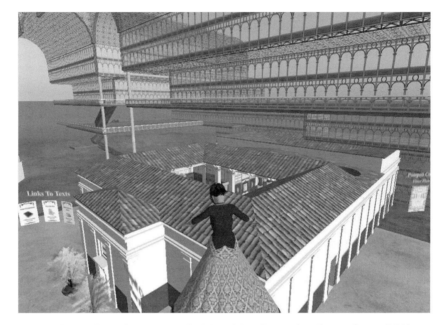

9.5 Avatar hovering over roof of the digital Pompeian Court, Second Life.
Author's screenshot.

of the tourist who scrambled over the site's ruins, or better the archaeolo-
gists who peered down at the homes they were about to exhume – the first
humans to inspect them for two thousand years. The essentially private
nature of Pompeian houses (at least as understood from the viewpoint of
Victorian domesticity) added extra frisson to this voyeuristic, penetrative
gaze, which could now be experienced in Sydenham.[31]

Through their avatars and camera controls, visitors to our model can
explore the VW from within and from all angles, set precisely in the
middle of a visual field, which is generated by the computer in response to
their movements. Just as the Court translated not the larger environment
of the archaeological site but the gaze experienced in it, our model arouses
some of the novelty of becoming the mobile spectator through the gift of
virtual flight. Such affordances of VWs help us not so much to recapture
the lost Court, but to look at the Court as we now know it with a different
eye than that academic gaze we generally employ in poring over archive
material.

Prothyrum[32]

> If you are new to SL, you may find it tricky to steer through the narrow vestibule. Once in, you can peruse the walls and the floor mosaic and, by clicking on the information icons hovering over each space and figured panel, consult your virtual guidebook.

The first role of the model is that of online archive to assemble and make publicly accessible visual and textual sources pertaining to the Court. At each information point, the virtual guidebook offers the relevant extract of Scharf's text as well as metadata (our own explanations and information). The rest of Scharf's guidebook, extracts from others and initial press reviews are available elsewhere on site in their entirety as well as in snippets on notecards distributed by our robot avatars, avatar characters controlled by script rather than a human user. The architecture of the model, which acts as the depository for the archive, replicates the Court's dimensions. The motifs on the walls and floors are 'cut out' from the contemporary publications (including the *Real Museo Borbonico*, the catalogue to which Abbate himself contributed drawings) by reference to which Scharf legitimated them.[33]

As a result, while the Court's walls appeared seamlessly coherent, our model, which follows Scharf's meticulous dismantling of the walls into their constituent elements, is clearly a scrapbook sum of disparate parts. Moreover, despite the Palace's commitment to polychromy and Pompeian painting's key role in advancing knowledge of ancient colour, those parts are resolutely monochrome.[34] Since they have been traced from nineteenth-century sources, they are both absolutely authentic archival objects (in terms of fact and our expectation of the Court as filtered through all those monochrome stereographs and lithographs) and completely wrong restoration (with the exception of the floors in *tablinum* 8 and *oecus* 20 which were taken from Wilhelm Zahn's innovative coloured volumes).[35] Again, our process of restoration fails to revive the Court itself, delivering instead its raw ingredients and foregrounding the processes of selection and combination that lay behind the Court's finished whole.

Atrium[36]

> Entering the atrium, the house opens up before you. Take a few steps to the left and your viewpoint approximates that of the Capri lithograph (fig. 1) and any number of litho-, stereo- or photo-graphic views of the Court. A Victorian couple walks by, disturbing the stillness. Their avatar tags announce them as Alva Wirsing and Isaac Bowenford. If you type a

greeting, they pause momentarily to say good morning. They perambulate
the atrium, stopping at key points to comment and consult their guide-
books. By their second time round you realise they are not live avatars but
scripted robots endlessly repeating their visit.

This viewpoint is the best from which to appreciate our restoration, both
because of the wide vista and the familiarity of comparative images against
which to test it. In the guidebook plan, the *atrium* is not numbered – it
is an entity in itself rather than part of the touring sequence. Almost all
the images of the Court record the *atrium*, assuming a position outside
cubiculum (1), suggesting a viewer who (in defiance of Scharf's instructions)
peeks into every exhibit, experiences them as tableaux and moves on.[37]
Alva's and Isaac's conversation, lifted from guidebooks and reviews, voice
contemporary uncertainties about the aims and uses of restoration. Isaac
reflects the extreme confidence in the Court's restoration that we have
already encountered. The Court is so successful that it has somehow
become 'the thing itself', entirely manifest to the visitor without recourse
to imagination.

 Alva counters that 'literal correctness' is neither possible nor desir-
able.[38] Instead, Lady Eastlake (who reviewed the guidebooks in the
Quarterly Review and whose words Alva channels) worried that the uned-
ucated would simply be distracted by the delightful doll's-house effect
of the Courts, which she describes as gingerbread toys, an anxiety that
seems to prefigure twentieth-century warnings against heritage's dazzle.[39]
The use of that same term by sceptical commentators, such as Herman
Melville and the French newspaper *L'Illustration* helps to explore its impli-
cations. *L'Illustration*'s favoured term, 'jou jou', occurs elsewhere in French
discourse as a term to denigrate other kinds of restorations, always to
imply not a lack of seriousness but an innate redundancy.[40] To read Lady
Eastlake's comment this way, to configure the Court as an amusing trin-
ket rich to the eye but ultimately inaccessible and useless, also begins to
expose the stress on the Palace reconstructions' visual impact as a means
of masking their lack of life.

 This reading of restoration's disappointments is stimulated by experi-
ence of VWs. Surveying our *atrium* you may be impressed but inclined to
question the point. Certainly, it opens up the restoration to the visitor's
scrutiny as judge and spectator but offers no obvious role beyond. This
alienating, passive effect has been seen as the scourge of historical, digital
visualisations which promise so much, but offer little beyond their impres-
sive representations.[41] Both as museum or house, the space we have visu-
alised here is essentially social (as is SL itself), enlivened and determined

by the interactions which take place within it.[42] If our Court is to be more
than a toy in this most reductive sense it needs animation in order to
unfreeze the familiar and compelling, but ultimately repellant, tableau.[43]
Alva's and Isaac's main role is precisely to animate as they studiously repli-
cate the sequence of Scharf's visit, providing a cue to expected behaviour.
Their conversation serves as a prompt to help visitors calibrate their first
real view of our model and as an inkling of the debates about originality
and reproduction instigated both by the Palace and VWs.

Around the atrium (1–17)[44]

> If you are obeying Scharf's itinerary you are now negotiating each cubicu-
> lum in turn, and perhaps finding steering your avatar rather tricky, par-
> ticularly if other visitors are doing the same. These visitors not only block
> your way or your view but may chat incessantly. As your screen blocks up
> with lines of text chat, you find that solace can only be found by moving
> beyond their range.

The *atrium* offered some logistical difficulties to the Palace company; extra
side doors were provided to aid circulation and relieve congestion at the
front entrance while the whole thing was made bigger so as to accom-
modate crowds.[45] Reviewers' comments reflect their spatial experiences as
they moan about the poky *cubicula* or fret about the dangers of unmarked
steps (in tribute to which concern Isaac trips every time he enters the *tab-
linum*).[46] There are, however, other sense experiences that the VW cannot
replicate; other inconveniences that shattered the happy illusion of visual
immersion in the past, of literally stepping into the stereoscope, such as
the low temperature that belied the Court's Mediterranean atmosphere,
or the smell of paint that gave away its newness.[47] From within the stereo-
scope, however, that is to say from within the VW, it is precisely the lack
of other sensory input (beyond some basic sound) that exposes the limits
of visual immersion.[48]

Despite some enthusiasm voiced in the press for the adoption of the
atrium house in British life, the comments from those actually walking the
Court shows that experiencing this space drew attention to the differences
of Roman domestic life, for example the uncomfortable and unprivate
bedrooms. The tendency to reflect rather more on Roman lifestyles than
art was clearly stimulated by the spatial experience of the Court. The
spatiality of SL allows us to prompt similar reflection in our visitors. Just
as a number of 'real' gallery settings have aimed to re-stage Victorian
exhibition events, our model likewise invites visitors not simply to view
the paintings but to experience their exhibition space.[49] The difficulties

of negotiating crowds and picking out details in awkward spots may be differently experienced through the VW than on the exhibition floor but these familiar frustrations help reinforce the sense of event. Meanwhile, our ability to navigate, and watch others navigating, the space evokes the possibility of using our Court as an 'experiential laboratory' in which to test potential modes of circulation around the exhibit and environmental effects on it.[50] We cannot presume that our visitors replicate paths taken by 'real' Victorian visitors; nevertheless, their difficulties and choices may prompt new insight into how the space enabled or hampered the mobile spectator. For example, we can observe the crash between human traffic entering from the front entrance and moving slowly in a circular motion (enforced practically by the water-filled *impluvium* and pedagogically by the guidebook) and those taking the direct shortcut through the side doors, who perhaps stole only a brief transitory glance at the Court in their hurry for the train.[51] These different movements encourage not only awareness, but experimental mapping, of other possible experiences than that pre-scribed by Palace texts, again shifting our view of the Court's affordances.

Peristyle (18)[52]

Scharf now leads you up fauces (7) to the quieter rear of the house and the marble lararium, or household shrine. Usually an unremarkable exhibit, occasionally its flame rekindles and characters appear around it in ancient dress, the doomed Pompeian inhabitants of this ancient house, amongst them Ione and her slave girl, Nydia.

As itself a spectacle of resurrection and an exhibition of many possible paths, Pompeii offered many juxtapositions to the Pompeian Court. In particular, the Court's overt 'toy-like' nature prompts recognition of the toy-type nature of the ruins, both in terms of their explicitly recognised role as diminutive copies of Roman archetypes and, too, the attractive and inspectable, almost-alive but really dead and passive spectacle they offered tourists.[53] As a reproduction of those ruined sites, the Court might also be identified with a very specific type of toy, the tourist souvenir, a memento of Digby Wyatt's and Scharf's own travels.[54] The repeated fantasy of reanimation, either through time-travel or an encounter with phantoms, might be seen as an attempt to overcome this frustration in order to gain some 'real' experience on site.[55]

Two-dimensional restorations, like the Capri lithograph (figure 9.1), often resurrected the city's inhabitants alongside its buildings. As Pompeii restored, the Court likewise encouraged such fancies of 'step(ping) bodily' into the past. One guide replaced the inconveniences of fellow visitors

barging by and the intrusion of uninvited sounds and smells by refram-
ing them as the light touch of a priest of Isis brushing past, the chatter
of household slaves, and the perfume of flowers in the peristyle, while no
end of Roman celebrity ghosts could be imagined there.[56] But of all the
ghosts haunting the Sydenham Pompeii, the most popular were the cast
of Bulwer-Lytton's *Last Days of Pompeii*.[57] The Court itself encouraged this,
taking a number of details from the House of the Tragic Poet (the real
Pompeian house in which Lytton had lodged his hero Glaucus) and by
Scharf's prefiguration of his own tour of the Court with Lytton's tour of
Glaucus' home earlier in the guidebook (a tactic also regularly employed
in guidebooks to Pompeii itself).[58] By this means, the Court was able to
authenticate itself to its audience by feeding off the familiarity of Lytton's
Pompeian world while perhaps admitting the fantasy of inhabiting the
past.

The names of our Pompeian robots pay homage to Lytton while their
bona-fide fictional status is ensured by their independent appearance in a
short animation, their own melodramatic *Last Days of Pompeii*. The scripted
robot has been recognised as the virtual equivalent of the uncanny phan-
tom and so offers our best opportunity to represent this facet of visitor
imaginations.[59] But, whereas they existed in the Court only as mental
vision, our phantoms exist in the same experiential plane as the restora-
tion, guidebook text and visitors themselves, claiming equal not marginal
influence. They highlight another possible understanding of the nature
of the Court as adaptation, to be considered alongside the adaptations
of Lytton's novel available elsewhere in the Palace, whether as opera or
firework displays.[60]

Thalamus (19)[61]

Having woken from your Pompeian reverie, you continue, only to encoun-
ter more robot avatars, this time in Victorian dress.[62] Having engaged in
preliminary pleasantries they take care to ascertain your status and gender,
which once discovered may change their manner considerably. You may
experience deference, rudeness, share confidences or even be ignored. All
sorts of information might be thrust into your hands (or deliberately kept
from you if you are not deemed a suitable recipient) via notecards.

Like the Palace, the Pompeian Court was subject to anxieties about class
interaction. In its very conception, it was a paradigm of class interest, its
domestic status reflecting the middle-class values expressed by the Palace
Company.[63] In practice too, one can observe how visitors used the setting
to rationalise the mix of classes potentially present. The familiar order of

the serviced household helped assign each to his place, from the master in the *tablinum* to the 'servant' washing up in his 'pantry'.[64] Meanwhile, the fact that plebeians were regularly admitted to the *atrium* of smart Pompeian houses in order to pay their respects seemed to justify their incursion.[65]

The ability to acquire and benefit from knowledge was a key component in class difference, and distinctions drawn between the 'curiosity' of the uninformed and the 'inquiry' of the Court's more competent visitors might seem to chime with more recent fears about the ways in which heritage maintains class distinctions.[66] The Court was the setting for one of the most scathing examples of the lower classes' inability to benefit from the Palace's mode of rational recreation.[67] The sympathetic *Westminster Review* lingered on the ignorance of a 'tradesman's wife' who fails to recognise the historicity of the Court.[68] Her spectacle of incompetence becomes in the wrong hands justification for the economic status that denies her access to real Pompeii – she is not even competent for virtual travel. Satires which imagined working-class caricatures recounting garbled impressions of Palace sights or sentimental accounts of the navvies' talk of 'Pompey's house' reinforced the idea of the incompetent visitor.[69] The gap between the enlightened and nonplussed (at least as characterised by the enlightened) exaggerated class differences in the Court.

SL, which is populated by avatars of myriad appearances (not all humanoid), with no clue as to their operators' gender, age, ethnicity or status, generates its own social fears. Anxieties expressed by new users in particular about how to react to odd-looking avatars (or even to themselves as a strange avatar) or how to reconcile their mistrust of the identity of operators behind those avatars are not by themselves directly comparable to the anxieties experienced by some Palace-goers, but in eliciting social discomfort may prepare the way for our robots, who make class their priority.[70] The use of characters to enliven exhibits has been criticised as the worst, anti-critical kind of heritage imagineering, sanitising the reality of past bodies and encouraging unquestioning identification.[71] But the advantages of such characters has also been recognised, not least in terms of their ability to represent unpalatable or otherwise excluded voices: in our model a bereaved child distributes a newspaper clipping detailing the horrific injuries sustained by workers during the construction of the Palace.[72] The opinions and sources meted out by our characters, while working outside the 'official' information channel of the guidebook, have the opportunity to talk directly across it at the same volume.

The appearance of our stereotypical Victorian characters, wearing clothes (a product of SL design) apparently ripped from the wardrobe of *Dr Quinn Medicine Woman* (a 1990s American TV show) invites comparison

with that of their Pompeian counterparts, and rightly so, since their car-toon nature should remind visitors that our co-presence with them is as impossible as was Victorian audiences' with Pliny. Nevertheless, their impossible presence has a strong effect on 'real' visitor outcomes. From a variety of classes themselves, our Victorian avatars are scripted to dis-tinguish between visitors according to the status and gender each visitor inhabits in SL, their assessment prescribing their response. Their role in drawing visitors into the performance is not only to affect the pleasantness or otherwise of their visit but partly to determine what they can learn.[73] We have surrendered the deliverance of an overarching, apparently objec-tive, narrative shared by all our visitors to the aim of exposing them to conditional, partial and subjective narratives, which are not necessarily the same as, but of a kind which Victorian visitors of different statuses may have experienced.

Summer Triclinium (26)[74]

> The welcoming sign 'Sit here' hovers above the couches here. Award yourself the break – even Lady Eastlake enjoyed the Court's relaxation opportunities – and watch other visitors entertaining themselves.[75]

While Scharf's itinerary includes room for nothing other than hard work, the reinvention of the Palace in this century has privileged everyday, personal encounters.[76] Individuals consumed the Pompeian Court, like the others, in ways that sometimes ignored or deliberately subverted its didactic aims. Some were quite orchestrated – one music journal sent its editors to meet subscribers there, using the Court for their own com-mercial gain.[77] A poem presenting itself as a skit on a working couple's day at the Palace has them sit in the Court in between getting sozzled under the screen, enjoying rides on the terrace and walking in the gardens, whilst another fictional young man finds the Court a refuge from which to declare his love out of earshot of his would-be mother-in-law.[78]

As with the worries about behaviour in the Palace, outsiders' percep-tion of SL is beset with society's over-egged anxieties (fears of drunk-enness replaced by that of predatory sexual behaviours). In the main, our model attracts a range of less threatening, if mildly subversive uses: from an SL Victorian interest group holding a social, a new SLer practis-ing flying, a child avatar rehearsing a cheerleading routine, to various cyber-misbehaviours, such as landing our Palace park's air balloon in the *atrium*, stripping off clothes, and pushing over the robots. These activi-ties highlight the inherent difficulties in controlling the ambiguous spaces necessary for recreation in which other forms of play might become hard

to resist. So, while the Palace's 'toy' courts were meant for what might be recognised as identity and power 'play', leading visitors to experience and identify with the flexing of the Crystal Palace Company's muscles, they inevitably invited other kinds of more frivolous, personal play.[79] If such distraction was hard to resist in fact, it was more effectively curtailed in the formal narratives created around the Palace. Much criticism of the apparent preoccupations of Palace crowds suggests an inability to concede that alternative interactions with the Palace had any valency or that enthusiasm for relaxation and spectacle did not necessarily mean complete disregard for art. Yet again, distaste for play and a refusal to allow for such places to accommodate any subversion or manipulation combine to diminish the Palace experience.[80]

SL's game-like look, its reputation as virtual playground and the general 'rules' of knowledge-acquisition in our Court (collecting notecards, talking with robots, unlocking layers) inevitably foreground play in our model, thereby highlighting the possibilities of play in the Palace. The educational role of play in VWs is hardly uncontested, and enthusiasm for its ability to enhance interaction and accommodate open-ended, variable outcomes is regularly countered by fear of the disruption of the coherence of the historical narrative and the undermining of academic control.[81] Our model does not solve this tension, rather it maps it onto the Court in order to start to explore the ways in which visitors' uses of the space interact(ed) with and challenge(d) the official Palace line.

Winter Triclinium (27)

Scharf finishes his tour here, offering no exit, though you are very near the rear vestibulum (25).[82] Should you have clicked on every icon, read every notecard, Scharf would assume that you are fully appraised of the facts surrounding Pompeii. Feeling exhausted, you may be pleased to see a Palace employee, who directs you to the refreshment area appropriate to your class and proudly hands you an inventory of the fine foods consumed in the Palace.[83] You will of course never reach the refreshment stand, since the rest of the Palace remains unrealised and you find yourself instead in the Palace park, where you might take a stroll, relax by the 'monsters' pond or fly in our air balloon. And not for you a train-ride home on the London–Brighton line, rather an instant teleport to discover other VWs or a logging out, restoring you instantly to your office/living-room which, in truth, you never left.

The information visitors to the 'real' exhibition encountered and the narratives they constructed depended partly on the journeys they took

through the Palace. Experiences of walking the courts must have borne
an intriguing relationship to the guidebook texts. Claims that the Palace
represented a full encyclopedia of world knowledge, apparently dem-
onstrated by endless inventories of its contents, were surely not real-
ised in practice since it seems unlikely that many visitors witnessed all
the exhibits (which themselves were often changing) or that the Palace
added up to a coherent whole that was only unlocked on the last stand.[84]
Similarly, commentaries on the Fine Arts Courts almost all create a
didactic sequence around a grand narrative of rise and decline, which
could not be replicated on the ground unless visitors ran back and forth
along and across the nave.[85]

The information gained by visitors to our Court is determined by the
robots' perception of their status and the paths and opportunities to gather
information that they have chosen to take or ignore. Presenting research
spatially in a VW equally scuppers the opportunity to match an overarch-
ing narrative with user experience. Since the space is experienced princi-
pally from the point of view of the user's avatar, there is no mechanism by
which either to impose a master narrative or automatically to harvest each
user's own narrative.[86] Freedom of movement, as in the Palace, allows
visitors to slip our grasp. Such freedom might be criticised on the grounds
that, like play, it threatens academic authority and even responsibility,
and conversely that this 'freedom' is a sham in an environment entirely
dictated by its academic creators. Nevertheless, digital media and web
technologies are increasingly inviting experiments with new ways of pre-
senting research that might provide a playful challenge to the linearity and
authority of the academic monograph.[87] They provide a model not only
for our chosen mode of presentation but for the very project of mashing
up and challenging the authoritarian stance of Scharf's own monographic
text.

Productive juxtapositions?

The weaknesses of an appeal to accessibility as a means of justifying such
experiments are predominantly that they are easily shattered by the expe-
riences of visitors themselves. What happens, for example, when visitors to
our model simply feel real confusion rather than realising they are being
manipulated into this state in order to reflect on that of Victorian visitors?
However, while we cannot from this early vantage point presuppose other
visitors' experiences, we can learn from our own.[88] The final significant
role of our restoration comes when, as visitors ourselves, we are forced to
look at the Court presenting back to us the Palace we have re-imagined.

The model visualises the effect of academia's current lines of inquiry, and its apparent distortions invite (inevitably unfulfilled) contemplation of the ways in which our own reception of the Palace has altered what it might have been. In privileging themes of the subversive, personal, playful, visual and eclectic, the Pompeian Court presented here transforms the terribly modern Palace into a post-modern paragon. We might have expected our choice of format to be implicated in this transformation; after all, the productive juxtaposition is predicated on enjoying the links and transferences between nineteenth- and twenty-first-century approaches to, and technologies of, restoration. However, that juxtaposition also relies on ultimately acknowledging the distance between the two and it is here that this model of reception begins to break down.

We are ever mindful that the reason why VWs seem so apposite a place to explore nineteenth-century culture is because our recent reception of that culture has predetermined our choice, as a return to the beginning of our virtual, virtual tour and the acknowledgement of the Palace as a product of Victorian scopic regimes, might demonstrate.[89] As Crary observes in his own book charting those regimes, revisions of the period's viewing revolutions are indelibly coloured by their authors' own experience of the digital 'transformation of visuality'.[90] This tendency to gaze at the Victorian past through the lens of the digital revolution is emphasised more overtly in attempts, for example, to designate the telegraph as the 'Victorian internet'.[91] At the same time, apologists for virtual reconstruction have justified themselves by fashioning it in its imagined Victorian image. In attempts to make novel digital media recognisable, to afford them status and an academic discourse, they have sought their own connections to nineteenth-century techniques of reconstruction and viewing, which they interpret as the first experiments in virtuality.[92] Far from providing a safe distance from which to look back at the Palace, the digital is intimately bound with it.

This circularity is also evident in the discourse surrounding reconstruction. Just as fear of fakery launched itself retrospectively from the later twentieth century onto the Victorian era, it had projected itself forward onto VWs even while they only existed in concept. Baudrillard's later essays developed his arguments precisely through the example of virtual hyper-reality.[93] This loop is all the more inescapable because, in the UK, precisely the Victorian period has been seen as the dominant focus of hyper-real heritage practices, from television adaptations to heritage parks, such as Beamish. Such features of 'theme-park Victoriana' are said to favour atmosphere over fact, experience over history and encourage a cosy conception of yesteryear.[94] The immersive technology of our

Court, experienced from the intimacy of one's keyboard and accessed through familiar gaming techniques and interaction with fictional characters, might be a prime example of this phenomenon. Juxtaposition here might only be unproductive as each format (the Victorian Palace and the VW) is pre-/post-programmed to confirm the other's failures and lack of authenticity. Assessment of the reconstructions of both nineteenth-century and twenty-first century virtual reconstruction continue to suffer from an increasingly outmoded polemic against the fake, even while opinions on heritage restoration have been under revision for some considerable time, causing a resurgence of academic interest in and curatorial practice of reconstruction, reproduction and re-enactment in even our most 'highbrow' museums and galleries.[95]

These revisions, of course, have provided the backdrop against which it has become possible to relaunch the Crystal Palace and from which we have drawn corroboration for our own practices (even if we must accept them as being as ideologically preoccupied and contingent as those they intend to replace). Their most consistent justification of the heritage practices they consider is an emphasis on framing, which flags performance to the visitor. Presence in the frame supposedly promotes a theatrical self-awareness of ourselves as interlopers, by which our attention is drawn to the 'cultural production of knowledge' in order to produce a longer-term, critical awareness of the rhetoric of exhibition displays and our own presence in the museum.[96] In the case of the 2001 re-staged RA exhibition at Somerset House, visitors not only played the part of Victorian gallery-goers but saw themselves collectively in role on screen, via CCTV images that relayed events in the gallery.[97] From this point of view, perhaps the saving grace of VWs is that they also rely on such self-awareness since the user has the sense simultaneously of inhabiting the environment and watching it from the other side of the computer screen.[98]

Returning to a scopic metaphor, these reassessments presume a kind of 'double vision' by which we are able to be both immersed and critically distanced. Heilmann and Llewellyn introduce the concept of 'metafiction' to describe recent neo-Victorian texts, which ape nineteenth-century historical novels but self-referentially, continually exposing the workings of their imitation even while sustaining their fictional worlds.[99] They offer a literary paradigm which might be attractive to our own model's attempts to engage critically with Victorian modelling, even through the mode of 'theme-park Victoriana'. Our mode of delivery provides a useful comparative frame for the nature of Victorian reception of the Roman past, while acknowledging our own limitations in understanding the Victorian period.[100] As restoration, our model might be doomed to fail. As

meta-restoration, it might just offer a legitimate type of inquiry, not shedding away accretions and losses to recover a pristine, 'original' Court but providing an ambivalent space in which to explore its impossibilities.[101] To recognise our Court as toy might be to accept the ultimate futility of our efforts but also to recognise its capacity to be played with. Configuring our attempts to grasp the past as play provides the inauthentic with a positive paradigm by recognising a mode of reception that is essentially and necessarily ludic.[102] Most importantly, it does so in a format that might just be able to encourage a range of users beyond the academy to consider the effects and ethics of reproduction and exhibition as a central part of their engagement with the past.

Postscript: A last visit to the Court

The Pompeian Court is such a strong metaphor for the Crystal Palace because the excavation and resurrection of the site itself promises such a positive paradigm of restoration. However, many narratives of reconstructions (especially that of the Palace), which begin with the vibrant process of bringing to life, end in the failure to sustain that animism. As the real-world hype around SL has faded, debate in the last few years has focused instead on vigorously anticipating its demise.[103] Unable to sustain the interest of real-world business, SL has returned to its niche, leisure audience, probably still the most popular VW of its type but no longer the host of a virtual gold-rush. When land leaseholds expire and the tenants move on, creators leave behind the shells of their virtual real estate. To that extent, the metaphorical value of the site of Pompeii is less often that of the revived and more that of the ruin. Digital space is already reported to be scattered with abandoned, dead sites which explicitly invite the comparison.[104] The Pompeii as deserted ruin metaphor will be familiar to any observer of the wreck of the Pompeian Court after the Palace fire, the moment when it at last looked authentically Pompeian and proved itself the most appropriate of the Palace's restored pasts (figure 9.6). On the 75th anniversary of that fire, a small crowd gathered in the dark SL night, toasting-forks in hand, to witness a one-night-only extravaganza. As the flames leapt from our Court, their crackle clearly audible, we watched the paintings char. The fire marked the end of our own SL leasehold. For now our model is safe in open-source Open Sim. But will it leave anything long-term to challenge the Capri lithograph? Safe inside its archive box, cherished by the academy as part of an authentic, authoritative text, that artefact bides its time to reassert itself as a genuine and worthwhile vision of Pompeii. And it does so, perhaps, safe in the knowledge that its future

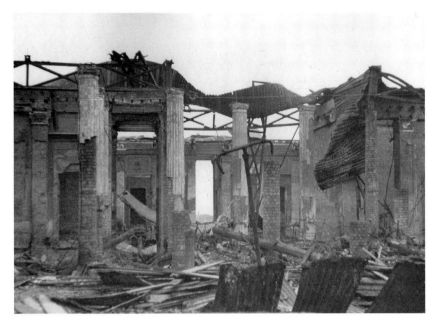

9.6 Remains of the Pompeian Court, 1936, photograph by A. Talbot. Bromley Local Studies and Archives.

scholarly viewers will have long forgotten both Digby Wyatt's and our phoney Pompeian Courts.

Notes

1 F. Niccolini, *Le Case ed I monumenti di Pompei disegnati e descritti* (Naples: Fausto Niccolini, 1854–96). For a brief introduction to the aims of the volumes see P. L. Ciapparelli, 'The Editorial Adventures of the Niccolini Brothers', in R. Cassanelli, S. De Caro and T. M. Hartmann (eds), *Houses and Monuments of Pompeii. The Works of Fausto and Felice Niccolini* (Los Angeles: J. Paul Getty Museum, 2002), pp. 10–25; M.-N. Pinot de Villechenon, 'De l'archéologie des frères Niccolini à celle de l'architecte Alfred Normand: l'*imaginaire* de la villa pompéienne et du service de porcelain de Sèvres du prince Jérôme Napoléon', in E. Perrin-Saminadayar (ed.), *Rêver l'archéologie au XIXe siècle: de la science à l'imaginaire* (Saint-Étienne: Publications de l'Université de Saint-Étienne, 2001), pp. 240–4. On the gravitas of the *restauro*, particularly in French academic training, see *Pompei e gli Architetti Francesi dell'Ottocento* (Paris: École nationale supérieure des Beaux-Arts, 1981); M. Royo, '"Le monde antique des Pensionnaires", ou les rapports ambigus de l'archéologie et de l'architecture à la fin du XIXe et au début du XXe siècles', in Perrin-Saminadayar, *Rêver l'archéologie*, pp. 203–36.

2 To compound the confusion, this restoration is mistakenly labelled in Cassanelli *et al.*, *Houses and Monuments of Pompeii* (pp. 198–9, pl. 164) as being of the House of Marcus Lucretius.

3 For an extended description and analysis of the Pompeian Court see S. Hales, 'Re-casting Antiquity in the Crystal Palace', *Arion*, 14:1 (2006), 99–133. K. Nichols, *Greece and Rome at the Crystal Palace: Classical Sculpture and Modern Britain, 1854–1936* (Oxford: Oxford University Press, 2015) offers a much more extensive analysis of the role of the classical in the Palace, and our model owes an enormous debt to her work.

4 The reception of Pompeii is a burgeoning field. On the history of excavations see A. Cooley, *Pompeii* (London: Duckworth, 2003). Recent collections considering the range of Pompeii's influence on the modern world include V. Coates and J. Seydl (eds), *Antiquity Recovered. The Legacy of Pompeii and Herculaneum* (Los Angeles: J. Paul Getty Museum, 2007); R. Cremante, M. Harari, S. Rocci and E. Romano (eds), *I misteri di Pompei. Antichità pompeiane nell'immaginario della modernità* (Pompeii: Flavius Editore, 2008); S. Hales and J. Paul (eds), *Pompeii in the Public Imagination from its Rediscovery until Today* (Oxford: Oxford University Press, 2011); L. Jacobelli (ed.), *Pompei. La costruzione di un mito* (Rome: Bardi Editore, 2008).

5 *Chambers's Journal of Popular Literature, Science and Arts*, 74 (2 June 1855), 346; E. McDermott, *Routledge's Guide to The Crystal Palace and Park at Sydenham* (London: Routledge, 1854), p. 175. Abbate's roles in Naples further confused his relationship with originals and copies. He had contributed to the plates in the Niccolini volumes and was also charged with restoring paintings left in situ in Pompeii: *Athenaeum* (16 March 1861), p. 363.

6 *Sunday at Home* (15 November 1862), p. 734 (on Roman dining habits); *Journal of Sacred Literature and Biblical Record*, 7:13 (1858), 65 (on Roman houses).

7 *Dublin University Magazine* (1 January 1877), p. 106; *Musical World* (27 July 1878), p. 479.

8 G. Scharf, *The Pompeian Court* (London: Bradbury & Evans, 1854), p. 65; *Morning Post* (20 July 1854), p. 135.

9 See *Art Journal* (1 December 1853), p. 312 on the expense of such volumes.

10 *Bentley's Miscellany* (1 July 1856), p. 64. The palace had been built for Tsar Nicholas I's wife Alexandra Fyodorovna in 1852. On Neo-Pompeian style more generally see A-M. Leander-Touati and S. Hales (eds), *Returns to Pompeii* (Swedish Institute of Archaeology, forthcoming). The familiar 'exoticness' of the Pompeian Court, in fact, rendered it suitable for tourists to describe entirely non-Pompeian surroundings by reference to it. Dickens, for example, calls on its 'fresco-filled dens' as an evocative means to conjure an impression of his exotic North African hotel room. *All the Year Round* (9 June 1866), p. 525.

11 D. Lowenthal, 'Authenticity? The dogma of self delusion', in M. Jones (ed.), *Why Fakes Matter: Essays on Problems of Authenticity* (London: British Museum Publications, 1992), pp. 184–92.

12 *Builder* (16 April 1853), pp. 242–5.

13 *Gentleman's Magazine* (1 June 1866), p. 885.

14 V. G. Swanson, *The Biography and Catalogue Raisonné of the Paintings of Sir Lawrence Alma-Tadema* (London: Garten & Co., 1990), p. 301 (no. 70); Scharf, *Pompeian Court*, p. 51; p. 45.

15 S. Hales, 'Re-casting Antiquity', 108.

16 Conflations of 1854 and 1851 occur in, for example, P. Connor, 'Cast Collecting in the Nineteenth Century: Scholarship, Aesthetics, Connoisseurship', in G. W. Clarke (ed.), *Rediscovering Hellenism* (Cambridge: Cambridge University Press, 1989), p. 209.

17 P. Greenhalgh, 'Education, Entertainment and Politics: Lessons from the Great International Exhibitions', in P. Vergo (ed.), *The New Museology* (London: Reaktion Books, 2000), p. 76. On the way in which the denigration of play is used as a means of demonstrating superiority on behalf of the observer, see B. Sutton-Smith, *The Ambiguity of Play* (Cambridge, MA: Harvard University Press, 1997), p. 9.

18 On the decline of the period room, for example, see C. Saumarez Smith, 'Museums, artefacts and meanings', in Vergo (ed.), *New Museology*, pp. 6–21.

19 Nichols, *Greece and Rome at the Crystal Palace*, pp. 90–1, 120–1. J. Baudrillard, *Simulacra and Simulation*, trans. S. Glaser (Ann Arbor: University of Michigan Press, 1994); U. Eco, 'Travels in Hyperreality', in *Faith in Fakes* (London: Secker & Warburg, 1986), pp. 1–58.

20 K. Walsh, *The Representation of the Past: Museums and Heritage in the Post-Modern World* (London: Routledge, 1992), esp. pp. 53–69.

21 *Ibid.*, p. 49. The classic discussion of heritage's relationship to history is D. Lowenthal, *The Heritage Crusade and the Spoils of History* (Cambridge: Cambridge University Press, 1998).

22 See, for example, L. Jordanova, 'Objects of Knowledge: A Historical Perspective on Museums', in Vergo (ed.), *New Museology*, p. 35. On the French and British anxiety concerning this turn in culture see D. Maleuvre, *Museum Memories: History, Technology, Art* (Stanford: Stanford University Press, 1999), p. 117; A. Heilmann and M. Llewellyn, *Neo-Victorianism: The Victorians in the Twenty First Century, 1999–2009* (London: Palgrave Macmillan, 2010), p. 216.

23 We would here like to thank local groups and individuals local to the Park such as the Crystal Palace Foundation, Crystal Palace Museum and 'Tulse Hill Terry', who have offered knowledge, advice, support and archive material throughout our project. On an ideal, local 'sense of place', see Walsh, *Representation of the Past*, pp. 160–75.

24 Further information on the technical aspect of the build, ongoing reflections on the process and preliminary data on user reactions, please see our website and blog http://sydenhamcrystalpalace.wordpress.com.

25 For a brief overview of the history of Second Life and its antecedents see T. Boellstorff, *Coming of Age in Second Life* (Princeton: Princeton University Press, 2008), pp. 32–59. On SL as a commercial enterprise and on commercialism

within SL see *ibid.*, pp. 206–36. The commercial nature of Linden Labs does not always sit comfortably with users. Our own retreat from SL was enforced by Linden Labs' withdrawal of their educational discount, a financial decision that has not been unchallenged by users; see http://primperfectblog. wordpress.com/2011/11/30/the-destruction-of-the-pompeii-court-at-the-crystal-palace-the-closure-of-another-educational-region/. Our lease in SL having expired (see postscript) the model now resides in Open Sim, an open source variant of SL – for advice on accessing the model see http://sydenhamcrystalpalace.wordpress.com. We are grateful for funding from both JISC and the University of Bristol. In particular, we would like to thank Ale Fernandez, Laura Hall, Darren Sherriff, Ben Showers, Andrew Wray, and Drew Baker and Hugh Denard from KVL for all their technical advice and support.

26 The term is Henning's, used in the context of perceived connections between the World Wide Web and the curiosity cabinet. M. Henning, 'The Return of Curiosity. The World Wide Web as Curiosity Museum', in J. Lyons and J. Plunkett (eds), *Multimedia Histories from the Magic Lantern to the Internet* (Exeter: University of Exeter Press, 2007), p. 73.

27 Scharf, *Pompeian Court*, p. 44. See also F. K. J. Shenton, *General Guide to the Crystal Palace* (Sydenham: The Crystal Palace Company, 1879), p. 55.

28 Nichols, *Greece and Rome at the Crystal Palace*, pp. 97–9. See also Verity Hunt, 'A Present from the Crystal Palace', in this volume.

29 K. Flint, *The Victorians and the Visual Imagination* (Cambridge: Cambridge University Press, 2000, pp. 8–11; J. Crary, *Techniques of the Observer* (Cambridge, MA: MIT Press, 1991); Royo, 'Le monde antique des Pensionnaires', p. 219.

30 W. H. Galperin, *The Return of the Visible in British Romanticism* (Baltimore and London: Johns Hopkins University Press, 1993), esp. 42–6 (on Pompeian panoramas see pp. 53–4). On the bracketing of exhibitions and panoramas see Flint, *Victorians and Visual Imagination*, p. 4. For immersive exhibition strategy see, for example, S. Bann, 'Views of the Past', in G. Fyfe and J. Law (eds), *Picturing Power* (London: Routledge, 1988), pp. 56–60; G. Blix, *From Paris to Pompeii: French Romanticism and the Cultural Politics of Archaeology* (Philadelphia: University of Pennsylvania Press, 2009), pp. 62–71; E. N. Kaufman, 'The Architectural Museum from World's Fair to Restoration Village', in B. M. Carbonell (ed.), *Museum Studies: An Anthology of Contexts* (Oxford: Blackwell, 2004), pp. 273–89; Greenhalgh, 'Education, Entertainment and Politics', pp. 89–95. *Builder* (15 April 1854), p. 193 gives some indication of the clarity of vision such environments were supposed to afford, stressing the correctives that the Palace's reconstructions will give to the inevitable deceptions of two-dimensional plans, sections and elevations.

31 J. Urry, *The Tourist Gaze*, 2nd edn (London: Sage Publications, 2002), pp. 152–6; Flint, *Victorians and Visual Imagination*, pp. 139–66. On the erotics of digging Pompeii see J. Wallace, *Digging the Dirt: the Archaeological Imagination* (London: Duckworth, 2004), pp. 79–100.

32 Scharf, *Pompeian Court*, p. 45.

33 *Real Museo Borbonico* (Naples: Stamperia Reale,1824–57). Other frequent sources include F. Mazois, *Les ruines de Pompéi* (Paris: Fermin Didot, 1824–38) and W. Zahn (and O. Jahn), *Die schönsten Ornamente und merkwürdigsten Gemälde aus Pompeji, Herkulaneum und Stabiae* (Berlin: G. Reimer, 1828–59). Tracing the origins of the motifs themselves also illuminates the processes of selection, showing a preference for the novelty value of very recent excavations.

34 On polychromy in the Court see Hales, 'Re-casting Antiquity', 111. On the impact of Pompeian colour more generally see Leander-Touati and Hales (eds), *Returns to Pompeii*.

35 Zahn, *Die schönsten Ornamente*, II, p. 87.

36 Scharf, *Pompeian Court*, pp. 45–8.

37 A rare image of the rear of the Court (a view inside *thalamus* 19) can be found in *London Journal* (29 July 1854), 341 although, interestingly, on the following page the journal misidentifies it as one of the front *alae*.

38 *The Ten Chief Courts of the Crystal Palace* (London: Routledge, 1854), p. 40; E. Eastlake, 'The Crystal Palace', *Quarterly Review*, 96:92 (1855), 317. For more on the nature of contemporary debates concerning the means, aims and effects of restoration of ancient buildings, see Royo, 'Le monde antique des Pensionnaires'. On the conversation around the reconstructions at the Palace see Nichols, *Greece and Rome at the Crystal Palace*, pp. 87–98.

39 Eastlake, 'Crystal Palace', 311.

40 Melville derides the Egyptian Court as a 'vast toy' in a diary entry 29 April–1 May 1857. See J. Leyda (ed.), *The Melville Log* (New York: Harcourt, Brace and Co., 1951), p. 576); *L'Illustration* (January 1858), p. 78, in the context of distinguishing it from the 'real' Maison Pompéienne in Paris. For that building and more discussion of 'jou jou' restrorations, see S. Hales, 'The Novel Interior', in Leander-Touati and Hales (eds), *Returns to Pompeii* (forthcoming); M-C. Dejean de la Batie, 'La Maison pompéienne du Prince Napoléon, avenue Montaigne', *Gazette des Beaux-Arts*, 87 (1976), 127–34. On the desire to avoid another full-scale ancient house becoming a 'jouet', this time the later Villa Kerylos on the Côte d'Azur, see Royo, 'Le monde antique des Pensionnaires', p. 233.

41 On the disappointments of virtual reality (VR) see M. Heim, *The Metaphysics of Virtual Reality* (New York, Oxford: Oxford University Press) 1993, pp. 122–3; M-L. Ryan, *Narrative as Virtual Reality: Immersion and Interactivity in Literature and Electronic Media* (Baltimore and London: Johns Hopkins University Press, 2001), p. 25.

42 On the museum as social space, see P. Wright, 'The Quality of Visitors' Experience in Art Museums', in Vergo (ed.), *New Museology*, pp. 119–48. On the Pompeian house as social space, see A. Wallace-Hadrill, *Houses and Society in Pompeii and Herculaneum* (Princeton: Princeton University Press, 1994), pp. 38–61; S. Hales, *The Roman House and Social Identity* (Cambridge: Cambridge University Press, 2003), pp. 97–134.

43 On the definitions of the tableau, toy and miniature used here, see S. Stewart, *On Longing: Narratives of the Miniature, the Gigantic, the Souvenir, the Collection* (Durham, NC: Duke University Press, 1993), pp. 56–68. On the disappointment of the empty SL space, see Boellstorff, *Coming of Age*, p. 182. On the importance of virtual presence over the imitation of reality as key to the potential of VWs, see R. Coover, 'The Digital Panorama and Cinemascapes', in T. Bartscherer and R. Coover (eds), *Switching Codes. Thinking Through Digital Technology in the Humanities and the Arts* (Chicago: University of Chicago Press, 2011), p. 216; D. Abernathy and C. Johanson, 'Evolving Strategies: Projects of the UCLA Cultural Virtual Heritage Laboratory', in M. Forte (ed.) *The Reconstruction of Archaeological Landscapes Through Digital Technologies* (Oxford: Archaeopress, 2005), pp. 221–8; G. Earl, 'Video Killed Engaging VR? Computer Visualizations on the TV Screen', in S. Smiles and S. Moser (eds), *Envisioning the Past* (London: Blackwell, 2005); 204–22; R. Shields, *The Virtual* (London: Routledge, 2003), p. 55.

44 Scharf, *Pompeian Court*, pp. 48–58.

45 Shenton, *General Guide*, p. 53; Scharf, *Pompeian Court*, p. 27.

46 Eastlake, 'Crystal Palace', 317.

47 *Athenaeum* (20 January 1855), p. 81; see also Nichols, *Greece and Rome at the Crystal Palace*, pp. 41–4, 95–6.

48 On the emphasis of the VW on representation and its discounting of empirical sense data, see K. Hillis, *Digital Sensations. Space, Identity, and Embodiment in Virtual Reality* (Minneapolis: University of Minnesota Press, 2009), p. xv.

49 On restagings at Somerset House and Manchester Art Gallery, see H. Rees Leahy, 'Watching Me, Watching You: Performance and Performativity in the Museum', in A. Jackson and J. Kidd (eds), *Performing Heritage: Research, Practice and Innovation in Museum Theatre and Live Interpretation* (Manchester: Manchester University Press, 2011), pp. 26–38.

50 The term is borrowed from Abernathy and Johanson, 'Evolving Strategies', pp. 226–7, who use it to describe their 3D reconstruction of Santiago de Compostela. On the appeal of the spatiality of VWs for digital humanities see L. Lancaster, 'Virtual Reality in the Humanities', in Forte (ed.), *Reconstruction of Archaeological Landscapes*, pp. 1–8.

51 On the in-transit, tourist glance, and its emergence alongside new travel technologies such as the steam train, see Urry, *Tourist Gaze*, p. 153.

52 Scharf, *Pompeian Court*, pp. 58–9.

53 *Ten Chief Courts*, p. 48; S. Phillips, *Guide to the Crystal Palace and Park* (London: Bradbury & Evans, 1854), p. 16; Scharf, *Pompeian Court*, pp. 27–30). On the souvenir, see Stewart, *On Longing*, pp. 132–50; B. Gordon, 'The Souvenir: Messenger of the Extraordinary', *Journal of Popular Culture*, 20:3 (1986), 135–46.

54 On souvenirs of Sydenham, see Hunt, Chapter 2, in this volume.

55 M. Bridges, 'Objects of Affection: Necromantic Pathos in Bulwer-Lytton's City of the Dead', in Hales and Paul (eds), *Pompeii in the Public Imagination*, pp. 90–104; S. Hales, 'Cities of the Dead', *Ibid.*, pp. 153–70. Heilmann and

Llewellyn, *Neo-Victorianism*, suggest that our own recent preoccupation with the Victorians' own apparent preoccupation (as modelled through our eyes) might be a symptom of our own acknowledgement of the nature of regaining the past.

56 *Ten Chief Courts*, p. 40. Likewise *Leisure Hour* (13 April 1854), p. 231 has a policeman on duty in the Court relieved of his post by a togate Roman. See also *Athenaeum* (27 February 1858), p. 270.

57 See, for example, *Builder* (7 January 1854), p. 1.

58 E. Bulwer-Lytton, *The Last Days of Pompeii* (London: Richard Bentley, 1834), Book I, Chapter 3; Scharf, *Pompeian Court*, pp. 33–7. On the links between the Court and the novel, see further Hales, 'Re-casting Antiquity', 104–9; Nichols, *Greece and Rome at the Crystal Palace*, pp. 60–2.

59 See, for example, Shields, *The Virtual*, p. 35.

60 *Musical Herald* (1 August 1892), p. 237; Piggott, *Palace of the People*, pp. 191–5. On the nature of adaptation, both within and of the Victorian period see Heilmann and Llewellyn, *Neo-Victorianism*, pp. 211–45.

61 Scharf, *Pompeian Court*, pp. 59–60.

62 The latter French woman being present specifically to voice the criticism of *L'Illustration*. See note 40.

63 Hales, 'Re-casting Antiquity', 121–8. On class issues more widely in the Palace see Nichols, *Greece and Rome at the Crystal Palace*, pp. 19–52.

64 Eastlake, 'Crystal Palace', 317.

65 *Illustrated Crystal Palace Gazette*, 6 (1854), 67.

66 *Builder* (16 April 1853), p. 242; McDermott, *Routledge's Guide*, p. 172.

67 On rational recreation see *Art Journal* (1 May 1853), 37; P. Bailey, *Leisure and Class in Victorian England* (London, New York: Routledge & Kegan Paul, 1978).

68 H. Martineau, 'The Crystal Palace', *Westminster Review*, 62:122 (1854), 545–6.

69 *Illustrated Crystal Palace Gazette*, 1 (5 February 1854), 50; *Builder* (16 April 1853), p. 242.

70 On the identity issues faced by VW users, see Hillis, *Digital Sensations*, pp. 164–99; Boellstorff, *Coming of Age*, pp. 118–50; J. Blascovich and J. N. Bailenson, *Infinite Reality: Avatars, Eternal Life, New Worlds, and the Dawn of the Virtual Revolution* (New York: William Morrow, 2011).

71 Walsh, *Representation of the Past*, p. 103.

72 *Examiner* (20 August 1853).

73 See chapters by Jackson, Kidd and Farthing in Jackson and Kidd (eds), *Performing Heritage*. Blascovich and Bailenson, *Infinite Reality* present a number of experiments which aim to explore the relationship between 'real' identities and avatars, particularly in terms of the way in which experiences of using character avatars in VWs affect the attitudes of computer issues when they have logged off. On this relationship as an effective tool in promoting empathy, see Heim, *Metaphysics of Virtual Reality*, p. 126.

74 Scharf, *Pompeian Court*, pp. 62–4.

75 Eastlake, 'Crystal Palace', 317.

76 For example, D. S. Ryan, 'Staging the Imperial City: the Pageant of London, 1911', in F. Driver and D. Gilbert (eds), *Imperial Cities: Landscape, Display and Identity* (Manchester: Manchester University Press, 1999), pp. 117–35.

77 *Tonic Sol-Fa Reporter* (1 August 1869), p. 115.

78 *Fun* (7 November 1868), p. 91; *Bow Bells* (5 June 1884), p. 569.

79 On the necessary ambiguity needed for play, see Sutton-Smith, *Ambiguity of Play*, pp. 1–17. The types of play identified here are taken from his own categories, as charted on p. 215.

80 As an example of the reassessment of these limitations in heritage contexts, see L. Smith, 'The Doing of Heritage: Heritage as Performance', in Jackson and Kidd (eds), *Performing Heritage*, pp. 76–81.

81 Lancaster, 'Virtual Reality in the Humanities'; Gillings (p. 234) advocates play as the key to the profitable use of VR: M. Gillings, 'The Real, the Virtually Real, and the Hyperreal: the Role of VR in Archaeology', in Smiles and Moser (eds), *Envisioning the Past*, pp. 222–39.

82 Scharf, *Pompeian Court*, pp. 64–5.

83 *Chambers's Journal* (5 August 1854), p. 96.

84 *Builder* (17 June 1854), p. 318; *Illustrated London News* (17 June 1854), p. 580.

85 A complaint voiced by Eastlake, 'Crystal Palace', 317. The tactics of the guidebooks also raise the question of the extent to which the acquisition of information can be equated to knowledge and critical understanding. Here, we find another juxtaposition with debates about the ways in which VWs privilege information over thought and analysis. See, for instance, Hillis, *Digital Sensations*, p. 171.

86 Ryan, *Narrative as Virtual Reality*, pp. 48–74.

87 Ruth Tringham's experiments in presenting her research into Neolithic households online offer perhaps the most extended and committed experiments in this sphere, allowing the user to explore, privilege and re-order her data as they wish. See www.bmrc.berkeley.edu/people/tringham/chimera.html. Also Gillings, 'The Real, the Virtually Real, and the Hyperreal', p. 231. Among other noteworthy recent experiments, one of the papers in a recent digital humanities edited volume is presented as a card game. See E. Zimmerman, 'Figment: The Switching Codes Game', in Bartscherer and Coover (eds), *Switching Codes*, pp. 191–8.

88 As indicated earlier, the current middle stage of our project involves collecting and analysing visitor responses.

89 Flint, *Victorians and Visual Imagination*; Crary, *Techniques of the Observer*.

90 Crary, *Techniques of the Observer*, pp. 1–2.

91 T. Standage, *The Victorian Internet: The Remarkable Story of the Telegraph and the Nineteenth Century's Online Pioneers* (London: Weidenfeld & Nicolson, 1998).

92 Boellstorff, *Coming of Age*, pp. 32–6, 93; Coover, 'The Digital Panorama and Cinemascapes'; Blascovich and Bailenson, *Infinite Reality*, pp. 24–36; Shields, *The Virtual*, pp. 1–17, 112.

93 See, for example, J. Baudrillard, *The Vital Illusion* (New York: Columbia

University Press, 2000). For analysis of Baudrillard's stance on VR, see Ryan, *Narrative as Virtual Reality*, pp. 27–35. On the applications of the language of the hyper-real and ensuing critiques of heritage to VR, see Lancaster, 'Virtual Reality in the Humanities'; V. Gaffney, 'In the Kingdom of the Blind: Visualization and E-science in Archaeology, the Arts and Humanities', in M. Greengrass and L. Hughes (eds), *The Virtual Representation of the Past* (Farnham: Ashgate, 2008), p. 127; Shields, *The Virtual*, p. 4; Boellstorff, *Coming of Age*, p. 244.

94 J. Gardiner, 'Theme-Park Victoriana', in M. Taylor and M. Wolff (eds), *The Victorians since 1901: Histories, Representations, and Revisions* (Manchester: Manchester University Press, 2004), pp. 167–80. Gardiner seeks to suggest the positives of these practices in rekindling interest in the Victorian period. See also the essays in C. L. Krueger (ed.), *Functions of Victorian Culture at the Present Time* (Athens, OH: Ohio University Press, 2002). In the final stages of writing this paper a young boy was killed at Beamish when he fell from a moving steamroller. The occurrence of a very real industrial accident punctures the illusion of the site as a space in which to 'play' safely in the past.

95 The obvious vantage point to see the call for such revision would be the essays in Vergo, *New Museology*.

96 Rees Leahy, 'Watching Me, Watching You', p. 29.

97 *Ibid.*, pp. 34–5.

98 Moreover, since the default camera position in SL is behind the avatar's head, this double vision is an inescapable part of the experience in-world too. Camera controls that can be detached from the avatar's point of view completely allow the user to watch the performance of their avatar in the third person. B. Frischer, 'The Digital Roman Forum Project of the Cultural Virtual Reality Laboratory: Remediating the Traditions of Roman Topography', in Forte (ed.), *Reconstruction of Archaeological Landscapes*, pp. 9–21, emphasises how different techniques of presenting data (as navigable space) and metadata (as 'dropdown' boxes of information) encourages something similar to what we have here termed 'double vision'.

99 Heilmann and Llewellyn, *Neo-Victorianism*, p. 174.

100 At this point we disagree with Heilmann and Llewellyn p. 222 that 'theme-park Victoriana' and the academic pursuit of the Victorian period are incompatible possibilities.

101 R. Beacham, '"Oh to Make the Boards Speak! There is a Task!" Towards a Poetics of Paradata', in Greengrass and Hughes (eds), *Virtual Representation of the Past*, pp. 171–7. Beacham is one of classics' most eminent pioneers in virtuality and stresses that VWs may be most effective when they are used to explore topics which share some of its own qualities, such as his own line of inquiry, the theatre. Baynes 2008, focusing on the teaching and learning experience in VWs comes to similar conclusions. S. Baynes, 'Uncanny Spaces for Higher Education: Teaching and Learning In Virtual Worlds', *Alt-J, Research in Learning Technology*, 16:3 (2008), 197–205. Such a move would

also bring the uses of virtuality somewhere nearer to the positive model, as
inventive mental modelling (in which, rather than the real being overtaken
by the fake, the real and virtual are used to re-examine each other), proposed
by P. Lévy, *Becoming Virtual: Reality in the Digital Age*, trans. R. Bonono (New
York: Plenum Trade, 1998). See also Ryan, *Narrative as Virtual Reality*, 2001,
pp. 35–9.

102 On the possibilities of a ludic model of classical reception, see W. Batstone,
'Provocation: The Point of Reception Theory', in C. Martindale and R. F.
Thomas (eds), *Classics and the Uses of Reception* (Oxford: Blackwell, 2006), pp.
15–17. Batstone models some of the ways in which 'play' might help show
the ways in which our identities are looped with those that we imitate (in
this case, the ways in which our own identities are seen in, and seen through,
those we imagine for our Victorian and Roman 'ancestors').

103 An insight into this debate on SL's future can be gleaned from: http://blogs.
hbr.org/2007/07/the-demise-of-second-life/; www.dgp4sl.com/wp/2012/
09/today-marks-the-end-of-second-life/; https://gigaom.com/2013/06/
23/second-life-turns-10–what-it-did-wrong-and-why-it-will-have-its-own-
second-life/; http://nwn.blogs.com/nwn/2014/05/second-life-isnt-dead-
but-deadish.html (accessed 20 March 2015).

104 Gillings, 'The Real, the Virtually Real, and the Hyperreal', pp. 222–4. The
link is made explicit at http://deletedcity.net (accessed 20 March 2015).

Index

Illustrations are indicated by page references in *italics*, notes by an *n* between the page reference and note number (eg. 93*n*4)